On This Day In
DETROIT
HISTORY

BILL LOOMIS
PHOTOGRAPHY BY BARNEY KLEIN

THE
History
PRESS

Published by The History Press
Charleston, SC
www.historypress.net

Copyright © 2016 by Bill Loomis
All rights reserved

First published 2016

Manufactured in the United States

ISBN 978.1.62619.833.3

Library of Congress Control Number: 2015954753

CONTENTS

Acknowledgements 5

Introduction 7

January 9

February 25

March 41

April 56

May 73

June 91

July 107

August 123

September 140

October 158

November 175

December 190

About the Author and Photographer 208

ACKNOWLEDGEMENTS

Thank you to Sallie Cotter Andrews, writing for the Wyandotte Nation, for the excerpt on Wyandotte chief Walk in the Water and for permission from the tribe to use the turtle totem of Walk-in-the-Water.

Special thanks to Thomas St. Aubin for the generous use of the image of his ancestor Basilide St. Aubin and his comments on the St. Aubin historic family farm.

Thank you, Bentley Library, University of Michigan–Ann Arbor, for assistance in researching Hazen Pingree.

The quotes from Cyrus P. Bradley are taken from his journal with permission from the Clarke Historical Library, Central Michigan University digital collection called "We Arrived in Detroit." Thank you.

"The Irish on the Urban Frontier: Nineteenth Century Detroit" by Eastern Michigan University professor JoEllen Vinyard is quoted on the economic depression of the 1850s as it was experienced in Corktown.

Bruns's book *Preacher* is quoted on preacher Billy Sunday.

And many thanks to Barney Klein for friendship and a brilliant photographic eye.

INTRODUCTION

This project was hard at times as I tried to decide what needed to stay or what needed to be bumped. I realized why Detroit has had so many city historians: Detroit's history is incredibly long, varied and fascinating. It gave me a chance to show off the panoply of three hundred plus years of Detroiters, the big deal events and the daily struggle all in tiny bites. It is amazing to talk about Stevie Wonder on one day, Chief Pontiac the next, Al Kaline, Jack Kevorkian and then General U.S. Grant dancing at a costume ball. I've tried to balance points of historical significance with everyday life, nostalgia and fun. The frustration came when bumping something out that I liked for something I thought was a better fit. Being limited to 250 words on some subjects that deserved more was at times maddening. I give my thanks to my wife, Janice, for her help rough editing and my daughter, Natasha, for her love and support. It was fun working with Barney Klein, and I appreciate his great skills with a camera. My personal favorite? Monk Parry—first monkey to drive a car in Detroit, July 3, 1904.

JANUARY

January 1

1895—Gentlemen Callers

On this day in Detroit, "all silk hatted swains," aka young bachelors, spent the entire afternoon and into the evening with friends going house to house calling on young, single ladies. Every girl measured her success and popularity by the number of gentlemen who came to offer greetings, jumping up each time the doorbell rang to welcome a new group with expressions of delight, making a mental note, "Forty-one, forty-two, forty-three…" Eventually, this custom grew tiresome, as described in the *Detroit Free Press*: "It was one thing for people to receive their friends and dispense hospitality, but when it came to receiving their friend's friends and friends of their friend's friends it became an abomination." A small, pretty wicker basket was set on the porch for callers to leave their card, which killed the tradition. The newspaper called it harsh but effective.

January 2

1842—Christmas Games

Emily Mason was the elder sister of Michigan's first governor, Stevens Mason. She was described as having the "manners of a queen, the brilliancy of a diamond, and an intellect like a blade of Damascus." However, in 1842, Emily Mason was fifteen. She described the Masons' Christmas in a letter to her father, who was in Washington, D.C., on business. In old Detroit,

as in other cities, Christmas was twelve days, so some form of celebration continued until January 5. They had a Christmas dinner with a "dozen or so special friends and with plenty of egg nog we were very merry." Among the guests was former U.S. senator Norvell, former governor of Northwest Territories and future U.S. presidential candidate in 1848 Lewis Cass and another highly respected Detroiter, Major Forsyth. They played Tableux, a parlor game that used a large frame, a gauze screen and a lantern light to produce silhouette figures. Emily, her sister Laura and Lewis Cass were the "actors." Emily claimed that others declared the Tableux "vastly pretty." Emily then convinced Senator Norvell and Major Forsyth into "various noisy games suitable to the season" such as "Blind Man's Buff" and another called "Puss in the Corner." As she wrote, "They entered into in such spirit! We have kept it up every evening since till we are quite worn out with our Christmas frolicking and shall be right glad to return to dignity again after Twelfth night till when we are to keep it up."

January 3

1965—John Conyers Joins U.S. Congress

On this day, John James Conyers Jr. began serving as the U.S. representative for Michigan's Thirteenth Congressional District. Conyers, as its longest-serving current member, is the dean of the House of Representatives. He is also the oldest and the longest-serving current member of the United States Congress. He was born in Highland Park in 1929. After graduating from Northwestern High School in Detroit, Conyers served in the Michigan National Guard (1948–50), U.S. Army (1950–54) and the U.S. Army Reserves (1954–57). Conyers served for a year in Korea as an officer in the U.S. Army Corps of Engineers and was awarded combat and merit citations. Conyers grew up in Detroit and received both his BA and his law degree from Wayne State University. Conyers is one of the thirteen founding members of the Congressional Black Caucus and is considered the dean of that group. After Martin Luther King Jr.'s assassination in 1968, Conyers introduced the first bill in Congress to make King's birthday a national holiday. It is now celebrated as Martin Luther King Jr. Day.

January 4

1940—Detroit's Supreme Court Justice

Today, President Franklin D. Roosevelt nominated Frank Murphy to the U.S. Supreme Court in 1940. Murphy was famous for his support of African Americans, dissenters, Native Americans, women, workers, unions and other "outsiders." He wrote in 1944, "The law knows no finer hour than when it cuts through formal concepts and transitory emotions to protect unpopular citizens against discrimination and persecution." William Francis "Frank" Murphy was born in Michigan of Irish parents and followed his father's footsteps to become a lawyer. After graduating from the University of Michigan, Murphy opened a law office in Detroit and became the chief assistant U.S. attorney for the Eastern District of Michigan. He served as a judge in Detroit's recorder's court from 1923 to 1930. He was a presiding judge in the famous murder trials of Dr. Ossian Sweet and his brother, Henry Sweet, in 1925 and 1926. He was elected mayor of Detroit from 1930 to 1933 during the early years of the Great Depression and in 1936 served as the thirty-fifth governor of Michigan.

January 5

1914—Ford Announces Five Dollars a Day Wages

On this day in 1914, Henry Ford introduced a revolutionary pay rate of five dollars per day for all Ford workers. When reporters asked why Ford was raising his employees' pay, he told them he wanted Ford workers to earn enough to be able to afford to buy a Ford motorcar. Later, his financial right-hand man and future mayor of Detroit, James Couzens, would claim the five-dollars-a-day pay was his idea to ensure Ford Motors would have enough labor for the future.

January 6

1988—Michigan Central Depot Closes

Today, the Michigan Central Depot boarded up its magnificent doors. It stands sixteen stories high with five hundred offices. It opened in 1913. At

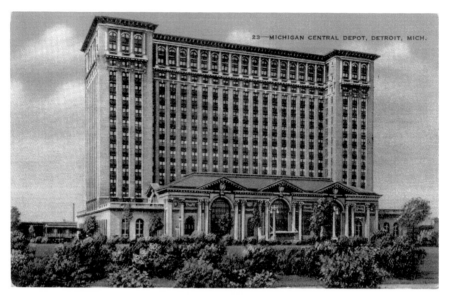

Michigan Central Railroad Depot in Corktown. *Author's collection.*

the beginning of World War I, the peak of rail travel in the United States, more than two hundred trains left the station each day, and lines of ticket holders would stretch from the boarding gates to the main entrance. In the 1940s, more than four thousand passengers a day used the station, and over three thousand people worked in its office tower.

January 7

1827—Authorities Against Entertainment

The lawmakers of the then Michigan Territory found little use for public entertainment. On this day in 1827, they passed a law that read: "If any person, or persons, shall exhibit any puppet show, wire dancing, or tumbling, juggling or sleight of hand, within this territory, and shall ask or receive pay in money, or other property, for exhibiting the same, such a person or persons, shall for every such offense pay a fine of not less than ten nor exceeding twenty dollars."

January 8

1994—"Why? Why?" The U.S. Figure Skating Championship at Cobo Hall
From January 3 to January 8, 1994, Detroit hosted the infamous U.S. Figure Skating Championship when reigning champion Nancy Kerrigan was suddenly clubbed in the right knee with a police baton by Shane Stant after a practice session, an assault planned by rival Tonya Harding's ex-husband Jeff Gillooly and co-conspirator Shawn Eckardt. The incident became known as the "Whack Heard Round the World." Some of the attack and its aftermath, which took place in a corridor at Cobo Arena, were caught on camera and broadcast internationally, particularly the now-famous footage of attendants helping Kerrigan as she grabbed at her knee wailing, "Why, why, why?" Kerrigan quickly recovered, and Tonya Harding was stripped of all her medals.

January 9

1837—Wildcat Banking
State banking between 1816 and 1863 in the United States is known as the Free Banking Era. This era was not a period of true free banking: banks were free of only federal regulation. Banking was regulated by the states, and the actual regulation of banking varied wildly from state to state. Michigan's may have been the worst when the state passed the "Free Bank Act" in January 1837. According to some sources, the term came from a bank in Michigan that issued private paper currency with the image of a wildcat. After the bank failed, poorly backed bank notes became known as wildcat currency, and the banks that issued them as wildcat banks.

January 10

1928—Poet Philip Levine
This day was the birthday of poet Philip Levine, born in Detroit. Philip Levine was educated in the Detroit public school system and at Wayne State University (at that time called Wayne University). After graduation, Levine worked a number of industrial jobs, including the night shift at Chevy Gear

and Axle, reading and writing poems in his off hours. In 1953, he studied at the University of Iowa, earning an MFA from the Iowa Writers' Workshop. Throughout his career, he published numerous books of poetry. He won the Pulitzer Prize in 1995, National Book Award in 1991, the National Book Critics Circle Award in 1991, the first American Book Award for Poetry in 1975 and the 1977 Lenore Marshall Poetry Prize from the Academy of American Poets. Phillip Levine died on February 14, 2015, in California.

January 11

1812—Tecumseh in Detroit

For one year after Detroit was surrendered to the British in the War of 1812, the town was ruled harshly by British military. The great Indian leader Tecumseh, who fought for the British, also wintered in Detroit and was well liked by Detroiters for his fairness. A British officer provided a description of the man at the time:

> *Tecumseh's appearance was very prepossessing: his figure light, and finely proportioned; his age I imagined to be about five-and-thirty; in height, five feet nine or ten inches; his complexion light copper; countenance oval, with bright hazel eyes, bearing cheerfulness, energy, and decision. His dress consisted of a plain, neat uniform, tanned deer-skin jacket, with long trousers of the same material, the seams of both being covered with neatly-cut fringe, and he had on his feet leather moccasins, much ornamented with work made from the dyed quills of the porcupine.*

January 12

1959—Motown Records Is Founded

Today, Motown was founded by Berry Gordy Jr. as Tamla Records, later to be renamed Motown Record Corporation. During the 1960s, Motown amazed the music industry as a small start-up record company from Detroit, achieving spectacular success with seventy-nine records in the Top Ten of the Billboard Hot 100 record chart between 1960 and 1969. In 1959, Billy Davis and Berry Gordy's sisters started Anna Records. They wanted Berry

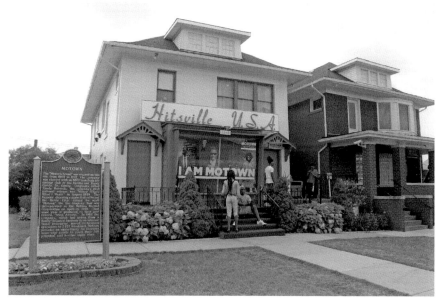

Always one of Detroit's most popular attractions—the Motown Museum on West Grand Boulevard. *Photo by Barney Klein.*

to be the company president, but Berry wanted to strike out on his own. He started Tamla Records with an $800 loan from his family and from royalties earned writing songs for Jackie Wilson. Also in 1959, Gordy purchased the iconic house on West Grand Boulevard that would become Motown's Hitsville USA studio.

January 13

1899—Detroit's Whiskey Baron Hiram Walker Passes Away
Hiram Walker began as a grocer. He was born in Douglas, Massachusetts, of a poor family, grew up working in dry goods stores and arrived in Detroit at age twenty-two eager to make a fortune. After a few false starts and stumbles, he opened a successful grocery on Woodward Avenue below Jefferson: the Walker Wholesale and Retail Store. He first learned how to distill cider vinegar in his grocery store in the 1830s before moving on to whiskey and producing his first barrels in 1854. Because of the rise of the temperance movement in the United States and Detroit, in 1856, Hiram

Walker moved with his family to the other side of the Detroit River. In three years, he had opened his distillery, calling it the Windsor Distillery and Flouring Mill (later to be Hiram Walker & Sons). Walker's whiskey was sold in bottles, which was an innovation, and it was particularly popular in the late nineteenth-century gentlemen's clubs of the United States and Canada; hence, it became known as "Club Whisky." He always considered himself a Detroiter, so when his sons were old enough to take over the business, he returned to live in Detroit. He died in 1899 and is buried in Elmwood Cemetery.

January 14

1872—A Day at Woman's Hospital

In 1868, seven courageous women founded the Woman's Hospital and Foundling's Home in a rented five-room tenement on Cass and Montcalm Avenues; a hospital for unmarried, pregnant mothers and indigent women, it received vicious criticism, and its founders were seen as "encouraging lawlessness." On this day in the release of the third annual report, the board recorded the following accomplishments: "57 women admitted and nine foundlings, 47 infants born. The admitted were of four classes—married women, deserted wives, widows, and unmarried women. Ten were under 20 years, twelve were 20 years, sixteen were between 21–25, the rest were over 25 years. Their nationalities were US 25 patients, Ontario 14, Ireland 6, England 5, Germany 3, Scotland 2, Newfoundland 1. Nine were seamstresses, the rest were domestic servants. During the year 13 infants were adopted, nine died." At the end of the report, they added this challenge:

> *We would like to say a word or two to those who oppose us in our work. It is strange that effort should be required to secure support for such an institution,* [as if] *attempts to save foundlings and their mothers is to sanction a crime. This is a false, hard, and unchristian view. These mothers are heart virtuous….It is altogether a mistaken opinion that mother's* [sic] *of illegitimate children have little natural affection for their children. On the contrary, they part with them with the most marked evidence of intense sorrow.*

January 15

1961—Diana Ross and the Primettes Sign with Motown

On this day in January 1961, Berry Gordy, founder of Motown Records, agreed to sign Diana Ernestine Earle Ross and her group, the Primettes, on the condition they change their name. Eventually, group member Florence Ballard picked "Supremes" out of three name choices. Upon hearing of the new name, the other members weren't impressed, with Ross telling Ballard she feared the group would be mistaken for a male vocal group. The Supremes became Motown's most successful act and are to this day America's most successful vocal group as well as one of the world's bestselling girl groups of all time.

January 16

1919—Statler Hotel Offers Whale Meat on the Menu

On January 16, assistant manager Mr. William Allen of the elegant Statler Hotel in downtown Detroit announced a new menu item: whale steaks. As the menu explained, since the whale is not a fish but a mammal, the whale meat did not have a "fishy taste" but was similar in texture to beef without bones or fat or gristle. "However, it does not taste like beef," Mr. Allen explained. "It is very distinctive."

The former Statler Hotel, shown here in 1910. Courtesy of the Library of Congress.

January 17

1880—Next! At the Barbershop

Detroit boasted over 115 barbershops open for business with 315 men who made their living cutting hair and clipping beards. The typical

price for a shave in 1880 was ten cents; the barber got six cents, and the shop owner, who furnished everything but shaving razors, took four. On this day, a young man with a tough beard but tender skin enters the shop. He removes his coat, collar and tie and seats himself. He is offered a newspaper. The barber covers the man's shirt with a perfectly clean towel. His beard is lathered, the razor stropped and the shaving begins. The trimming shave takes fifteen minutes. The customer's face is then washed, rubbed with alum and coated with Bay Rum aftershave. His face is further coated with Lily White or magnesia. His mustache is combed and coated with French cosmetique. Then his hair is trimmed in back and then dressed with bay rum, oil and pomade. He steps out of the chair, and the shop kid brushes him from head to foot. He hands back the newspaper; puts on his coat, collar and tie; pays the barber; and with a smile steps back into the world.

January 18

1825—Horse Racing on Ice

A challenge printed in the *Detroit Gazette*:

> *River Raisin, January 18, 1825*
> *To Sportsmen*
> *The subscriber will pace his horse Bas Blanc against any trotting or pacing horse, mare, or gelding in North America, from two to five miles, for any sum from fifty to ten thousand dollars. The race to take place on the ice, the present winter, at some place within the Territory, and the horses to be driven before a carriole or rode, as the party pleases.*
> *Isadore Navarre*

January 19

1940—Smokey Robinson

On this day in Detroit, William "Smokey" Robinson was born. As lead singer of the group Smokey Robinson and the Miracles, Robinson performed hits like "The Tears of a Clown" and "The Tracks of My Tears." As a producer

and writer, he lent his skills to Mary Wells with her single "My Guy" and the Temptations' "My Girl." In 1972, Robinson became a solo artist, and the hits continued. Robinson was inducted into the Rock and Roll Hall of Fame in 1987. He continues to write and perform today.

January 20

1833—Detroit's Young Men's Society

On this day, a new group drafted bylaws for the "Young Men's Society." Near the close of 1832, a group of well-intentioned young men met at a store on Jefferson at Woodward to devise an organization for intellectual improvement. Meetings were held for literary exercises and debates every Friday evening during the winter months. In a few years, the Young Men's Society built its own meeting hall, and the organization continued to grow in popularity. By the 1860s, the society had six hundred members, a library of sixteen thousand books and a national reputation for stimulating intellectual venues of excellence. While the organization fell on hard times and disbanded in the 1880s, some of the speakers who came to Detroit to present at the Young Men's Society are known to this day: Mark Twain, Ralph Waldo Emerson, Anthony Trollope, Matthew Arnold, Horace Greely and Henry Ward Beecher.

January 21

1936—The Ford Foundation

The Ford Foundation was established in January 1936 in Michigan by Edsel Ford (president of the Ford Motor Company) and two other executives "to receive and administer funds for scientific, educational and charitable purposes, all for the public welfare." After the deaths of Edsel Ford in 1943 and Henry Ford in 1947, the presidency of the foundation fell to Edsel's eldest son, Henry Ford II. The foundation would become the largest philanthropy in the world. Current assets are recorded at $10.9 billion.

January 22

1818—Making Do at Early School

For many years in the early American days of Detroit, the only teacher in the small town was Reverend John Monteith, age thirty-one, Detroit's first Protestant minister. At the time, there was no writing paper in Detroit, nor were there student "copy books." The resourceful Monteith trained students in handwriting using a quill and damp sand pressed smooth into the shallow lid of a large trunk that he kept in the center of the classroom. Later, John Monteith would become the first president of the newly formed University of Michigania, later to be called the University of Michigan.

January 23

1918—Restaurant Riots in Detroit

The earliest restaurants appeared in the 1870s in Detroit, and by 1899, Detroit had 169 restaurants. People had come to rely on restaurants for lunch, dinner and throughout the night. Night-shift workers, many living in lodging houses with no kitchen, depended on restaurants as their only source of victuals. On this day in 1918, a series of riots broke out in Detroit when the state coal director for Michigan, William K. Prudden, ordered restaurants and all "non-essential businesses" closed due to a coal shortage: "Fear of rioting in the street accompanied by destruction of restaurant properties by Detroit's thousands of hungry night workers Tuesday caused the state Fuel Administrator W.K. Prudden to amend his drastic fuel saving order to permit Detroit restaurants to open 24 hours a day."

January 24

1999—Compuware Announces Move to Downtown

On this day when downtown Detroit was practically a deserted island, the *Detroit News* editorialized:

> *For reasons not yet understood, perhaps by even the man himself, Peter Karmanos wants very much to move his very modern and successful*

The Compuware Building, now owned by Dan Gilbert, provides a contemporary touch to Campus Martius downtown. *Photo by Barney Klein.*

software business into the notoriously antiquated and unsuccessful downtown Detroit. Undeterred by the city's problems in delivering basic services, by its high cost of government and by the conspicuous lack of amenities typical of other large cities, Karmanos has pushed for months to make a decision on Compuware's future headquarters that's a win for both his company and his hometown. The benefits to the city and the metropolitan area would be considerable.

In 2003, Compuware moved to Campus Martius and into a new, beautiful building.

January 25

1898—Harper and Grace Hospitals' Brand-New Ambulances
On this day, Harper and Grace Hospitals were to receive orders for two new horse-drawn ambulances. Grace's was nearly finished and was described in the *Detroit Free Press*: "The Grace Hospital ambulance is a

beautiful specimen of the carriage maker's art. It is finished in pure white enamel with the words 'The Grace Hospital' on the side panels, in large gold letters." Inside was a movable stretcher upholstered in fancy buff Moroccan leather to match the interior of the ambulance. At the sides were straps to hold down violent patients, and at rear where the surgeon stood was a speaking tube to communicate with the driver. Two side lights were nickel plated and detachable to be used as lanterns when needed. Thirty-two small lights, rows of red and white on the outside, identified it as an ambulance at night, and one large white lamp inside ran off a large battery on the ambulance's roof: "It is thought this will be a big improvement since it does away with the disagreeable smell that comes from an oil lamp." Both ambulances had rubber tires for comfort. When finished, the ambulances would cost "well over $500."

January 26

1837—Michigan Becomes a U.S. State and the Capitol Is in Detroit

Today, the territory of Michigan became the State of Michigan with its first state capitol located in Detroit in what is now called Capitol Park. The first building to serve as the state capitol was the territorial courthouse. The courthouse was located on the corner of Griswold Street and State Street. Later, following a decision made to move the capital from Detroit to Lansing, the Detroit building then became a public school (the Union School, at one time the city's only high school) and library until it burned in 1893.

January 27

1869—Auction!

Detroiters loved good auctions that combined bargain shopping and entertainment. Many bought everyday items. Farmers came in from out of town and spent the night in hotels waiting for auction day, local housewives would come over for bargains and young men hung out to watch the action. As the newspaper reported, "The badinage of the auctioneer creates merriment and good humor in the audience." Auctioneers held red flags to identify their authority. The bidding began. On this day, one young man bought a

photograph album for his sweetheart, and the wealthy farmer bought a watch for his son working diligently in the hot sun. Up for bid were gloves, blankets, sets of crockery, writing paper, a backgammon board, umbrellas and pocket mirrors. Government-seized goods brought forth the most excitement. A dozen women's night chemises (nightgowns) won by a young man brought out hot fire teasing from the auctioneer and howls of laughter.

January 28

1850—Kissing Like You Mean It

Today in 1850, the *Detroit Free Press* published some advice to young women: "If girls will kiss let them perform the ceremony as if they loved it. Don't let them sneak about the thing as if they were purloining cheese or drop their heads like lilies o'er pressed with the rain. On the contrary, they should do it with an appetite. And when they 'let go' they should give rise to a report that will make the old folks think somebody is firing pistols around the house!"

January 29

1783—Severe Winter

The winter of 1783 was one of the severest on record. The ice on Lake St. Clair, a mile from shore, was three feet, two inches thick, and the snow was measured at five feet deep. The deep snow interfered with hunting and the ice with fishing. The winter was a trying one, but resourceful Detroiters succeeded in getting a large quantity of venison from a herd that strayed into the neighborhood, and with the surplus of this, some also purchased corn.

January 30

1933—"Who Was That Masked Man?"
The Lone Ranger *Debuts on WXYZ Radio*

Three days a week, every kid in Detroit and twenty million others across the nation would listen to Rosssini's overture to his opera *William Tell* waiting for the call "Hi-yo, Silver! Away!" They knew it was time for the *The Lone*

Ranger radio show on Detroit's station WXYZ. The show debuted from Detroit on this day. *The Lone Ranger* was the brilliant idea of WXYZ station owner George Trendle and writer Fran Striker, neither of whom had even the slightest experience with the Wild West, cowboys or even horses; he was intended to be an all-American version of Zorro. As the story goes, the Lone Ranger was a former Texas Ranger who never swore, never got dirty, was good at hand-to-hand combat and would only shoot to wound—never to kill. He only used silver bullets, which seconded as his calling cards. The Lone Ranger, aka "Kemo Sabe," was joined by his faithful Indian scout, Tonto. Tonto was a bit controversial, as he seemed to be sometimes more servant than companion. He also had a unique Indian speech with phrases like "You betchum!" The title character was played on the radio show by George Seaton, Earle Graser and Brace Beemer. John Todd and others were the voice for Tonto.

January 31

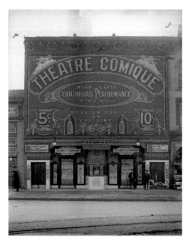

Theatre Comique, a vaudeville theatre. *Courtesy of the Library of Congress.*

1880—Theatre Comique Reopens

On the night of January 31, 1880, the vaudeville theater, Theatre Comique, on Jefferson Avenue reopened, managed by Max Redesheimer, who boasted of new acts that included Baughman and Butler, fancy marksmen; Sepperloeff's Tyrolean Warblers; Chas. Warfield, banjoist; Miss I.O., cornet and banjo player and trapeze performer; Collins Brothers, song and dance men; the Fountainbleaus; Dolly Foster, serio comic; Dot and Lulu Cathlett, double cloggists; the Sermans, Irish vocalists; Mike O'Brien, comedian; and Verona Carroll, ballad singer.

FEBRUARY

February 1

1927—The Purples

The Purple Gang began terrorizing Detroiters with the street executions of its enemies, killing a police officer named Vivian Welsh on February 1, 1927 (who was later revealed to be a dirty cop and was reputedly trying to extort money from the Purple Gang). The gang members grew up in Paradise Valley in Detroit's lower east side. They were the children of Jewish immigrants from Eastern Europe, primarily Russia and Poland, who had come to the United States in the great immigration wave from 1881 to 1914. Perhaps the most ruthless bootleggers of their time, they might have killed over five hundred members of rival bootlegging gangs during Detroit's bootleg wars. Although the Purple Gang remained a power in the Detroit underworld until 1935, long prison sentences and intra-gang quarrels eventually destroyed the gang's manpower.

February 2

1889—Detroit's First Skyscraper

Detroiters watched as the first skyscraper rose up at the corner of Griswold and Fort Streets in the Financial District. The ten-story Hammond Building in Detroit was Michigan's first skyscraper. It was designed by Harry W.J. Edbrooke and was the first to be built with a steel frame. George Hammond grew up dirt poor in New England but moved to Detroit and opened a small

meat shop on Gratiot Avenue. In 1868, William Davis invented a freezing process that he used to produce a refrigerated railroad car. He linked up with Hammond, who now could ship meat to Boston at a high profit. In the first year Hammond used one car, the following year eleven cars and the third twenty-one cars. By 1885, George Hammond was using eighty cars shipping meat and perishables three times a week to the Atlantic Coast. He grew extremely wealthy, and the Hammond Building was the result. The Hammond Building was demolished in 1956 to make way for the National Bank of Detroit Building, which is currently called "the Qube."

February 3

1937—Sit-Down Strike

The GM Sit-Down Strike was an effective protest that stopped work at General Motors. Instead of walking off the job, autoworkers occupied the General Motors Fisher Body Plant Number One in Flint, even sleeping at the plant. The strike began in December 1936 and lasted forty-four days.

Dear Margarett,

We are having a hell of a good time in Plant 4 and we are here to stay till hell frezes [sic] *over if we have to. I have to good faith in the CIO* [Committee for Industrial Organization] *to let you be without coal or food go down to the Hall when the coal gets low tell Mary the same if they say anything about the car let me know at once fore I would hate to lose it don't let Roy drive the car all over. Take your letter to the Hall Adress i* [sic] *to Plant 4 Chev write as soon as you get this*
I will say good bye, Earnest P., Plant 4 Cheve

February 4

1902—Charles Lindbergh Born in Detroit

Famous pilot Charles Lindbergh became the first to fly from New York to Paris, the first nonstop solo flight across the Atlantic Ocean. His famous plane, the *Spirit of Saint Louis*, brought him to Paris, France, in 1927. On this day, Lindbergh was born in Detroit on Forest Avenue near the current

Lodge Freeway in what is today the neighborhood called Woodbridge; for many years, the house was adorned with a bronze plaque on the front indicating it was the birthplace of Lindbergh. The house was torn down in the 1970s as part of a program of urban renewal. In 1876, Lindbergh's mother, Evangeline Lodge Lindbergh, was born on the site off Grand Circus Park where the historic Whitney Building stands today. She was said to have followed Lindbergh's historic flight across the Atlantic on the radio. While Lindbergh did not live long in Detroit, he later returned to celebrate his flight and to participate in the aircraft construction at Willow Run Airport during World War II.

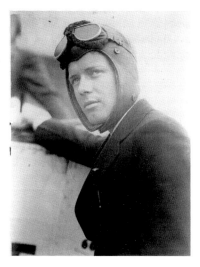

Charles Lindbergh was a resident of Detroit and lived in Woodbridge. *Courtesy of the Library of Congress.*

February 5

1812—Walk-in-the-Water

Walk-in-the-Water, whose traditional Wyandotte name was Maera or Awmeyeeray or Mirahatha, was born in the late 1700s in the Great Lakes area. He was well known and respected on both sides of the Detroit River during the early days of American-occupied Detroit. The Wyandottes lived on the American side of the Detroit River, a strategic location on the land-based supply route to Ohio. American leaders such as Governor William Hull and General Anthony Wayne placed great importance on their friendship. Along with Tarhe, Roundhead, Splitlog and Leather Lips, Walk-in-the-Water was one of the prominent Wyandotte leaders of that period of history. Walk-in-the-Water was one of the signers of the 1795 Treaty of Greenville and was a warrior in the War of 1812. His totem, or mark, was a turtle. Walk-in-the-Water was imposing. He was nearly six feet tall, well proportioned and always ramrod straight. He was mild and pleasant in his deportment and was also a fearless fighter. Although he could be "grave-

faced," he was articulate and passionate in his vision for the Wyandotte people. On February 5, 1812, he signed a petition with seven others addressed to President James Madison. They were hoping to save their land that they had peaceably cultivated and lived on from time immemorial. They pleaded for a title that would prevent their being dispossessed at the end of fifty years as provided by the act of Congress.

February 6

2011—The Fist

On this day, the sculpture *The Fist* was featured on a Super Bowl advertisement for Chrysler Corporation. As the camera pans the statue, a narrator says, "It's the hottest fires that make the hardest steel." *The Fist* is a monument to the Detroit boxer Joe Louis. It was controversial when it debuted, with many critics claiming it did not capture Joe Louis's character and other critics describing it as art from a third-world dictator. Today, like other works of art

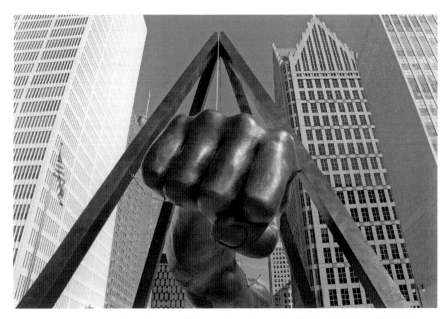

The Fist sculpture near Hart Plaza by Mexican American artist Robert Graham. *Photo by Barney Klein.*

at first hated then beloved, *The Fist* has become a symbol of the city's raw determination to fight back from bankruptcy. The cast-bronze sculpture, commissioned by *Sports Illustrated* magazine, was created by the Mexican American sculptor Robert Graham and was originally dedicated in 1986.

February 7

1838—Brady Guards Standing Firm

Detroit's militia company, the Brady Guards, was mustered into service during the Patriot War in Canada. In 1832, at the end of the Black Hawk War, the Detroit City Guards were disbanded. A number of young men, including some former members of the Detroit City Guard, formed a new independent volunteer company in Detroit in 1836. The organization was soon renamed the Brady Guards after Brigadier General Hugh Brady. In 1855, the Brady Guards became the Detroit Light Guard. This unit has had a continuous existence to the present day and is now Company A, 1st Battalion, 125th Infantry.

February 8

1985—Stroh Brewery Closes Its Detroit Plant

The Stroh family began brewing beer in a family-owned inn during the eighteenth century in Kirn, Germany. In 1849, during the German Revolution, Bernhard Stroh, who had learned the brewing trade from his father, immigrated to the United States. Beer was brewed in Detroit as early as 1836. By the eve of the Civil War, there were "upward of 40" breweries in the city. Stroh established his brewery in Detroit in 1850 when he was 28 and immediately started producing Bohemian-style pilsner, which had been developed at the municipal brewery of Pilsen, Bohemia, in 1841. By the 1880s, Stroh was Detroit's biggest brewery. In the years following World War II, Stroh fought with Goebel and Pfeiffer for dominance in the city. By 1982, Stroh was the nation's third-largest brewery, but Stroh's acquisition of Schlitz led to the closing of the 135-year-old Detroit plant on February 8, 1985. Eventually, the company was taken over. Stroh's beer is still produced by Pabst Brewing Company.

February 9

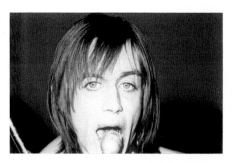

This image of Iggy Pop was taken at Farmington High School, a few years before his show at the Michigan Palace. *Author's collection.*

1974—Iggy and the Stooges at the Michigan Palace

Iggy Pop was born in Muskegon and raised in Ypsilanti. He was inducted to the Rock and Roll Hall of Fame in 2010 never having had a hit single but maintaining a proud lore of anarchy and punk rock politics. Iggy and the Stooges played their last show ever at the Michigan Palace in Detroit on February 9, 1974. The night before, Iggy went on a Detroit radio station calling a local motorcycle gang, who had been harassing the band at past gigs, a "bunch of pussies." Of course, the gang turned up at the show, and all hell broke loose. As soon as the band walked onstage, they were immediately bombarded with broken glass, beer jugs, coins, ice cubes, urine-filled bottles and even shovels. Iggy then decided to dive into the hostile crowd and was immediately beaten up, but it was a quintessential Iggy Pop logic and became part of his legend.

February 10

1942—Detroit Produces for World War II

On this day in 1942, all car production came to a complete halt for production of war materials. Lieutenant General Behon B. Somervell, commanding general of the army's services and supplies wrote at this time, "The road ahead is dim with the dust of battles still unfought. How long the road is no one can know. But it is shorter than it would have been had not our enemies misjudged us and themselves. For, when Hitler put his war on wheels, he ran it straight down our alley. When he hitched up his chariot to an internal combustion engine, he opened up a new battle front—a front we know well. It's called DETROIT." From 1939 to V-J Day in 1945, the automobile industry delivered to the government almost $50 billion worth of war materials.

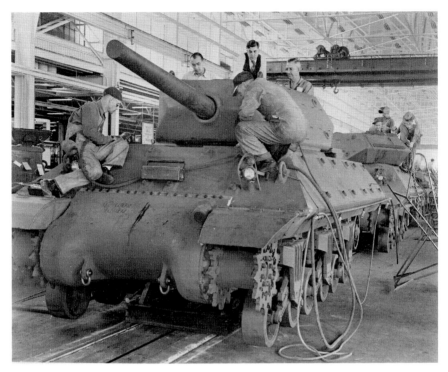

An M10 tank destroyer from the General Motors Tank Arsenal, 1943. *Courtesy of the Library of Congress.*

February 11

1930—Jessie DeBoth Cooking Demonstration

From the late 1920s through the mid-1950s, a national sensation would emerge: Jessie DeBoth, cooking instructor. Jessie DeBoth was the cooking and homemaking powerhouse of the Great Depression from Green Bay, Wisconsin. She was tall at five-foot-ten with "Titian" hair and immensely popular as she toured the country, drawing twenty-five thousand per show. In Detroit, the classes, which were more like variety shows, were billed as the Detroit News Cooking School Featuring Jessie DeBoth. These events took place at the Masonic Temple, where the stage was turned into a fully equipped kitchen facility, dining room and functioning laundry room. DeBoth's four-day presentations were a mixture of cooking demonstration, household tips, flamboyant entrances and giveaways.

Audience participation was a must. DeBoth would make audience members sing or dance on stage. She would give away pots and pans for young couples, "mothers of quintuplets" or the last seat in the auditorium. When she offered a prize to the tallest, thinnest old maid in the house, they hesitated, so she said, "I'm an old maid, and I don't mind a bit." Samples of food wrapped in waxed paper were tossed out to the audience for refreshments. She cracked jokes and encouraged audiences to get silly with kitchen utensils. Local bands of whatever city she was in provided music, singalongs and amateur shows.

February 12

2014—Artist Matthew Barney in Detroit

Internationally famous visionary artist Matthew Barney made part of his highly controversial film *River of Fundament* in Detroit (Act Two). It premiered in Brooklyn, New York, on this day. The *River of Fundament* is a reworking of Norman Mailer's novel *Ancient Evenings*, published in 1983. Barney's film runs five hours and fifty-two minutes with two intermissions. It took seven years to make. Barney collaborated with composer Jonathan Bepler to mix traditional narrative with sculpture and opera, reconstructing Mailer's story of Egyptian gods and the seven stages of reincarnation, including vomiting, excrement, blood, death, mythology and—Detroit's connection—the execution of a 1967 Chrysler Imperial. Reviews were mixed. Film locations in Detroit included Delray, the Belle Isle Bridge, the Rouge and Detroit Rivers and the landing for McLouth Steel in Trenton. More than two hundred members of the local music and art scenes contributed.

February 13

1986—Detroit's Castle

The Grand Army of the Republic (GAR) building was added to the National Register of Historic Places on February 13, 1986. It was designed by architect Julian Hess and constructed at West Grand River and Cass as an appropriate structure for meetings and other GAR-related activities. The

GAR Castle was recently restored by Tom and David Carleton and Sean Emery. Closed for many years, it now offers office space and two restaurants: Republic and Parks and Rec. *Photo by Barney Klein.*

cost was split between the Grand Army of the Republic (which paid $6,000 of the cost) and the City of Detroit (which paid the remainder of the $44,000 total cost). Construction commenced in 1897 on the five-story building. As GAR membership was restricted to veterans of the Civil War Union army, its numbers dwindled through the beginning part of the twentieth century. By the 1930s, the GAR had vacated the building and the city took ownership. Recently, local business investors Tom and David Carleton and their friend Sean Emery purchased the GAR and have refurbished it for the offices of their company, Mindscape.

February 14

1842—Valentine's Day—"Will You Be Mine?"

In 1842, young men in Detroit secretly delivered their valentines by hand, as U.S. postal service had not reached Detroit at that time. A Detroit man named John Webb Chester recalled those days in the 1840s when he was interviewed in his nineties by the *Detroit Free Press* in 1914: "Oh, of course we used to send them. All the boys did…We would go to a house where the girl of our choice lived, stick our valentines under the door, and then disappear as fast as ever we could." In 1848, the Detroit post office handled seven hundred valentines. "And who doubts," wrote a reporter of the day, "that many a heart beat high with pleasant emotions at the receipt of some of those tender effusions." Today, the U.S. Greeting Card Association estimates Americans exchange 190 million valentines a year, most of them sent to kids.

February 15

1953—20 Grand

The 20 Grand opened its doors in 1953, and for the rest of that decade and through much of the 1960s, it was the place to go, as said at the time, where you had to "get sharp" first. Its owners were Bill Kabbush and Marty Eisner, who both had a deep love of rhythm and blues. It became one of Detroit's most famous nightclubs, located at Fourteenth Street and Warren Avenue. On this day, 20 Grand was a place where people could go to dance and see live performances. There was also a club night for teens. Inside were the Driftwood Lounge and the Fireside Lounge. On the first floor was a bowling alley, and above it was the Gold Room. The acts were nearly every famous Detroit performer of the day, including the Temptations, the Miracles, the Tops, Martha Reeves, Jackie Wilson, Chuck Jackson, the Flamingoes, Funkadelic, Edwin Starr, Bill Doggett, Jimmy Smith, the Spinners, the Marvelettes, Marvin Gaye, the Contours, the Supremes, Billy Stewart, Stevie Wonder and Joe Tex. In 1964, Mick Jagger went to the 20 Grand to see B.B. King play the blues.

February 16

1850—Dancing with U.S. Grant in Detroit

The Detroit hotels the Mansion House and, later, the Michigan Exchange were popular for dances in the late 1840s, regularly attended by then lieutenant Ulysses S. Grant and his wife. Grant's regiment, the Fourth United States Infantry, was stationed in Detroit at the time. Many in the regiment and others that made up the crème de la crème of Detroit's youth were part of an exclusive dance club called the "400," and they held cotillion (dancing) parties. People took lessons and learned the dances of the day. By the 1850s, the Detroit 400 had moved from dance parties to costume balls. And on this day, the costumes were elaborate, with some dressed as characters from Shakespeare plays, English royalty, Sir Walter Scott's novels or simply imaginative thinking: according to Friend Palmer in *Early Days in Detroit*, "Miss Sallie Webster was beautifully dressed as the Maid of the Mist." It was said Grant always came as himself.

February 17

1882—"I Was Very Much Disappointed by the Atlantic Ocean"—Oscar Wilde Does Detroit

As a young man, Oscar Wilde (1854–1900)—the poet, novelist, playwright and wit known around the world for his flamboyant, dramatic and highly publicized gay life in London and Paris—made two visits to America. On the first visit, he gave 140 lectures that spanned the entire year, starting in New York City and ending in Sacramento, California. On February 17, 1882, Wilde came to Detroit and lectured to nearly four hundred people at the Music Hall. The subject was "The Decorative Arts." Wilde was then a highly controversial person, and his reception in Detroit was not enthusiastic. He kept the audience waiting for half an hour until they "rattled their feet," causing him to appear on stage. Detroiters did not know what to make of him; his speaking was described "like a child singing Mary's Lamb." His appearance shocked many as he wore roseate slippers, a rumpled white vest, a "claw hammer" coat, a white Toodles tie and his famous long hair. It was said by the *Free Press* reviewer that as a speaker he was a "failure"; however, Wilde "urged Detroit…to make itself beautiful and for its brave men and beautiful ladies, to devote themselves to decorative art."

February 18

1917—Costume Ball at the Scarab Club

On February 18, 1917, the Scarab Club, Detroit's arts club, which is still thriving on Farnsworth Street, held its first costume ball. The Scarab Club's over-the-top annual costume balls, which ran from 1917 to 1950, drew national attention and were attended by thousands at their peak popularity. *Life* magazine featured the event in 1937. The first ball was held at the Addison Hotel and was titled "A.D. 2017." The theme was fashion of the future. It featured a 2017 Girl who was dressed in "long pantalets and multicolored cubist garb." The club was founded in 1907 and was renamed the Scarab Club by a former president who brought back scarab carvings from a vacation in Egypt in 1913.

February 19

1922—Bathing Suit Parade

During the 1920s, Detroiters began to spend winters in Florida. On this day, the *Detroit Free Press* reported, "In St. Petersburg, Florida the city planned to hold a 'Bathing Suit Parade.' Three women's organizations filed protests, declaring that such a display of bathing apparel would be indecent...The purity league recently urged the mayor to appoint a bathing suit inspector 'to protect married men from the wiles of sea-vamps.'"

February 20

1961—Barbra Streisand Sings at Caucus Club

On this evening in 1961, the headline singer at the Caucus Club (now closed) was eighteen-year-old Barbra Streisand for her first gig outside New York City. She said later that the bar was noisy and she had to perform behind a large pillar. When in Detroit, she did manage to visit the Detroit Institute of Arts.

February 21

1847—Detroit Fights Starvation in Ireland

"This evening a meeting for the relief of the starving people of poor, down-trodden and oppressed Ireland is to be held and we trust that we find few will be absent...The meeting we are confident will be a large one and the offering of Michigan will not shame her sons," reported the Detroit newspapers. In 1847 and several years after was the infamous nightmare famine in Ireland when the principle food of the Irish, potatoes, rotted in the ground. It is referred to as the "Great Starvation." As many as one to one and a half million Irish from the west and southwest of Ireland immigrated to the United States, and tens of thousands starved to death from 1847 to 1855. On February 21, 1847, a meeting was held in Detroit to raise money and food for Ireland. Detroiters raised enough money to send 2,348 barrels of food, of which 2,175 were flour. Irish immigrants poured into Detroit primarily from Counties Cork, Limerick, Tipperary and Kerry.

February 22

1903—Breakfast Now Includes Tryabita Cereal

Dr. Price made millions in the 1870s by inventing Crème of Tartar, which he called "Dr. Price's Cream Baking Powder." (He was the grandfather of actor Vincent Price.) In a less stellar idea, Dr. Price saw all the celery grown in Kalamazoo and so formed the Price Cereal Company to produce "Tryabita"—"the first celery flake cereal scientifically produced food product conducive to muscle, brain and nerve power." Despite years of advertising and promotion, Tryabita celery cereal never caught on. Finally convinced to let it die, Dr. Price was not one to let a good idea go, so he came up with Tryachewa, a celery-based chewing gum—also a flop.

February 23

1932—Bill Bonds on 7 Action News

He was born on this day in 1932. A native of Detroit and a graduate of the University of Detroit, Bill Bonds came to fame initially as a reporter for WKNR-AM, known as Keener 13. He joined WXYZ in 1963 and worked his way up to the anchor desk to prominence for the station's coverage of the 1967 Detroit riots. He left for Los Angeles but returned to WXYZ-TV in 1971. Two years later, WXYZ became the highest-rated news broadcast in Detroit, a position it held up until 2011.Over that time, Bonds became something of an icon to the Detroit viewing public. The book *The Newscasters* by Ron Power called Bonds one of the six most influential news anchors in the nation. His drinking was also legendary after multiple drinking and driving arrests. It is said that one of his favorite drinks became a local favorite. The "Bill Bonds" (a mixture of Crown Royal Canadian Whiskey and butterscotch-flavored schnapps) is commonly ordered around Detroit-area establishments. Bonds passed away in 2014.

February 24

1906—Oleo Wars

In 1869, Frenchman Hippolyte Mere Mouies invented a substitute butter made from animal fats that we know today as margarine. The product with trade names like "Butterine" looked and tasted like butter but was sold at a far lower price. Americans loved it. Many retailers were selling it as butter, which caused a panic in the dairy industry. It began a public relations campaign claiming margarine was made from dead street animals and diseased pigs and was produced in unsanitary conditions. It pressured U.S. Congress and raised a high tax on "colored oleo" while Michigan's senate placed strict rules on production. In Detroit, counterfeit and illegal margarine operations sprang up in 1880s. One such production was in Corktown at a house on Michigan Avenue at Trumbull. In 1906, the U.S. Revenue Inspectors from Cincinnati busted Alonzo Hart and his two sons, who, in a secret passage of a house that led to another building, were producing 10,000 pounds of margarine. They found another 4,800 pounds at another house of the Harts. The Harts continued being harassed by government inspectors and ended up in jail in Detroit and Chicago for "fraudulently coloring oleomargarine." Nationally, after repeated arrests, Alonzo Hart was nicknamed the "Oleo King."

February 25

1701—Fort Pontchartrain on the Detroit River

Alphonse de Tonty, Baron de Paludy, was an officer who served under Cadillac and helped establish Fort Pontchartrain du Detroit in 1701. On this day in 1701, Alphonse de Tonty described the newly settled area that would soon be referred to as Detroit: "Our fort is one arpent square without the bastions…[an "arpent" was 192 feet, a form of measurement of old France]…very advantageously situated on an eminence…We took care to put it at the very narrowest part of the River, which is one gunshot across being everywhere else a good half-quarter of a league; and if the post is inhabited, the ground is very good there for building eventually a large town."

February 26

1837—Detroit's First Orphanage

Father Martin Kundig was born in 1805 in Switzerland, educated in Rome and served in the Swiss Papal Guard before coming to work in the Diocese of Detroit in 1833. A year later, a cholera epidemic broke out in the city and the Catholic Female Association, organized by Kundig, assumed the burden of nursing, burying the dead and caring for the orphans. One nineteenth-century writer commented on Father Kundig: "When the cholera appeared in Detroit, this good priest…was at every bed-side, in every house, carrying in his arms the sick and dying to his improvised hospital." Kundig's medical skill, administrative ability and compassion were recognized, and on this day in 1834, the county board of supervisors appointed him superintendent of the poor and the Ladies Orphan Association of Detroit on Antoine Street. In 1841, he was elected a regent of the University of Michigan.

February 27

1898—Sousa Plays Detroit

On this evening, the internationally famous John Philip Sousa, "with his matchless aggregation of musicians," gave a band concert at the Lyceum Theatre in Detroit. The theater was packed as Sousa, feature solo players and singers ran through the classics. When he played "The Star-Spangled Banner," the audience rose "en masse" to sing and cheer at the ending.

John Philip Sousa from around 1922. *Courtesy of the Library of Congress.*

February 28

1895—St. Aubin's Farm

St. Aubin Street once bordered a "ribbon farm," owned by the St. Aubin family, that ran from the Detroit River north to Hamtramck. "It was granted to my ancestor, Jacob Casse dit St. Aubin in 1710 by Cadillac,"

said Thomas St. Aubin, a direct descendant. "The last of our farm was sold in 1947." On this day, Jacob St. Aubin arrived in Detroit from Quebec with his wife, Louise. He and his descendants farmed or lived on the narrow strip of land until Louis St. Aubin passed away in 1895.

Basilide St. Aubin was born in Detroit in 1840 on the ribbon farm now marked by St. Aubin Street. *Courtesy of Thomas St. Aubin.*

MARCH

March 1

2000—Sparky Anderson Inducted into the Baseball Hall of Fame
"If anything's better than the Hall of Fame, I haven't seen it," said Sparky
Anderson, a seventeen-season Detroit Tigers manager. He received word
on this day that he was one of three inductees named by the Hall of Fame's
Veterans Committee. Baseball's third-winningest manager won a World
Series in Detroit and took the Cincinnati Reds to four World Series during
the 1970s. "I knew I just wasn't going to lay in bed—I had the yipes,"
Anderson said. "Then, the longer the morning went on, I got very nervous.
When it got to be eleven o'clock, I said, this is not too good," said Anderson,
who called the Hall of Fame "the most precious place in the world."

March 2

1910—Tough Love in Kindergarten
On this day, former kindergarten teacher Marion Hamilton Carter expressed
her strong views of the kindergarten class of 1910 in an interview with the
Detroit Free Press:

> *The little boy anxious to do right is safer in the gutter than in the kindergarten.
> This vaudeville kind of education inculcates a taste for the sugar-coated,
> painless life. There's no sense saving a wee child from every little hurt that comes
> his way. A little bumping now and then is wholesome, just enough taste of the*

bitter…To feel the sharp edge of things that life is not all a rose strewn path where he spends his time cooing and gurgling and making little fol de rol things out of colored paper…It's a namby-pamby sort of upbringing, in my opinion.

She added, "And this is true of the girls as well!"

March 3

1805—Augustus B. Woodward Appointed by Thomas Jefferson

President Thomas Jefferson and Woodward knew each other personally and shared mutual interest in science and education. Jefferson appointed Woodward on March 3, 1805, as the Michigan Territory's first chief justice. Woodward was born Elias Brevoort Woodward in 1774 in New York; however, it was said he changed his name because he thought it sounded too Dutch. He read the law and practiced as an attorney in Washington, D.C. Woodward never married and remained always a hardened bachelor. He stood six feet, three inches tall and was thin, sallow and stooped. His long, narrow face was dominated by a big nose. He had thick, black hair. His contemporaries commented on his slovenliness and the general dirtiness of his clothing. People in Detroit complained because he took showers naked outside in the rain. He also laid out the street plan for Detroit based on his experience in Washington, D.C., and he was one of the founders of the University of Michigan in 1817. Unfortunately (or fortunately), there is only one sketch of Woodward, and that looks more like a cartoon.

March 4

1947—WWJ Begins Detroit's First Television Station

Michigan's first television station, WWJ, began daily broadcasts on this day in 1947. WWJ's entry into television was based on the certainty that TV would spread widely as soon as the nation recovered from World War II. WWJ originally was owned and operated by the *Detroit News*. No one believed television might replace radio; in 1947, there were only four thousand television sets in Detroit and just sixty thousand across the United States. But it was thought that a successful radio station like WWJ should

have television as part of its overall operation. But television popularity exploded, and by 1948, most large cities had their own local broadcasting stations. By 1990, 98 percent of homes had televisions.

March 5

1829—John Sheldon Jailed

John Pitts Sheldon was born in Rhode Island in 1792 and, after service in the War of 1812, headed west. In Buffalo, New York, he met Ebenezer Reed; the two young men decided to pool their resources, and they began a newspaper in Detroit. The first issue of the *Detroit Gazette* appeared in 1817, and it lasted until the spring of 1830, when their office was destroyed by fire. On this day, Sheldon was fined $100 for writing articles critical of territorial courts. He was then jailed by the Michigan Supreme Court for contempt of court when he refused to pay, choosing to remain in the Wayne County jail.

March 6

1896—First Horseless Carriage on Streets of Detroit

Charles Brady King, an engineer, entrepreneur, artist, musician and even a self-described mystic test drove the first "horseless carriage" in Detroit in front of hundreds of spectators on March 6, 1896, at speeds of up to seven miles per hour. He completed his four-cylinder vehicle at John Lauer's machine shop on St. Antoine Street and provided Henry Ford with insights and specific parts to help Ford with his "quadricycle" that appeared three months later. In an interview with the *Detroit Journal* the following day, King boldly stated, "I am convinced they [horseless carriages] will in time supersede the horse." In 1911, after studying European motorcars for two years, King designed his own car and opened the King Motor Car Company in Detroit. In addition to automobiles, King was a poet; an accomplished flute player; a painter with pictures in the National Gallery in Washington, D.C.; a notable architect; and a yachtsman. He sent his important collection of automobile, marine designs and papers to the Henry Ford Museum, along with antique cannons, muskets and historic weapons he had collected. King died in 1957 at eighty-nine years old.

March 7

1917—Laura Freele Osborn Elected to School Board

Laura Freele Osborn was a campaigner for school reform and a long-serving member of the School Board of Detroit Public Schools during the early half of the twentieth century. She was born in 1866 and raised in Huntington, Indiana. She was first elected to the Detroit School Board on this day in 1917, campaigning as a Republican on a platform of reform. She was the first woman elected to citywide office in Detroit and served on the school board for thirty-eight years until her death in 1955. During that time, she was selected as school board president seven times. In the 1930s, she helped to develop Wayne State University. Osborn High School is named after her. She was inducted in the Michigan Women's Hall of Fame in 1995.

March 8

1900—Quadruplets Born

Today, Mrs. Allen McDonald, who lived at the corner of Edison and Woodward Avenues, gave birth to four children, two boys and two girls. Their average birth weight was three and a half pounds. The mother and babies were reported as doing fine. The father was a laborer for Michigan Telephone Company.

March 9

1987—Chrysler Buys American Motors

American Motors Corporation (AMC) was an American automobile company formed by the 1954 merger of Nash-Kelvinator Corporation and Hudson Motor Car Company, eventually succeeding when Detroit auto companies were known as "the big four" (AMC, GM, Ford and Chrysler). AMC focused on smaller cars and was run by former Michigan governor George Romney (father of the perennial presidential candidate Mitt Romney.) AMC brought out great and not-so-great cars that included the infamous "Mirth Mobile," which was a 1976 AMC "Pacer" that was

featured in the 1992 movie *Wayne's World*. AMC was sold to Chrysler on this day. Chrysler kept the Jeeps but turned AMC into Eagle Brand, completing the merger by 1990.

March 10

1778—Daniel Boone Brought as a Prisoner to Detroit

During the Revolutionary War in 1778, the famous pioneer from Kentucky Daniel Boone was captured by Shawnee Indians. Boone was brought to British-controlled Detroit as an American prisoner, arriving on March 10. British lieutenant governor Henry Hamilton was in charge at Detroit. He was excited to have hold of such a famous American rebel and offered the Shawnee one hundred British pounds for him; however, the Indians refused to give him up. On April 10, 1778, they left Detroit with Boone and moved on to Ohio. Soon afterward, Daniel Boone managed to escape. In 1884, Boone Street in Detroit was named after him.

March 11

2013—Kwame Kilpatrick

On this day, former mayor Kwame Kilpatrick was found guilty of twenty-four federal felony counts, including racketeering, mail fraud and wire fraud. In October 2013, he was sentenced to twenty-eight years in prison. The *Detroit Free Press* called it "one of the biggest public corruption cases in Detroit's history." Kilpatrick was indicted in 2010 and charged with running illegal business through the mayor's office along with Bernard Kilpatrick, Kwame's father; Bobby Ferguson, Kwame's high school friend; and Victor Mercado, the former director of the water department. Kwame Kilpatrick was convicted on twenty-four of the thirty federal corruption charges that included bribery, extortion and racketeering.

March 12

1880—Owning a Hack in 1880

On this day, the *Detroit Free Press* interviewed a "hack" (a horse-drawn taxi driver waiting for fares outside Detroit's train station).

The taxi driver, called "Jehus" was one of the oldest and best known in Detroit: "Well, that's my rig and I count it now $1,500 all told now. The wagon I bought three years ago and paid $1,325 for. The horses are 6 and 7 years old, and for the business I think they're the best in the city. I wouldn't sell them for $800 cash. Then there's the harness, the blankets, and robes all told worth $125....Now put the interest on the investment at $120; then add to that $50 a year for horse shoeing, wagon grease, lamp oil wicks, and a dozen other trifles. Now put another $50 down for repairs and paint, varnish, trimmings and other parts of the wagon. Last of all allow $1,200 a year for keeping of the horses and the hackman's family." It takes a good many 50 cent fares to make up that sum, doesn't it? "You bet. But money is made..."

March 13

1934—Infamous Father Coughlin

From 1926 to 1939, Charles Edward Coughlin, popularly known as Father Coughlin, was a controversial Roman Catholic priest based at Shrine of the Little Flower church in Royal Oak. He was one of the first to use radio to reach a mass audience, as up to thirty million listeners across the United States tuned to his weekly broadcasts during the 1930s. At first a supporter of Franklin Roosevelt's economic policies, he broke with him in 1934 for more radical ideas. Eventually, he condemned the banks and began anti-Semitic rants. Detroit banks came under his violent, emotional broadcasts, calling them "criminal" and "high treasons of finance"; he was effective, as Detroit banks reported deposit withdrawals immediately following his paranoid radio rambles. His days were numbered when he began supporting Hitler in Germany. He was forced off the air in 1939.

March 14

1817—Alexander Macomb Describes Detroit

Having just arrived in Detroit, Alexander Macomb wrote a letter on this day describing his impressions of Detroit:

> *Our population is a mixture of French and Yankees, and considering this is a frontier province, the society is wonderfully good. We are not much troubled with politicks because the people generally think one way…No elections take place here…We only want a few New England families to set an example of industry and in the true mode of farming. The French people are of the times of Louis the 14th, without any of the changes or improvements of the present day.*

March 15

2004—Bob Seger Inducted into Rock and Roll Hall of Fame

On this day, legendary songwriter and rocker Bob Seger was inducted into the Rock and Roll Hall of Fame. Fellow Detroiter Kid Rock gave the induction speech, and Michigan governor Jennifer Granholm proclaimed that date Bob Seger Day in his honor. Jon Pareles from the *New York Times* commented on a Seger performance at Madison Square Garden in 2015. "Grizzled yet smiling and robust, with his stalwart voice and vigorous band, Mr. Seger and his songs promised that it's possible to look back, with and without regrets, yet still live fully in the present."

March 16

1908—Harry Houdini Trapped in Ste. Claire Hotel in Detroit

"Say, put it in the paper that the great Houdini met with his first defeat and we done it," said a chuckling bellboy at the Ste. Claire last night. "You see it was this way. Houdini's stopping up at room 157 with his wife and the boys wanted to see if they really could make him call for help." Two bellboys, Herman Watts and Harry Hurst, go up to the room with a key and lock Houdini in his room; the keyhole doesn't go through. Soon, the office gets a call, as reported in the *Detroit Free Press* on this day. "Yes, this is Houdini.

Can you send a boy up with a key and let me out? I'm in a hurry to get to the theatre." Herman and Harry are sent up and let him out. Houdini says, "All right you got me, but I was in a hurry. I'll just bet you my week's wages against yours that you can't lock me in tonight!"

March 17

1977—Dick Vitale Leads University of Detroit to NCAA

Dick Vitale was hired in 1973 by the University of Detroit to become its head coach. Vitale took U of D to the thirty-two-team NCAA tournament in 1977, reaching the Sweet Sixteen only to be defeated by Michigan on this day 86–81. Vitale had a 78-30 record during his tenure at Detroit, which included a twenty-one-game winning streak during the 1977 season. Reluctant to leave coaching, Vitale accepted an offer to try television broadcasting from fledgling sports network ESPN. Dickie V called his first college basketball game in December 1979—DePaul defeated Wisconsin.

March 18

1875—Relief for Grasshopper Sufferers

In response to a call from Detroit's mayor Hugh Moffat on the evening of March 18, 1875, a rally was held at the Michigan Opera House to raise money to relieve the suffering of pioneers in Nebraska, Kansas, Iowa and the Dakotas who had been wiped out by enormous swarms of grasshoppers. About 100 people showed up to hear stories of farm families living in sod "dug out" homes reduced to starvation by destruction from locusts. Entire fields of one hundred acres were decimated in a single hour by ravaging clouds of insects. According to the fundraisers, as many as 20,500 men, women and children would likely starve to death without immediate assistance. However, after months of heartrending appeals and donations of thousands of dollars from Detroiters and residents of other cities across the United States, it came out that many of the claims of grasshopper suffering were exaggerated. A Detroit editorial in 1876 stated, "A man rejoiced that he can now contribute to the relief of victims of Yellow Fever, because he has given to the grasshopper suffers until the thing became monotonous."

March 19

1879—First Performance in Detroit of Gilbert and Sullivan

H.M.S. Pinafore; *or, The Lass That Loved a Sailor* is a comic opera with music by Arthur Sullivan and libretto by W.S. Gilbert. It opened in 1878 at the Opera Comique in London, England, and ran for 571 performances. It was Gilbert and Sullivan's first international sensation. It came to Detroit and played at Whitney's Opera House on March 19, 1879. The reviews were enthusiastic.

March 20

1897—Kresge Works in His First Dime Store

On this day, Sebastian Spering Kresge, with business associates, opened the first Kresge dime store on Woodward Avenue between Grand River and State Streets. Store No. 1 at that time was two thousand square feet, employed eighteen associates and carried 1,500 items—none costing more than ten cents. "Dime stores" or "five and dimes" sold many products for either a dime or a nickel. Detroiters shopped at Kresge's for daily needs, such as housewares, linens, clothing, school supplies, cosmetics, toys and seasonal décor. It was also well known for its lunch counter. It became one of the top-three such stores in the United States, making Kresge wealthy in the extreme. By 1924, Kresge was worth approximately $375 million (in 1924 dollars, around $5 billion in current dollars) and owned real estate of the approximate value of $100 million. That's a lot of nickels and dimes.

March 21

1909—Detroit's Maritime Artist Dies

Detroit's most prominent nineteenth-century artist was Robert Hopkin, and he died on this day in 1909. Hopkin was nationally known for his paintings of ships and maritime scenes. He was born in Glasgow, Scotland, in 1837; immigrated with his family to Detroit in 1843; and remained a resident of the city until his death. In all, he produced at least 390 watercolors and oils.

He was entirely self-taught. Hopkin won commissions to paint decorative scenes for significant buildings, including the Detroit Opera House in 1869 and the Cotton Exchange in New Orleans in 1883.

March 22

1866—First Gas Stove on Display in Detroit

At No.10 Good Fellows Hall, a revolutionary household appliance was on display: a gas-powered cooking stove. It drew a lot of attention from householders who owned wood-burning stoves since a cord of wood had risen to seven dollars and "another two to saw it," as reported in the *Detroit Free Press*. The gas stove used Naptha or Benzine gas, which the agent claimed to cost one cent per hour for a single burner. It was set up in the dining hall of the Odd Fellows Hall. The gas source was in a tank safely set up in a separate room and then sent through a pipe to the stove. It made a hissing sound, like illuminating gas lights. "They are as easily lighted as [a] common kerosene lamp, without any of its danger."

March 23

1839—Union Beginnings in Detroit

While Detroit has always been considered a union town, the first labor union in the city was founded by printers in the 1830s. It made public its bylaws on this day: "Detroit Typographical Society At a meeting held on March 23, 1839…Resolved: That in our opinion our numbers are now sufficient to warrant such an [*sic*] union among us… Resolved: We have organized ourselves into a society…for the purpose of maintaining the honor and welfare of our craft, the securing of fair remuneration for our labor, and for the moral and

Samuel Gompers was the first and longest-serving president of the American Federation of Labor (AFL). *Courtesy of the Library of Congress.*

social improvements of its members." More like an association of printing craftsmen, it did call a strike in 1839; the effects are unknown. Later, the Detroit Typographical Union (DTU) No. 18 claims to be the oldest union in the city formed in 1853. It functions to this day.

March 24

1877—Linoleum Reaches Detroit

In 1877, a new floor covering—linoleum—was introduced from London, England, and would soon be popular for Detroit homes. It was made by heating linseed oil and applying it to canvas cloth. *Detroit Free Press* reported on it on this day: "The natural color of this superior floor covering is a soft brown upon which a multitude of chaste designs are imprinted…It is noiseless, impervious to moisture, and does not accumulate dust. It never shrinks or swells like oil cloth. All first class carpet dealers keep it. It is called Linoleum, which name is on the back of every square yard." The first buyers put it throughout the house. Later, it was reserved for kitchens and bathrooms.

March 25

1942—Aretha Franklin Born

Aretha Louise Franklin was born in Memphis, Tennessee, on this day. Her father, Clarence LaVaughn Franklin, known as C.L., was a preacher from Shelby, Mississippi, while her mother was a pianist and vocalist, excellent in her own right. Prior to Aretha's fifth birthday, C.L. Franklin located the family to Detroit, where he founded the now famous Baptist church New Bethel. After success singing gospel in 1967, at age twenty-five, Franklin signed with Atlantic Records and achieved stardom with classic favorites such as "Respect," "A Natural Woman" and "Think." These hits and more helped her to gain the title the Queen of Soul by the end of the 1960s. Franklin has won a total of eighteen Grammy Awards and is one of the bestselling female artists of all time, having sold over seventy-five million records worldwide. She has lived in New York and Los Angeles but currently resides in Bloomfield Hills.

March 26

1901—The Greatest Kamper Structure Never Built

In 1900, plans began for Detroit's bicentennial (1701 to 1901). Along with parades and a reenactment of Cadillac's landing at Detroit, complete with a descendant of Cadillac as a guest of honor, calls went out for a suitable memorial for this momentous two-hundred-year celebration. Proposed sketches and ideas arrived from across the country, some from the leading architects of the day, such as Stanford White. On March 26, 1901, Detroit architect Louis Kamper submitted sketches to commemorate the bicentennial, described by the newspapers:

> *A mammoth arch Corinthian in style was submitted by Louis Kamper. It is calculated to span Woodward Avenue at the Grand Circus Park, with minor arches spanning the sidewalks on either side. A statue of Cadillac surmounts the arch. In the frieze below is an immense allegorical sculpture representing the flight of time. On either side are heroic statues of historic Indian chiefs and missionary priests. Slender Corinthian pillars of exceeding grace give an airy look to an otherwise substantial structure.*

Kamper's arch won the vote for the bicentennial memorial, but sadly the Bicentennial Committee couldn't raise the funds and the arch and all the commemorative projects were dropped.

March 27

1804—Land Office Established for Michigan

The first task for new settlers coming to Michigan to start farms and build homes was to visit the Detroit Land Office, established by an act of Congress and opened on March 27, 1804. It listed and sold surveyed government-owned land. In 1818, President James Monroe authorized the first sale of public lands. The reason was to offer land to veterans of the War of 1812 as payment for their military service.

March 28

1909—Typhoid Milk

Today, physicians at St. Mary's Hospital in Detroit reported that an unusual number of typhoid cases had been reported that year. In one room at St. Mary's lay Mrs. John Schoen and her four children, all suffering from typhoid fever that was probably the result of drinking "unpure" milk. Mrs. Schoen and her three daughters, Frieda, Elizabeth and Lillian, were taken to the hospital the day before after Dr. R.I. Pfeiffer discovered they had been ill with the disease for an unknown period. The son, Harold, age five, had caught typhoid fever five weeks ago. Dr. Pfeiffer attended him, and he was recovering. On his last call to the home, Frieda complained of symptoms, and the doctor discovered the mother and girls all had the disease. Lillian's condition was the worst, and Pfeiffer said she would likely not live. The doctor was frantically trying to locate the milk peddler who sold them the infected milk, but he complained that it was extremely difficult because they bought milk from several sources.

March 29

1823—Schoolcraft Marries a Woman with a Beautiful Name

Henry Schoolcraft (source of Schoolcraft Road and Schoolcraft College) came to Detroit from upstate New York. He was a geographer, geologist and ethnologist, noted for his early studies of Native American cultures. In 1823, he married an Ojibway woman from Sault Sainte Marie named O-bah-bahm-wawa-ge-zhe-go-qua, which translates to "the Woman of the Sound [Which the Stars Make] Rushing through the Sky." Conveniently, she was also known as Jane Johnston. Johnston wrote poetry and traditional Ojibwa stories, and she translated Ojibwa songs into English. She mostly wrote in English, but she wrote several poems in the Ojibway language as she lived her daily life in both Ojibwa and English. Her writings have attracted considerable interest from scholars and students, especially those concerned with American Indian literature and history. Her writing was the inspiration for Longfellow's popular poem "Song of Hiawatha."

March 30

1930—Hunting for a Job during the Great Depression

On this day in 1930, Henry Nelson was in search of a job during the Great Depression. He was interviewed by Helen Hall, who published his story, along with others, in *Survey* magazine under the title "When Detroit's Out of Gear." Hall wrote:

The age factor may have entered somewhat into Henry Nelson's problem. He seemed anxious to sit down when we came in and steadied himself by the furniture, but I didn't know then that he was weak for lack of food...he had had little or nothing to eat for three days. He was fifty-two, a bad age, practically hopeless for a job when young men couldn't get work, and he was aware of it for he was an old Detroiter who had worked for Ford, Graham-Paige, and Fisher Body, and he knew the ropes. But he had kept on trying because he had the "missus to look after." There were two sons and the son-in-law had been out of work for three months—four men workless and wage-less in one family.

March 31

1898—Lillian Russell in Detroit

At the Empire Theatre in Detroit, the nationally famous Lillian Russell would appear in the comic opera *The Wedding Day* for three evenings. Appearing with Lillian Russell were two other big stars of the day, Della Fox and comedian Jefferson De Angelis. The reviewer wrote, "The opera is full of light, catchy music, contrasted with some fine ensembles." Russell was one of the most famous actresses and singers of the late nineteenth and early twentieth centuries, known for her beauty and style, as well as for her voice and stage presence. She was married four times, the longest to Diamond Jim Brady, and he supported her extravagantly for forty years.

The actress Lillian Russell, who regularly performed in Detroit, in 1900. *Courtesy of the Library of Congress.*

APRIL

April 1

1873—April Fool's Day

As long as there are any boys, just so long will there be April Fool's Day in City and Village.
—Detroit Free Press, April 2, 1873

About 150 years ago, April Fool's Day was a day given over to boys to play practical jokes. The public had a surprising tolerance for boys and their sense of humor. This was real Little Rascals stuff. What could be funnier than pulling a thin wire four inches above the sidewalk then watching foolish, unsuspecting adults trip on it and fall flat on their faces? One man broke his shoulder. They started early at 7:00 a.m. to catch people on the walk to work. Old hats were used to cover bricks, large stones or raised edges of sidewalk so when the man or woman kicked the hat aside they broke their toe and limped away as they howled in pain. Those boys hammered pocket watches into the wooden plank walkway. When an alderman reached to yank and tug at the watch, twenty to thirty boys "raised his hair by their yells and whoops!" It was mayhem as they sent doctors on phony emergency calls, lawyers with fake summons, dentists to treat a boy with false cow's teeth in his mouth and even a clergyman three miles to marry a couple only to find a single, eighty-year-old woman who "gave him a blessing which he will not soon forget."

April 2

1929—The Guardian Building Opens

It was originally called the Union Trust Building when it opened, and it was clear the bank that had been founded in 1907 had abandoned the stodgy Greek Revival architecture of the past, as reported by the *Christian Science Monitor* in June 1929: "The Union Trust Company's skyscraper [is] now receiving finishing touches…it is as gay as a May morning. Making a deposit becomes an adventure in a modern Aladdin's cave." It was nicknamed the Cathedral of Finance, and it is the expression of ebullient confidence so common in Detroit in the 1920s. It is a masterpiece. The exterior blends terra cotta, limestone and orange brickwork with tile and sculpture by Detroit master Corrado Parducci. The building's interior is so lavishly decorated with mosaic, Pewabic and Rookwood tile it leaves visitors breathless. In 1989, the Guardian Building was added to the National Register of Historic Places.

One of Detroit's most dramatic Art Deco buildings is the forty-story Guardian Building, originally called the Union Trust Building. It is known for its extensive use of vivid colorful tiles and metal work: elevator doors are decorated with colored glass made by Louis Tiffany of New York. *Courtesy of the Library of Congress.*

April 3

1887—Thirty-ninth Spiritualist Convention in Detroit

In Fraternity Hall, 131 Detroit spiritualists, people who claimed to communicate with living souls in the world of spirits, gathered for their annual meeting. Spiritualism was very popular in the Victorian era as a form of entertainment and as a quasi-religion. Spiritualism developed and reached its peak growth in membership from the 1840s to the 1920s, especially in the United States and Europe. By 1897, it was said to have more than eight million followers, mostly drawn from the middle and upper classes. People used séances to reach out to loved ones and friends beyond the grave. On this day for this special Detroit meeting, a guest speaker from Boston, Mrs. Richings, would address the audience. Mrs. Richings was a "medium" who could call up spirits that would then inhabit her body and speak through her. She was famous for conjuring up one spirit in particular, a woman named Helen Stuart. In this performance, she took a scarf from a member of the audience and brought forth the original owner of the scarf, a deceased relative. Despite planted hecklers, "in no case did [Mrs. Richings] fail to convince her audience" wrote a reviewer.

April 4

1967—CKLW Wins the Hit Music War Against WKNR

AM radio station CKLW, which broadcasts out of Windsor, Ontario, used a variety format approach in the 1950s and early 1960s, but basically the station did OK thanks to its powerful signal; CKLW could be heard from Toledo and west to Grand Rapids and, of course, everywhere in Detroit. It shed the variety format in 1963 and reemerged as "Radio Eight-Oh" to compete in the teenage and youth market by playing contemporary hits, even though in the local Detroit ratings, CKLW still lagged well behind the competing king hit maker WKNR. However, on April 4, 1967, CKLW got a drastic makeover with Bill Drake's "Boss Radio" format. Within a few months, the station transformed into "the Big 8," with new jingles sung by the Johnny Mann Singers, and ratings soared. By July 1967, CKLW claimed the number-one spot in the Detroit ratings for the first time, and WKNR was left in the dust, switching to an easy-listening format as WNIC less than five years later.

April 5

1883—Start of a Permanent Art Museum for Detroit

The first citywide interest in an art exhibit occurred in 1883 when leading citizens of Detroit put up $1,000 each to fund the "Art Loan Exhibition" of 1883, an idea and project from William H. Brearley. It was located on Larned Street and opened from September until mid-November 1883. The exhibition attracted 134,000 people and displayed nearly five thousand works of art in twenty-six large rooms. It included oil paintings, watercolors, sculptures, bronzes, prints and drawings. It was considered a huge success with the public. On April 5, 1883, while Brearley was setting up the Art Loan Exhibit, a letter came from U.S. senator Thomas W. Palmer of Detroit in which he put securities worth $10,000 to build a permanent museum for Detroit. "The City of Detroit has taste and wealth enough to found and maintain an art gallery which will be creditable to the public spirit of her citizens." The first Detroit Museum of Art was built at the corner of Jefferson Avenue and Hastings Street and opened to the public in 1888.

April 6

Grand River on a snowy day in 1900. *Courtesy of the Library of Congress.*

1886—Worst Winter Storm in Detroit History

On this night, the snow started at midnight. A newspaper described that "by seven o'clock the next morning it lay six feet deep on the level." Accompanying winds caused drifts up to twelve feet high in some places. All forms of transportation in southeast Michigan were halted: trains were delayed seven hours. The storm covered the large portion of the northern United States from Pennsylvania to Illinois. While Detroiters had to shovel their own walkways to the street, they at least did not have to shovel driveways since there

were no automobiles. The horse-drawn trolley cars and railroad lines were responsible for clearing the tracks. On city streets, horse "car" lines used six to eight horses instead of the normal team of two to slowly drag rail cars through the heavy drifted snow.

April 7

1870—Black Detroiters Celebrate Fifteenth Amendment

On this day, large crowds of over one thousand African American men, women and children from Detroit, Windsor and surrounding areas marched and celebrated the ratification of the Fifteenth Amendment to the U.S. Constitution, which gave them the legal right to vote. The day was sunny and beautiful. After several speeches, the procession formed at the African Baptist and Methodist churches on Lafayette Street. The crowd then proceeded to the Detroit Opera House, carrying portraits of Lincoln, Grant and John Brown along with banners and streamers. The procession filed into the Opera Theatre, where the celebration began with fifty young black women who took the stage wearing white dresses with scarves of different colors representing the states that ratified the amendment. Speakers and singing continued until five o'clock with "unbound and vociferous applause."

April 8

1865—General Custer's Brilliant Action

On this day during the Civil War, a *New York Times* correspondent reported on the action of the Michigan cavalry brigade lead by General George Custer at Appomattox Train Station:

> *I have just witnessed another brilliant and successful dash by Gen. George Custer at the head of the 3rd Cavalry division...The cavalry left camp...the 1st and 3rd divisions on one road, the 2nd division taking a road on the left...When the advance had arrived two miles of the station...some three hundred rebel soldiers made for the woods...Several advances were made and repulsed until finally, Gen. Custer, seizing upon a favorable opportunity made a grand dash just as the 1st division was moving*

in on his right. Custer never made a halt until he had reached Appomattox Courthouse some three miles…This enabled the [Michigan] 3rd Division to bring in their captured property consisting of thirty or more pieces of artillery, including the celebrated Washington Battery, about two hundred wagons loaded with supplies, forty or fifty freight cars, three locomotives and hundreds of horses, mules and prisoners…This fight lasted perhaps two hours and was one of the most strongly contested this command has yet experienced…to the frustration of Lee's whole army.

April 9

1872—Soldiers' and Sailors' Monument

Detroit's Soldiers' and Sailors' Monument is the largest and most prominent monument to soldiers and sailors killed in the Civil War in Michigan. It was funded by voluntary donations from Michigan citizens and designed and sculpted by Randolph Rogers, an Ann Arbor native and well-known artist for Civil War commemorative monuments across the United States. It was unveiled in the heart of downtown Detroit on April 9, 1872, and was attended by Generals George Armstrong Custer, Phillip E. Sheridan and Ambrose E. Burnside. The *Detroit Free Press* at the time reported that twenty-five thousand visitors from across the state attended the dedication and the city was decked out in red, white and blue bunting.

The Soldiers' and Sailors' Monument is the largest monument in Michigan to commemorate the veterans of the Civil War. It was designed by Randolph Rogers of Ann Arbor and dedicated in 1872. This photo is from 1915. *Courtesy of the Library of Congress.*

April 10

1818—An Unusual Letter

On April 10, the *Detroit Gazette* reported that it had received a letter addressed to the "Town of Detroit, as a body corporate." "Light Gives Light to Light to Discover Ad Infinatum." The letter was from one John Cleves Symmes, a former captain in the War of 1812 who was writing from "St. Louis, Missouri Territory, North America." Symmes believed the earth was a hollow shell 810 miles thick, filled with a series of concentric hollow globes that were habitable inside. Light filled the hollow earth from sunlight that reflected off enormous open holes at the north and south poles. These holes were also responsible for wind on the earth. Symmes wrote to Detroit and to other U.S. cities looking for one hundred men to join him to search for the holes in the Artic. They would start in Siberia, riding reindeer across the ice of the "frozen seas." He was certain they would find a "warm and rich land stocked with thrifty vegetables and animals." Symmes gave lectures for years across the United States, and the Symmes Hollow Earth theory was a popular pseudo-scientific idea of the nineteenth century that was the source of several novels, such as *Journey to the Center of the Earth* by Jules Verne. In the *Detroit Gazette*, he closed: "I pledge my life in support of this truth, and am ready to explore the hollow if the world will aid and support me in the undertaking." Men of Detroit passed on his offer.

April 11

2000—Comerica Park Opens for Tigers' First Game

Since 1901, the Detroit Tigers have played at the corner of Michigan and Trumbull Avenues, so the new baseball park on Woodward was viewed with deep skepticism for die-hard Tiger fans. Many grew up going to games as kids at Tiger Stadium. Fans wondered if the Tigers' new digs would measure up. The groundbreaking for the new baseball park for the Tigers was held in October 1997, and the new Comerica Park was opened to the public in 2000. The first game was held on April 11, 2000, against the Seattle Mariners. With tiger statues, Pewabic tile, fountains, fireworks and even a kiddy Ferris wheel and merry-go-round, what's not to love? The Tigers pack 'em in.

Comerica Park, home of the Detroit Tigers. *Photo by Barney Klein.*

April 12

1963—Top of the Flame Opens

In April 1963, a new restaurant opened on the twenty-sixth floor of the Consolidated Gas Building at Number One Woodward Avenue: "Top of the Flame." It offered spectacular vistas of the Detroit River and was one of those special occasion restaurants. It was run by Stouffers and featured a Thai menu as well as American; you could get a highball at the Bangkok Cocktail Lounge or visit the exotic Tempura Bar. The "flame" was extinguished in 1977.

April 13

1917—A Deafening Roar of Hundreds of Engines

In 1917, Henry Ledyard and his son Wilfred, who had started a new auto company called Lincoln Motor Car, responded to the need for war materials

for World War I. They began making Liberty engines, the famous aircraft engines for the Allies. The engine was designed by Packard Motors chief engineer Colonel Jesse G. Vincent. A specialized plant was built at Warren and Livernois Streets, and the area around the plant was made unlivable day and night by the deafening roar of hundreds of engines being block tested in open fields surrounding the factory.

April 14

1836—Joseph Campau

A Detroit character many immigrants from New England and New York would see on the street was old Monsieur Joseph Campau, the wealthiest man in Michigan at the time, said to have owned nineteen separate farms in Wayne County. He was frequently seen on Detroit streets chatting and greeting friends in French. On this spring day, newspaper columnist George C. Bates described the debonair Frenchman who, at time of the writing, was seventy-one years old:

> *"Bonjour! Bonjour! Monsieur Bates. Comment se tu, Mon Ami? Il fait beau temp, monsieur."*
>
> *"Ah, Good Morning, Monsieur Campau. Il fait tres, tres beau, Mon Ami."*
>
> *Monsieur Campau saluted the writer in his warm and courtly style. The old gentleman…was clad in a black full dress suit, white cravat [tie], rolling shirt collar, ruffled shirt, clean and white as snow, moving along with his long white hair, large grey eyes, and steady sturdy step, he was a man to arrest the attention and curiosity of all travelers on the streets of Detroit.*

Joseph Campau lived to be ninety-four years old.

April 15

1865—Detroiters Learn That Lincoln Was Assassinated

In the morning on this day, the city learned that Abraham Lincoln had been assassinated. As historian Silas Farmer wrote, "The whole city was at once in mourning; men wept like little children and an intense feeling pervade all

classes." On the evening of this day, John Bagley closed his store and went home. "I sat down in the parlor and tears would come. My little daughter came to me and said, 'Papa, what's the matter?' I said 'Mr. Lincoln is dead.'"

April 16

2015—Millions of Potatoes Being Shipped

On this day, a truck holding over fifty thousand pounds of potatoes was on its way to Better Made Snack Foods on Gratiot Avenue in Detroit. Better Made has been in business for eighty years in the city. It uses sixty million pounds of potatoes for its potato chips every year. The potatoes are unloaded from delivery trucks that are lifted by a hydraulic lift, and the potatoes are then transported by conveyors to storage bins. As needed, the potatoes are automatically conveyed to the plant floor, where they are washed, peeled, sliced and inspected. Better Made uses Michigan potatoes for ten months of the year and then buys elsewhere based on harvest schedules. Potatoes come from Florida, Missouri, Indiana, North Dakota, Minnesota or wherever the best potatoes are available for the remainder of the year.

April 17

1964—Birth of Detroit's Pony Cars

The Ford Mustang was introduced to the public on April 17, 1964, at the New York World's Fair. Executive stylist John Najjar, who was a fan of the World War II P-51 Mustang fighter plane, is credited by Ford to have suggested the name. Najjar co-designed the first prototype of the Ford Mustang known as Ford Mustang I in 1961, working jointly with fellow Ford stylist Philip T. Clark. It was originally based on the platform of the Ford Falcon, a compact car. The 1965 Mustang was the automaker's most successful launch since the Model A. It introduced a new class of American automobiles in the 1960s called the "Pony Cars," distinguished by long hoods and short rears, two doors for four passengers and being generally affordable. (The term comes from the "mustang" logo on Mustangs.) Almost overnight, competitors abounded, such as the

Chevy Camaro, Plymouth Barracuda, Dodge Challenger, AMC Marlin and Javelin and Mercury's Cougar. Pony cars should not be confused with "Muscle Cars," also American made but bigger, heavier and more powerful with V8 engines.

April 18

1849—HO! California! Detroiters Head for Gold.

The Wolverine Rangers left Marshall, Michigan, on April 18, 1849, by train headed to Chicago. From there, they took a steamboat to St. Louis and then went on to Independence, Missouri, which was the "staging" area. In April 1849, twenty thousand men with wagons and mules, horses and oxen gathered and waited to head out. Among them was twenty-two-year-old Oliver Goldsmith from Detroit. Goldsmith described his clothing: "Our dress was somewhat varied. Mine was a green baize [felt] hunting jacket, red shirt, corduroy trousers and white soft felt hat." He added that some of the young men were dressed like mountaineers or Indians. As the *Detroit Free Press* reported in 1849: "California—the Rage for Gold Dust…The most exciting point to this California news is the fact, now placed beyond even the shadow of a doubt that the deposits in gold are actually inexhaustible, and that new and fresh discoveries are made every day…Wonderful as these discoveries actually are, there can be no question that the wealth of California cannot be exaggerated."

April 19

1851—The Great Railroad Conspiracy

On this night in 1851, the sheriff of Wayne County and a posse rode out in the middle of the night to the village of Michigan Center near Jackson. They arrested 44 men, most of whom were farmers. Of that group, 37 were indicted and taken to Detroit for a trial that would last four months, include the testimony of 461 witnesses and become one of the most controversial cases of its day. Detroit jails were a misery, and the principal defendant died in jail before the trial even began. William Seward, a future U.S. secretary of state under Abraham Lincoln, was a lawyer for the defense and described the proceedings: "Not only was [it] an important judicial event in the history

of Michigan, but [it] also was entitled to a place among the extraordinary state trials of our country and of our times." The incident that provoked the trial would garner national attention as the "Great Railroad Conspiracy."

April 20

1905—New Drinking Fountains on Belle Isle

Today, parks commissioner Bolger announced that new, modern-style drinking fountains would replace the "old and hideous ice water barrels." The drinking fountain seemed to be more fountain than drinking, made of cement and cobblestones in a rustic style on Belle Isle's southern side.

April 21

1891—The Streetcar Riots

The journal *Street Railway Review* called Detroit's horse-drawn streetcar system "one of the poorest equipped street railway cities in the country." The Detroit City Railway was privately owned by George and Strathearn Hendrie of Ontario, who were determined to keep their horse-drawn lines. They would convert to rapid transit only if the city renewed its thirty-year contract, which was coming up for renewal in less than a year, and then refused to put in writing when they would convert from horses to electricity. They delayed rapid transit at every possible opportunity. In April

A typical horse-drawn trolley car that provided transportation for Detroiters for nearly forty years. *Courtesy of the Library of Congress.*

1891, a strike was called by transit workers, which turned into a three-day riot made up of mobs of workers and citizens in a vengeful mood, set on destroying the cars and tracks. It wasn't only the workingmen destroying property in the street; it also included some respected citizens, such as future

mayor and United States senator James Couzens. Joseph L. Hudson sent out clerks from his department store to collect money to support the strikers. City bakers provided free lunches. The *Detroit Free Press* wrote, "The railway company is reaping the harvest of its indifference to popular sentiment." The railway company ordered Mayor Hazen Pingree to call the governor and bring in state militia to force the end of the mêlée at rifle point. Pingree refused, saying that city forces were adequate. Pingree convinced the railway company to arbitrate with the strikers, a revolutionary strategy. They did, and the strike ended.

April 22

1835—Campus Martius Becomes a Park

Campus Martius was named in 1788 after a similar open space in Marietta, Ohio, the first city in the Northwest Territory, which in turn was named after the original Campus Martius in Rome, Italy. The name translates to "Field (campus) of War (Mars, the Roman god of War)." In short, it was an open space used to drill and train soldiers. Originally, it was much bigger with a swamp; it marked the end of the city. In the center it once had a military block house. But Campus Martius in Detroit was more than a training ground. For a time, it was a hay and wood market, a parking lot for farmer's wagons and a hangout for hucksters and peddlers that included knife sharpeners, toy balloon sellers and fruit wagons. Some of

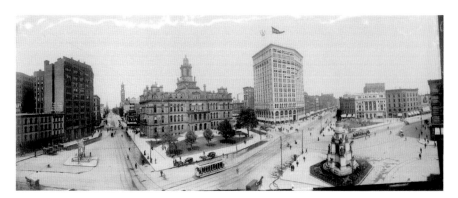

Campus Martius in 1900. *Courtesy of the Library of Congress.*

the curiosities featured at Campus Martius were "lightening calculators" and "lung testing machines." Political rallies were a regular Campus Martius activity and usually included huge bonfires. It was rough, muddy and unpaved. On April 22, 1835, the city council approved a resolution to turn the space into a public park.

April 23

2014—Diego Rivera's
Magnificent Murals

Artists Diego Rivera and Frida Kahlo, his wife, seen in 1932. *Courtesy of the Library of Congress.*

Edsel Ford commissioned murals by Mexican artist Diego Rivera for the Detroit Institute of Arts (DIA) in 1932. Composed in fresco style, the twenty-seven panels were titled "Detroit Industry." They have been called by one critic the closest America comes to Michelangelo's Sistine Chapel. They depict the elements and human spirits of the earth, panels of exploitation and the intensity of the production line at the Ford Motor Company's River Rouge Plant, including a modest portrait of Edsel Ford himself. The politically charged themes of proletariat struggle and Diego Rivera's well-known politically socialist beliefs have caused lasting friction with people holding conservative values and lovers of art and the fantastic mural. Rivera and his assistant, after a long day of working on the famous murals, would cross John R Street to have drinks, dinner and cigars at the Scarab Club. On one evening, Rivera and his assistant signed a beam above the second-floor lounge, a long-standing tradition of honor for Detroit and visiting artists. On April 23, 2014, the Detroit Industry Murals were given National Historic Landmark status.

April 24

1866—Trout Processing

On this day, several large fish dealers along the docks on the river at Cass, First and Second Streets were processing speckled and brook trout that came in iced oak barrels from Mackinaw and Lake Superior. The fish were salted, inspected and then repackaged. As the *Free Press* reported, "The busy thud of the cooper's adze [barrel makers] mingles with the sounds of other manual operations through which the scaline and skinny denizens of the deep must pass to be pronounced a fit dish to set before the king of epicures."

April 25

1925—Wide-Open Booze Town

On this day in 1925, Ernest Mandeville reported for *Outlook* magazine of the "flagrant example" that Detroit set. Booze was out of control in the city during Prohibition, with a reputed twenty thousand blind pigs in operation. Mandeville wrote that the liquor sold in Detroit was the "ruinous" quality and the profits of needle beer (beer made illicitly and under makeshift conditions with ether alcohol) were 1,000 percent. Moonshine (called "moon" in Detroit) sold for $2.50 a gallon. Many blind pigs were run by women and were also "centers of immorality." Mandeville wrote, "In the downtown section every manner of storefront is used to disguise the "blind pig."

April 26

1896—Bennett Park Opens as First Ballpark at Michigan and Trumbull

In 1894, Detroit Tigers owner George Van Derbeck began construction of the first baseball park to sit at the corner of Michigan and Trumbull Avenues. That stadium was called Bennett Park and featured a wooden grandstand with a wooden peaked roof in the outfield. It was named after the great early catcher Charley Bennett, who played for eight seasons with the Detroit Wolverines from 1881 to 1888. Van Derbeck literally broke ground in March 1894, as covered by the newspapers: "A pair of mules was kept reasonably busy dragging the unevenness from the surface of property

Mr. Van Derbeck has leased for his new ballpark. The sod was removed and laid away in piles and then the scraper was put on. The ground was very wet where the plate will be and was raised a trifle so as to drain better. Work on the Grand Stand is also going right along." On opening day, the new stadium was festooned with eight colorful flags for each of the Western League teams. A cannon was fired off every few minutes to announce the great day. Ballplayers (Detroit played Columbus) arrived by trolley car in uniform. Mayor Hazen Pingree gave a speech and then threw out the first pitch to Charley Bennett behind the plate. It was closed after the 1911 season.

April 27

1884—Pawning False Teeth

Today, a Detroit newspaper reported on a pawnshop. A well-dressed man entered and quietly put a hand to his mouth and removed an entire set of upper false teeth, bound together with a plate of pure gold. After wiping them off with a handkerchief, he handed them to the clerk, whispering, "Five dollars." The clerk handed him the money and a pawn ticket, and just as quietly, the man slipped out the door. "That man has been in here three times today," he told the reporter. "The first time he left his watch and chain. The second time he left his diamond stud and ring. I've advanced him money on his false teeth before." He added, "He'll be back for the teeth and other things on Monday or Tuesday. He's a poker player."

April 28

1900—At the Stove Factory

On this day in the Michigan Stove Company, Detroiters were invited to take tours to watch cast-iron stoves being made. The molding room was always the most popular as molders worked in teams of two. One man hammered the iron patterns into the casting sand to make a perfect impression of two panels while the other clamped a wooden box frame (called a flask) around the sand to keep it together when the liquid metal was to be poured. When the molten iron had reached the right temperature, bells clanged to make everyone aware of the danger. Men moved down the long aisles between

the wood frames and picked up the long-handled iron ladle that weighed fifty pounds, now filled from the furnace with forty more pounds of glowing, sparking cherry-red molten iron. Aisles were grated to prevent slipping. As described in an exuberant article from 1900, "Here and there men are hurrying with ladles of glowing molten metal. Some are pouring, some are unearthing the pieces that have been molded…It makes you think of the red blood that flows through the veins of these workers and through yours also. Each of these is working not alone for himself, but as well for the human race, each one an important factor in the progress of civilization."

April 29

1941—Detroit Tanks Unveils the M3

The Detroit Tank Manufacturer delivered its first tank to the U.S. military on this day. Detroit's newest and largest defense plant started producing the M3, which weighed thirty tons and was cranked out at a rapid pace during World War II. Officials from both the Chrysler Corporation and the American military gathered in Warren to witness a demonstration in which the new tank fired its weapons, crashed through a telephone pole and destroyed a house. By the time the war ended, the Detroit Tank Arsenal was producing more than twenty-two thousand tanks a year.

April 30

1876—Roller Skating Craze in Detroit

In 1876, roller skating took over Detroit. The city's first roller rink established at Young Men's Hall featured contests, matinees and shows, but on this evening was the "Grand Tournament" in which 1,200 Detroiters participated. The rink was illuminated with a "myriad of gas jets and Chinese lanterns producing a "blaze of light." At 9:00 p.m. the band played and thus began the "Grand March," which started with amateur skaters: masters and misses—young ladies and gentlemen of all ages. A bell was rung, and the amateurs made way for trick skaters, jugglers and five knights, dressed in armor, who performed a skating knights' joust.

MAY

May 1

1915—Milk Must Be Pasteurized

Detroit's milk peddlers were an independent lot. They usually owned one or more cows (in 1900, there were fifteen thousand cows in the city of Detroit), a horse or two and a milk wagon, which was initially an open-air, flat wagon with large metal cans of raw, unpasteurized milk. Peddlers would milk their cows before dawn and then load the milk cans into the wagon. They then ladled the milk into the pitchers of customers who were waiting along the street on their route. At the turn of the century, Detroit had only two milk

The Detroit Creamery was the largest dairy in Detroit in the 1920s. Its building was designed by Albert Kahn. *Author's collection.*

inspectors to cover milk delivered to 300,000 residents by more than 300 peddlers. The man in charge, Dr. William H. Price, concluded that it was impossible to inspect so many milk peddlers, so he pushed for pasteurization. On May 1, 1915, Detroit mandated that all milk be pasteurized. By 1921, the health department announced that baby death rates from diarrhea and enteritis in the city of Detroit had dropped by half, from 48.6 per 1,000 births in 1906 to 21.6. They attributed it to pasteurization and improved milk facilities and supply.

May 2

1939—Lou Gehrig Ends His Streak in Detroit

On this day, New York Yankees star Lou Gehrig sat out the May 2, 1939 game against the Detroit Tigers, ending his 2,130 consecutive game streak—a streak unbroken until 1995 by Cal Ripken Jr. of Baltimore. That morning, he had breakfast at the Book-Cadillac Hotel, and in the lobby of the hotel, he told team manager Joe McCarthy that he was taking himself out of the lineup. Announcer Ty Tyson informed the crowd at Detroit's Briggs Stadium that Gehrig had taken himself out to stunned silence. The Yankee manager asked Gehrig to take the pre-game lineup card to the umpire prior to the start. Detroiters gave him a "deafening cheer." Gehrig tipped his cap to the fans. Gehrig was struggling physically, and baseball fans noticed his diminished performance, but no one had any idea why, especially Gehrig himself. He was not yet thirty-six years old. He would soon learn he had ALS, or amyotrophic lateral sclerosis, which would come to be known as Lou Gehrig's disease. He retired from baseball that summer and on that July 4 gave his famous "The Luckiest Man on the Face of the Earth" speech. He died in 1941.

May 3

1968—Grande Ballroom

On this night in 1966, for $3.50, the Grande Ballroom featured the Yardbirds with Jimmy Page on guitar, later to become the brilliant guitarist of Led Zeppelin. The Grande Ballroom (pronounced Gran-dee) was completed in 1928 as a neighborhood dance hall. Located on Grand River near Joy

Road, which was then a Jewish neighborhood, the Grande was well known to dancers in its day for good-quality hardwood floors. Nearly forty years later, in October 1966, a teacher and disc jockey from Dearborn named Russ Gibb who was inspired by psychedelic live performance theaters in New York and San Francisco purchased the Grande, and the rock era legend opened for business. The first act was the MC5. Gary Grimshaw and Carl Lundgren's magnificent posters set the tone that packed suburban kids every night to hear local and nationally famous bands, such as the Who, the Grateful Dead, Janis Joplin, the Cream and more. The Grande closed its doors in 1972.

May 4

2010—"That one is loooong gone!" Home run! Ernie Harwell

On this day, broadcasting legend Ernie Harwell passed away after announcing Detroit Tiger games on the radio for forty-two years. Harwell may be the most beloved sports celebrity in Detroit and is considered by many to be among the best radio booth baseball men who ever called the game. Nationally, he broadcast two All Star Games and two World Series, CBS "Game of the Week" for NBC Radio from 1992 to 1997. Devoutly Christian and a lifelong collector of baseball memorabilia, he donated his collection, said to be worth $1 to $2 million, to the Detroit Public Library. Harwell also wrote poetry. In 2000, Harwell's name was honored to be listed among the retired numbers of the greatest Detroit players. Harwell was born in Washington, Georgia, and grew up in Atlanta, and he was famous for his relaxed, conversational delivery and southern accent that characterized summertime across Michigan. When asked which game was his all-time favorite, he responded, "I don't really have one favorite game, but in every game I see, I find something interesting."

May 5

1831—"The Freep"—On Guard for 184 Years

The original name of the newspaper was the *Democratic Free Press and Michigan Intelligencer*. It was Detroit's first daily newspaper and is the

longest continuously operating business in Detroit. Over the years, the *Free Press* has had a variety of names, including the *Daily Free Press*, *Democratic Free Press* and, in 1837, *Semi-Weekly Free Press*. It was begun by Shelden McKnight (twenty-one at the time), his uncles and others. In 1853, Wilbur F. Storey bought the paper and brought it to national status through innovation such as use of the telegraph: "The Latest News, by Telegraph." The Freep covered not only local news but also expanded coverage of national events, such as presidential elections. During the Civil War, *Free Press* correspondents sent lengthy firsthand accounts from the battlefields. In 1940, John Knight bought the *Free Press*, and in 1989, a one-hundred-year joint operating agreement was established between the *Free Press* and its main rival, the *Detroit News*. The two papers would share business operations and split profits but keep their editorial staffs separate.

May 6

1888—Fisticuffs at the Train Station

William G. Thompson was a Republican and served as Detroit's mayor from 1880 to 1883. Thompson had an explosive temper and regularly got into fistfights and threats with pistols at Thomas Swan's saloon. In 1888, Thompson was party to a sensational and public fight that drew national attention, as reported in the *New York Times*. His brother-in-law, Daniel Campau, was a Democrat on the Detroit City Council when he tracked down Thompson at the Michigan Central train station. Thompson was planning on divorcing his wife (Campau's sister) and apparently had said some nasty personal comments about her and their marriage at Swan's. Campau heard of this and, infuriated, sought Thompson out. He confronted Thompson and warned him that "he must not talk about his wife hereafter in barrooms and other public places, as he had been doing." Thompson responded with "a profane and vile epithet" and then charged Campau with his fists, but Campau struck Thompson on the head with his silver-headed cane, which knocked Thompson to the floor of the train station with a "severe scalp wound." Neither man pressed charges.

May 7

2014—Detroit's Casey Kasem's Tragic End

Casey Kasem was born in Detroit in 1932 to Lebanese Druze immigrant parents who had settled in Michigan, where they worked as grocers. Kasem received his first experience in radio covering sports at Northwestern High School in Detroit. He then went to Wayne State University for college. While at Wayne State, he voiced children on radio programs such as *The Lone Ranger* and *Challenge of the Yukon*. At the end of the 1960s, he began working professionally as a voice actor. In 1969, he started one of his most famous roles, the voice of Shaggy on *Scooby-Doo, Where Are You!* He did voice-overs for NBC, and at his peak the legendary deejay's warm voice was heard by a reported eight million listeners in seventeen countries. Many claim he was the most influential radio personality in history. At his death in 2014, Kasem's worth was estimated at $80 million. This likely spurred the bizarre ending to his life as his second wife, Jean, on May 7, 2014, had the eighty-two-year-old Kasem, who was suffering from a disease similar to Parkinson's, moved to a secret location (a friend's house) because his children from his first marriage came to visit him without getting her permission. (Jean Kasem played "Loretta," Nick Tortelli's girlfriend on television show *Cheers*). Casey finally passed away in 2014 and was secretly buried by Jean in Norway. RIP.

May 8

1921—First Riding Power Mower in Detroit

On this day in 1921, the world's first motorized riding lawn mower, patented by Ransom E. Olds and manufactured by the Ideal Power Mower Co. of Lansing, was used at Fort Wayne (as well as several other sites) for promotional purposes. The ideal gas engine–powered lawn mower was based on an R.E. Olds patent from 1914. In 1922, the operation was renamed the Ideal Power Lawn Mower Company. The earlier models featured a large roller that propelled the mower and rolled the turf at the same time. The mower company was in business in Lansing until 1945, when the operation was sold to the Indian Motorcycle Co.

May 9

1970—Walter Reuther Killed in Plane Crash

On May 9, 1970, United Auto Workers (UAW) president Walter Reuther; his wife, May; two others; the pilot; and the co-pilot were killed when their chartered aircraft crashed and went up in flames. The plane, arriving from Detroit in rain and fog, was on a final approach to the Pellston, Michigan regional airport near UAW's recreational retreat at Black Lake. A year and a half before the accident, Reuther and his brother Victor were nearly killed in a private small plane as it was landing at Dulles Airport in Washington, D.C. Both incidents were very similar: the altimeter malfunctioned. Victor Reuther was interviewed years after the Walter Reuther crash in Pellston. He said, "I and other family members are convinced that both the fatal crash and the near fatal one in 1968 were not accidental." An official report claimed the crash was due to no runway lights and poor weather.

May 10

1914—Mother's Day Official

On this day, President Woodrow Wilson signed the proclamation that declared Mother's Day a national holiday. In memory of their mothers, Detroiters wore white carnations in their lapels. A columnist for the *Free Press*, Harriet Culver, who wrote on women's subjects and culture until 1931, wrote in 1918: "This year we must wear the fragrant white in place of the blushing red and only the whispering winds and singing leaves in the tree tops can send her the message we want so much to give this Mother's Day."

May 11

1825—John Trumbull Walks on Trumbull Avenue

There were two famous John Trumbulls who were active during the American Revolution. They were cousins: one was a painter, the other a poet. Detroit became the residence of the poet. Trumbull was a prominent writer, poet and political satirist from Connecticut. So famous was Trumbull that Detroit named Ninth Avenue after him. His most popular work was a

beloved long poem titled "McFingal," which is considered a comic epic. He attended Yale in 1763 and studied law. In 1773, he was admitted to the bar and worked in the law offices of John Adams. He did not fight in the war due to a "weak constitution." After a long career as a lawyer and judge, he came to Detroit in the fall of 1825. His daughter had married Governor William Woodbridge, who had a farm in Detroit that was later sold and platted for the neighborhood that bears his name, Woodbridge. Trumbull lived with Woodbridge and his daughter for six years until his death on this day at age seventy-five. He is buried in Elmwood Cemetery. It was said he always wore a powdered wig when taking his daily walk. His cousin, John Trumbull, painted his portrait, which hangs at the Detroit Institute of Arts.

May 12

1890—Teamsters Driving Teams

Controlling a large team of horses took great experience; it was dangerous, and many cities would not allow the large teams on the streets. For a four-horse team, eight reins were held in one hand, a respected skill that required knowledge as well as strength. Backing up such a team to a loading dock drew crowds of onlookers on this day. Teamsters earned their name to distinguish them from one-horse light trucks and two-wheeled carts. Teamsters' wagons had four wheels pulled by a least two horses, and they began to appear in the 1830s. By 1900, their numbers soared. Many teamsters in Detroit were European immigrants or African Americans. In the lumber industry, teamsters were exclusively French Canadians. Driving two horses or more, carrying difficult, heavy loads required special knowledge and skills by a teamster. Nervous horses were placed on the right side since passing traffic excited them. If one horse was sluggish, the other would be overworked. For a team of two, four reins were held in the right hand, leaving the left for the whip or the brake; however, it was always considered more effective to control horses with the voice than the whip. The hold on the reins needed to be tight so horses knew they were under control, but the grip could not be excessive or it would hurt and damage the horse.

May 13

1914—Champion Joe Louis

Joseph Louis Barrow, better known as Joe Louis, was born on this day in Alabama but moved to Detroit at age fourteen during "the Great Migration" in which millions of African Americans came to northern cities for jobs soon after the end of World War I. Louis was world heavyweight champion from 1937 to 1949. He is considered to be one of the greatest heavyweights of all time. It has been said that Louis dropped his last name Barrow as a teenager to keep his mother from knowing that he boxed; she had forbidden it. Nicknamed the "Brown Bomber," Louis helped elevate boxing during a decline in popularity by establishing a reputation as an honest, hardworking fighter. In 2005, Louis was ranked as the top heavyweight of all time by the International Boxing Research Organization and was ranked first on the boxing magazine the *Ring*'s list of the 100 Greatest Punchers of All-Time. Coleman Young recalled running into the streets to celebrate his wins with thousands of other African Americans. Louis was considered the first mainstream sports hero for all races.

May 14

1833—Spring Arrives in Detroit

On May 14, the steamer *New York* arrived from Buffalo. The steamer turned the bend from Lake Erie up the Detroit River at 7:30 a.m. on a glorious spring morning. The captain, Sheldon Thompson of Buffalo, his mouth stained with tobacco juice, rapped loudly on passenger doors, yelling, "Turn out! Turn out! We are just now at Detroit, the place you've been impatient to see! Turn out!" A Detroit newspaper described the scene:

> *The sun had risen in all the gorgeous beauty of a May morning, and glinted and gilded the river, the shore, the old French farm houses on both sides…the peach and pear trees, some then over one hundred and fifty years old were covered with blossoms and the air was laden with rich perfume…the French carts along the shore, the old la Fountaine and other log houses, all newly whitewashed, neat, tidy, surrounded by cackling*

geese, chattering ducks, squealing pigs, and lowing cattle all of which could be heard on our deck presented a scene of exquisite beauty and a land so quaint, so unique and so beautiful that at once I was in love with it all.

May 15

1925—James Scott Memorial Fountain

According to contemporaries, Scott gambled, chased women and in business was vindictive and could not be trusted. Scott died in 1910 with no heirs, friends or colleagues, and he bequeathed his estate to the City of Detroit with the condition that the fountain include a life-sized statue of him. Debate on the fountain's design and placement went on from 1910 to 1925. Many found Scott's memory so disagreeable they wanted to turn down the gift, but others persisted. The sculpture of Scott was completed but tucked away behind the fountain. A leading French architect, Professor Eugene Duquesne, was selected to lead the competition, which was won by

The James Scott Memorial Fountain on Belle Isle was designed by internationally famous architect Cass Gilbert and is one of the most beautiful fountains in the United States. *Photo by Barney Klein.*

internationally famous architect Cass Gilbert in 1914. The newspapers at the time described the fountain to be as beautiful as anything at the French palace Versailles. Today, the magnificent white marble fountain on the west end of Belle Isle is considered one of the nation's most dramatic. The *New York Times* wrote that fountain details were based on the Roman Imperial era. The white marble bowl is 112 feet in diameter with water projecting 40 feet in the air. It features turtles, Nubian lions and various stylized figures of the sea. At night colored lights illuminate the water flows.

May 16

1907—Detroit Men's Favorite Pie

In 1907, national famous cookbook authors and cooking instructors complained that when they visited Detroit, housewives wanted to learn only one thing: how to bake a lemon meringue pie. Bakers could barely keep up with demand; it was especially critical to have a huge pile of white meringue on top. So much lemon meringue pie was eaten that doctors warned of the dangers of eating too much of the stuff. On this day, the *Detroit Free Press* interviewed one cooking instructor, who complained, "I get more requests for lemon meringue pie than anything else. No, they seldom ask me for bread and when I give a bread talk it is almost always empty seats. A pie talk is always well attended, and the women confess to me nearly always that they are awfully anxious to learn to make a real good pie 'because my husband does love it so.'"

May 17

1865—Boxing Match on Hog Island

On this day, a boxing match was held on Hog Island (not yet called "Belle Isle") between Scotty ("from the land of heather") and Toothless ("born on the Green Isle"). Crowds of men were brought over on a steamer, and open land was walked off, stakes planted and the ring marked with ropes. Toothless and his seconds chose the "high ground" for his corner and tied his colors to the stake. The fight began with action reported by the *Free Press*: "Round five: a give and take round, both showing glutton like qualities.

Toothless received a spanker on his fly hole and returned the compliment by cutting a gash on Scotty's cheek." Round 15 went twenty exhausting minutes: "Scotty was showing signs of putting up the shutter. Toothless made a lunge at Scotty's damaged right peeper, while Scotty showered thundering blows on Toothless's swollen orifice and now demoralized nasal protuberance." By Round 16, Scotty was declared the winner and was met by huge crowds back in the city.

May 18

2003—Joe Falls Retires

On this day in 2003, sportswriter and editor Joseph Francis Falls said goodbye. Falls began as a copy boy in 1945 in New York and then came to Detroit and wrote for the *Detroit Times* to cover the Tigers. He moved to the *Free Press* in 1960 and stayed until 1978. He finally moved to the *Detroit News* as columnist and sports editor. During the 1960s, Falls could get under the skin of baseball pros. He invented a new statistic, RNBI (Runs Not Batted In), for batters who left runners stranded. He kept this statistic on Tiger left fielder Rocky Colavito for several seasons. This infuriated the hotheaded Colavito and created a tense relationship between the two for several years. At his induction into the Baseball Hall of Fame in 2002, Joe said simply, "God bless America, and God bless baseball."

May 19

1903—David Dunbar Buick's Really Bad Decision

If I'd only got into the automobile business on the ground floor, what a millionaire I'd be today! If I'd started in like Ford and Dodge, I'd be sailing a yacht around the world right now. Well, they were lucky birds, those guys. They got a break.
–David Dunbar Buick, interviewed for Time *magazine in 1929*

On this day, Buick incorporated the Buick Motor Company. That September, unable to find investors in Detroit, the company was sold,

eventually landing in Flint. By the summer of 1904, Buick had produced the first production-built car, the Model B. With additional investment and outside help, the car was a huge hit with the public, and Buick became the foundation for General Motors; however, Buick himself was marginalized and in 1906 accepted a severance package and left the company that he had founded. Had he held on to his shares of General Motors stock paid to him when William Durant bought him out, his worth at the time of his death would have been over $10 million. Sadly, Buick died from colon cancer in 1929 penniless at age seventy-four.

May 20

1763—Chapman on the Detroit River

In 1763, a Jewish trader named Chapman, said to be the first Jew recorded in Detroit, made his way up the Detroit River in a bateau loaded with goods that he brought with him from Albany, New York. In May, he was seized by Chippewa Indians who took him ashore to be burned and tortured to death. Despite efforts by local French residents to hide Chapman, the Chippewas tied the poor man to the stake and lit the fire by his side. His thirst from the intense heat made him beg for something to drink. It was the Chippewas' custom to give a prisoner about to die his last request. A bowl of pottage or broth was given to him, but it was scalding hot and burned his mouth. Furious, he threw the bowl at the face of the man who had given it to him. "He is insane! He is mad! He is mad!" the Indians encircled around Chapman all agreed, and having a deep fear, respect and pity for the insane, they untied and released Chapman. This story was told by John Gottlieb in Ernestus Heckewelder's book *History, Manners and Customs of the Indian Nations* to illustrate Indian attitudes toward insanity and suicide.

May 21

1834—Detroit's First Streetlights

Lighting of Detroit streets was first publically discussed in a committee of Common Council in 1827 when committee members were in favor of lighting Jefferson Avenue. Nothing was done until May 21, 1834, when the

Common Council voted in favor of lighting Jefferson from Cass Avenue to Randolph Street. It presented an estimate of cost as follows:

Twenty lamps including posts—$5.00
Three quarts of sperm oil per night—$0.75
Total cost per year—$262.50

In January 1835, the committee was ordered to execute the plan. It hired James Delaney as lamplighter at ten dollars per month.

May 22

1868—Wrecked and Shivered by Electric Fluid

Mr. Thomas Hopson owned a house on East Jefferson when a terrific thunderstorm struck Detroit. In the middle of the night, the sleeping house suddenly was hit by lightning that shivered (exploded) it to splinters; however, amazingly, it was reported that all six inhabitants in the house were uninjured. Lightning, referred to as "electric fluid," in 1868 entered the chimney and went down to the cellar, where it hit a stone wall, tearing out stones and mortar; up along joists, ripping out floors on the main and second stories; down the house frame to a parlor, bursting the castors off a piano and exploding a center table; and then up to the bedrooms. As the *Free Press* described the scene: "Every window was blown out, every inner and outer door was shivered, two stoves were blown to atoms...the front of the house was pulled several inches from the joist...the walls ablaze with little spots of lurid flames." Nicholas Hopson, the twenty-five-year-old son, awoke his sister, who was stunned and covered with fragments of the house, and then ran to his parents' bedroom where his father "stupefied by the shock was leaning against the wall, listlessly trying to extinguish the same spots of flames on the wall with his finger, as he groped his way along the wall...The house was illuminated by a weird blue light and the rain was beating through a breach made by the lightening."

May 23

1712—Start of the Fox Wars

According to a French report submitted by the Ministry of the Marine at Versailles in 1714:

> *In May of 1712 the Foxes began harassing the outnumbered Detroit French, Huron and Ottawa now under command of Jacque-Charles Renaud Debuisson…The Mascouten and Fox numbered more than a thousand, and the outlook for the thirty-man garrison and settlers was bleak. At this tense time an army of six hundred French-allied Indians arrived including Potawatomi, Ottawa, Illinois, and other Great Lakes nations. This force had just killed about a hundred Mascouten near the St. Joseph River and was prepared to attack the Detroit Mascouten and Fox…After a nineteen day siege, the allies defeated the Fox and Mascouten, killing a thousand of them in the process. Thus began the Fox Wars that were to plague the French in the upper country and Upper Illinois for more than twenty years.*

May 24

2015—Marcus Belgrave

On this day passed away one of Detroit's finest jazz musicians: Marcus Belgrave. Belgrave played trumpet and flugelhorn and worked with the biggest names in jazz and general music across the United States. Belgrave settled in Detroit in the early 1960s. He is considered the founding father of the Detroit jazz scene. He was tutored by Clifford Brown before joining the Ray Charles touring band. He later worked with Gunther Schuller, Carl Craig, Max Roach, Ella Fitzgerald, Charles Mingus, Tony Bennett, La Palabra, Sammy Davis Jr., Dizzy Gillespie and even John Sinclair, among others. Belgrave died in Ann Arbor of heart failure.

May 25

1887—Detroit's Early Dog Show

The Detroit dog show was deemed a huge success as 1,500 people attended each day held at the Light Guard Armory; the *Detroit Free Press* noted the "high standing of visitors to the armory, a large portion being among the most prominent of the city." The newspaper also pointed to the large number of ladies who attended and "took a deep interest in the dogs." Exhibitors came from all over the country while a few were from Detroit such as the Wolverine Kennel Club. Detroit had a large variety of dogs that were judged, including Newfoundlands, pointers, Great Danes, deerhounds and greyhounds, as well as many breeds of terriers, spaniels and pugs. The winner of the pugs was Bo Peep from Chicago. The show included other breeds not well known today, such as Ulmer Dogges and Russian retrievers (a Russian retriever named Sandy won "ugliest in show"). The winner for the most talented trick dog was Tony from Simcoe, Ontario, who "played the piano, lay down dead and did various jumping tricks to the delight of the spectators."

In 1900, Mr. and Mrs. Kern could be seen with their trick dog Bobbie. *Courtesy of the Library of Congress.*

May 26

1937—Battle of the Overpass

The Battle of the Overpass became a national sensation on this day. Walter Reuther, Robert Kantor, Richard Frankensteen and J.J. Kennedy, leaders of the United Auto Workers, handed out leaflets, which read, "Unionism, Not Fordism" at the pedestrian overpass of the River Rouge Plant. Luckily for the men and the union, a *Detroit News* photographer had asked them to pose for a picture on the overpass as they were distributing the leaflets with the Ford company sign in the background. While they were posing, men from Ford's Service Department, an internal security department estimated to be forty men under the direction of Harry Bennett, came from behind and began to beat them and other workers severely; one organizer had a broken back, and J.J. Kennedy died four months later from his wounds. It made the men famous overnight and supercharged the union and labor movement.

May 27

2000—Birth of the Detroit Electronic Music Festival

The techno festival was originally titled the Detroit Electronic Music Festival (DEMF) and was offered as a free event scheduled for May 27–29, 2000, at Hart Plaza. Detroit became internationally famous for this music when it began with high school friends Derrick May, Juan Atkins and Kevin Saunderson in Belleville back in the 1980s. The first DEMF featured "over 50 electronic music acts and deejays from Detroit and across the world." Influential Detroit artist/producer and Planet E label head Carl Craig organized the event with Pop Culture Media's Carole Marvin, who served as the Monteux Detroit Jazz festival for six years. They claimed the plan was to establish a festival of significance in the city that elevated techno to a worldwide phenomenon. Attendance surpassed expectations, with estimates over the three-day run surpassing one million. Subsequent festivals drew even bigger crowds and spread the word of Detroit around the world. City officials and others, including media observers and local businesses, saw the apparent economic boost to the city, with the Visitors and Convention Bureau stating that in only its second year, the event had pumped over $90 million into the local economy.

May 28

1957—Kirk Gibson Plays for Detroit

Kirk Gibson, "Gibby," was born on this day in Pontiac and grew up in Waterford. He rookied in 1980 and settled in to play right field for the Detroit Tigers from 1983 to 1987 and was critical to the Tigers winning the 1984 World Series against the San Diego Padres. In 1987, Gibson helped them win the American League East over the Blue Jays in an exciting divisional race. In the 1980s, Gibson was considered an all-around outstanding player offering both power and speed; he was able to hit home runs as well as steal bases. He finished in the top ten in home runs three times in his career and ranked in the top ten in stolen bases four times. Gibson was known for hitting home runs at critical times. Gibson later played for the Los Angeles Dodgers and was voted MVP in 1988.

May 29

1848—Lewis Cass Nominated to Run for President

Lewis Cass was nominated as the Democratic presidential candidate against Whig Zachary Taylor, a southern slave owner who at the time was a popular general who fought in the Mexican war. A third candidate from the Free Soil Party was Martin Van Buren. As a former territorial governor of the Northwest Territory and U.S. senator, Cass seemed a good choice for a presidential candidate; however, he was in his sixties, and many felt his best days were behind him. The country was already ripping in two: pro- or antislavery. Cass always felt the breakup of the United States and potential for civil war far worse than slavery. He was a politician who looked for compromises that would keep the country together. But it cost him the presidency as Zachary Taylor took the election.

May 30

1878—The Detroit Yacht Club

The club was officially established in 1878, as reported in the *Detroit Free Press* on May 31: "A meeting of yachtsmen was held...last evening when

The Detroit Yacht Club clubhouse was built in the 1920s in a Mediterranean-style villa and is the largest yacht club in the United States. *Photo by Barney Klein.*

the Detroit Yacht Club (DYC) was organized." By 1915, the club was attracting the smart set of Detroit, including senator and former mayor James Couzins, the Horace Dodge family, Ransom Olds, the Fisher brothers, Henry Ford, Edsel Ford, Charles Kettering and power boat racer Garfield Wood. The architectural style of the fifth DYC clubhouse was designed by George Mason as a beautiful terra-cotta "villa" called Spanish Mediterranean. It has ninety-six thousand square feet and four floors. The grand entrance still has the original revolving doors, which are now nearly one hundred years old.

May 31

2015—King Solomon Baptist Church

On this day, the King Solomon Baptist Church with a long and proud history of civil rights activism was placed on the National Register of Historic Places. Dr. Martin Luther King Jr., Elijah Muhammad, Thurgood Marshall, Reverend Ralph D. Abernathy and the Reverend Benjamin Mays have all spoken at King Solomon Baptist Church. It was where Malcolm X delivered his famous "Message to the Grass Roots" address in 1963 in which he denounced the peaceful civil rights movement. The church was built in 1917.

JUNE

June 1

2007—"Dying Is Not a Crime" Jack Kevorkian Released from Prison

On this day, Dr. Jack Kevorkian, aka "Dr. Death," was paroled from prison on the condition that he would not offer advice, participate or be present in the act of any type of suicide involving euthanasia. In all, Jack Kevorkian claimed he had helped 130 people die between 1990 and 1998. He developed devices that would allow a person to activate the euthanizing drugs or carbon monoxide gas, therefore committing suicide. (He named the machines the Thanatron [Death Machine] and later Mercitron [Mercy Machine].) He avoided detection by operating out of a van. In 1999, Kevorkian was arrested and tried for his direct role in a case of euthanasia. He was convicted of second-degree murder and served eight years of a ten- to twenty-five-year prison sentence because in a video he was shown to push the button that activated the machine, making him guilty of homicide.

June 2

2013—Jack White Saves Masonic Temple from Financial Ruin

Former White Stripes rocker Jack White gave to the venerable Detroit Masonic Temple in Detroit, donating $142,000 in back taxes to stop the music venue from going into foreclosure. White, a Detroit native, had close ties to the theater—his mother was once an usher there, and he himself has played nine concerts at the theater over the years (seven with the White

Stripes, two solo). The president of Detroit's Masonic Temple, Roger Sobran, commented, "Jack's donation could not have come at a better time, and we are eternally grateful to him for it. Jack's magnanimous generosity and unflinching loyalty to this historic building and his Detroit roots is appreciated beyond words."

June 3

1864—Ransom Eli Olds

Ransom E. Olds is considered by many to be the founder of the American automobile industry. He was the first to manufacture and sell cars in quantity. Where competitive car makers were selling fewer than 10 units a year, in 1900, Olds was cranking out 1,400 cars and by 1904 was up to 4,000. Olds was born on June 3, 1864, in Geneva, Ohio. People called him "R.E." In 1897, he received his patent for a gasoline-powered car and founded the Olds Motor Vehicle Company. He began his first plant in Lansing, but in 1899 he relocated from Lansing to Detroit, renaming his company the Olds Motor Works. Olds envisioned a small affordable automobile, good for city as well as the farm, which led him to develop and manufacture the legendary "Curved Dash" Oldsmobile, the first commercially successful car mass-produced on an assembly line in the United States. It sold for $650.

June 4

1798—Father Gabriel Richard Arrives in Detroit

Father Gabriel Richard arrived in Detroit on the Feast of Corpus Christi in June 1798 to be the assistant pastor at Ste. Anne's Church. In 1804, he opened a school in Detroit, but this was destroyed by the fire that leveled the city in 1805. Father Richard organized the shipment of food aid to the city from neighboring ribbon farms in order to alleviate a food crisis following the loss of the city's supply of livestock and grain. He had the first printing press in Detroit and published a periodical in the French language entitled *Essais du Michigan*. Together with Chief Justice Augustus B. Woodward and Reverend John Monteith Richard, he was a co-founder of the Catholepistemiad of Michigania (which would become the University

of Michigan), authorized by the legislature in 1817. He served as its vice-president from 1817 to 1821. He died of cholera attending to sick and dying Detroiters during the cholera epidemic of 1834. His remains are held today at Ste. Anne's Church in Detroit.

June 5

2000—DIA Hits It Big with Van Gough Exhibit

On this day, the Detroit Institute of Art's exhibit "Van Gogh: Face to Face" closed, breaking all previous records for public shows. It was declared a "blockbuster"—the largest money-making show in the DIA's 115-year history, attended by 308,000 visitors in twelve weeks. Museum membership was boosted by 10,000. The museum shop grossed over $2 million in sales. Food service broke all records, with sales over $1 million.

June 6

1893—Detroit's First Urban Farms

Hazen Pingree's potato patches saved immigrant groups from starvation in 1893 during a financial depression. *Courtesy of the Library of Congress.*

In 1893, Detroit and the rest of the United States suffered from a terrible financial depression that hit Polish immigrants especially hard; many faced starvation, and they burned furniture to keep from freezing in their homes. Mayor Hazen S. Pingree initiated his original idea of urban farming, turning vacant land into garden plots. Since many of the foreign immigrants were not far removed from peasant farms, Pingree thought they might take to raising their own food. Pingree took his idea to the churches to raise money for tools and seed. The Detroit newspapers mocked Pingree, and the big churches treated the idea with contempt. Undeterred, Pingree sold his prize horse at one-third of its worth to kick off the potato patch program and got

access to farm 430 acres of city land on this day. In 1894, 3,000 families applied to work plots, but there was only money for 945. In the first year, those families grew $14,000 worth of produce, so much there was a surplus. In 1895, enrollment to farm plots grew to 1,500 and in 1896 to more than 1,700. The value of produce exceeded $30,000, more than the outlay of the city poverty commission. It was an unquestionable success, and Pingree became a national hero.

June 7

1914—Truck Postcard System

In an attempt to show the city that motorized trucks and truck drivers were responsible on the road, the Motor Truck Association of America issued postcards to truck drivers on this day. When they saw reckless truck driving or abuse, they were to fill out the postcard and mail it in to the association. The information was not for the general public but for the owners of trucks who paid drivers to haul goods. The card reports were also shared with tire manufacturers who wanted to know the conditions their tires were subjected to. The idea was short-lived, as truck drivers did not warm to the idea of squealing on other truck drivers.

June 8

2013—Detroit River Cleans Up

On this day in 2013, Doug Haffner, the Canada research chair at the Great Lakes Institute for Environmental Research, said that the Detroit River was something researchers and scientists have been working on for decades. Fishermen and people living on houseboats on the river reported that the water of the Detroit River was getting clearer and that they were seeing more fish and other creatures. Audubon groups reported hundreds of bald eagles on the river, and at one location downriver, an osprey was reported nesting, the first reported sighting since 1898. Haffner was quoted in the CBC News: "The industries along the Detroit River have actually disconnected themselves from the river, so the discharges are now going to the waste water treatment plants," Haffner said. "We've seen

The Detroit River has been steadily cleaning up for over a decade. *Photo by Barney Klein.*

that the storm water overflows have been corrected; we've done things in terms of correcting toxic chemicals, in terms of the discharge of PCBs and mercury into the system."

June 9

1934—Jackie Wilson Is Born in Detroit

On June 9, Jackie Wilson was born in Detroit. He grew up in Highland Park, which was a tough neighborhood in the 1940s, and often found himself in trouble with gangs. He began singing at an early age, accompanying his mother to church; she was once a choir singer. In his early teens, Jackie joined a quartet, the Ever Ready Gospel Singers, which became a popular feature of churches in the area. His childhood was troubled by crime, eventually leading to two stays in the Lansing Correctional Institute and causing him to drop out of school at age fifteen. His real love was singing. He worked as a gospel and doo-wop performer, and Wilson's fame spread quickly after he after he decided to go solo. Songs such as "Reet Petite," "That's Why," "I'll Be Satisfied" and "Lonely Teardrops" were among the many successes that made Wilson known throughout the United States; he was at times referred to as the "Black Elvis." In 2013, Jackie Wilson was inducted into Rock and Roll Hall of Fame.

June 10

1897—Shriners Take Over Detroit

The Shriners held their annual convention in Detroit with 100,000 Shriners, wives, girlfriends and more taking over the city. As reported in the *Detroit Free Press*, "Red fezzes of the orient with their long silken tassels…will be in evidence this week…The occasion is the annual meeting of the Imperial Order of the Ancient Arabian Mystic Shrine which begins its sessions Tuesday." They overflowed the hotels and established headquarters for the Imperial Potentate Harrison Dingman at the Russell House Hotel. At the Russell House, the Texas delegates brought their "tarantula juice," delegates from Temple Zem Zem (Erie, Pennsylvania) poured out their "Zem Zem Spirits" and the Indiana temple offered its "Wabash Water." Mystic Shrine ladies also "drank of the limpid waters of mirth and ministrely [*sic*]" at the Empire Theatre as they watched the "Monster Trolley Party" clanging up Woodward Avenue. The "Army of Mystic Shriners" whooped it up on trolleys, steamboats, Belle Isle, the roof of the Majestic Building, hotel lobbies and even on the trains that brought them to Detroit. They brought camels and elephants for the parade to cross the burning sands of the streets of Detroit. Attendees from the Temple Murhat (Indianapolis) brought their own camel and dressed in red socks, blue trousers, carmine blouse, crimson fezzes and yellow Turkish slippers. "Accompanied by weird music and a discordant chorus of Egyptian like songs," revelers grabbed hold of long ropes and serpentined and careened through the lobbies of hotels in lines of drunken nobles.

June 11

1796—British Surrender Detroit

The British finally decided to surrender Detroit to the United States. Despite the Treaty of Paris, which ended the American War for Independence, the British chose to retain the Territory of Michigan until June 11, 1796, when General Anthony Wayne and an American army marched into Detroit. Sixty-five American troops entered Detroit to take control. The American flag was raised, and Detroit was officially part of the United States—at least until 1812, when the British recaptured the city for a year.

June 12

1836—A Visit by the Famous English Author Harriet Martineau

Harriet Martineau (1802–1876) was a successful English author when she decided to spend two years traveling in America. She wrote *Society in America* about her experiences, one of which was time spent in Detroit: "We landed at Detroit, from Lake Erie, at seven o'clock in the morning. We reached the American [hotel] just in time for breakfast. At that long table, I had the pleasure of seeing the healthiest set of faces that I had beheld since I left England. The breakfast was excellent, and we were served with much consideration."

June 13

1989—Detroit Pistons Win the NBA Finals

The Pistons had dominated the Eastern Conference, winning sixty-three games during the regular season. After sweeping the Boston Celtics and Milwaukee Bucks, the Pistons beat the Chicago Bulls in six games, earning a second straight trip to the NBA Finals. In the season before, the Lakers had beaten them in a tough, seven-game series; however, the Pistons won the series in a four-game sweep, marking the first time a team (Los Angeles Lakers) had swept the first three rounds of the playoffs only to be swept in the finals. For the players' rough physical play, and sometimes arrogant demeanor, Pistons center Bill Laimbeer nicknamed them the "Bad Boys." The name became an unofficial "slogan" for the Pistons throughout the next season as well. Pistons guard Joe Dumars was named MVP for the series.

June 14

2005—The International Freedom Festival

Fireworks would go on as scheduled after Mayor Kwame Kilpatrick announced on this day layoffs in the police, fire and homeland security departments would be postponed until after the July 12 Major League Baseball All-Star Game in Detroit. Kilpatrick, fighting with the city council over how to eliminate a $300 million budget deficit, had earlier threatened to

cancel the fireworks but held back, saying the fireworks show was important enough to staff at an optimal level; during last year's celebration, a gunman opened fire on a crowd of people, killing one and injuring eight. Detroiter Ronald Bass, sixty-seven, said he was looking forward to finding a spot on Belle Isle or Hart Plaza again. "It's really good news."

June 15

1840—Silkworms and Mulberry Trees

During this week in 1840, an advertisement ran in the Detroit newspapers: "Silkworms. A Great Curiosity. By calling at George Fowler's store at the corner of Atwater and Bates streets, may be seen over 5,000 thriving silkworms fed from the white mulberry trees raised in this city. They have already passed two stages of moulting. Admittance 12½ cents for the season, which will continue for four weeks. Children half price." Today, white mulberry trees still thriving in Detroit are a legacy to George Fowler.

June 16

1903—Ford Motor Company Founded

This day in 1903 was described as a humid, very warm Saturday night when forty-year-old Henry Ford with twelve original investors putting up $28,000 founded the Ford Motor Company, his third and finally successful

Henry Ford's Highland Park factory employed fifty thousand people by 1913. *Author's collection.*

car company. The historic meeting took place in the offices of Scottish-born Alexander Malcomson. Malcomson was a thirty-year-old coal dealer in Detroit. Henry Ford met Malcomson when he worked for the Edison Illuminating Company in Detroit, a job that required him to buy coal to power the electric turbines. Malcomson wanted to get into the motorcar business, and he and Ford became friends and, in 1902, formed a partnership. He put up $500 to help Ford develop a prototype.

June 17

1875—Fred Schmidt Founds Sanders Chocolates on Woodward Avenue
The company was founded by German-born Frederick Sanders Schmidt on June 17, 1875, when he opened a candy store on Woodward Avenue at Gratiot in downtown Detroit. Schmidt, who went by his middle name, had originally opened his first shop in Chicago but relocated to Detroit after his Chicago store was destroyed by fire in 1871. The Pavilion of Sweets, Sanders's most famed confectionary shop, opened on Woodward in 1891. It had a stunning red and white awning and tower. Fred Sanders, who was well liked and admired in his day, died in 1913, but his family continued the business. By 1939, Sanders had twenty-one stores in and around Detroit.

June 18

1964—Ted Nugent Rocks the Rosedale Park Clubhouse
Ted Nugent's family lived in North Rosedale Park. In summers, the "Motor City Madman" rocked out with the Lourds at the Rosedale Park Clubhouse. By the time Nugent was fourteen, he and the band had won a battle of the bands in Detroit and gotten to perform at Cobo Hall opening for the Supremes and Beau Brummels. Soon thereafter came national fame as the lead guitarist of the Amboy Dukes before embarking on a solo career and over thirty albums selling in the millions.

June 19

2003—Polish Catholic Churches in Detroit

On this day, church Sweetest Heart of Mary joined with St. Josephat and nearby Old St. Joseph Church to become the new Mother of Divine Mercy parish. Thaddeus Radzialowski wrote about three Detroit Catholic churches in an essay for the journal *Ethnicity*:

The Sweetest Heart of Mary—one of several Polish churches on Detroit's east side. During the economic depression of the 1890s, the church was being taken by the bank. Parishioners mortgaged their homes to buy it back at court auction. *Photo by Barney Klein.*

> *Along a short stretch of Canfield Street…stand three majestic Catholic Churches—Sweetest Heart of Mary, St. Albertus, and St. Josaphat…They stand as lonely symbols of the deep other worldy faith and worldly pride…of the Polish immigrants who built them. Like the medieval men they were in essence, the Poles adorned their communities with soaring Gothic churches of a kind that few peasant villages in Poland had ever known. They were status symbols of a country people who could now build their monuments bigger than those in the towns of the old country. Building funds for the churches were produced only at the cost of heroic and sometimes brutal sacrifices. During the [economic] depression of the 1890s, the parishioners of Sweetest Heart mortgaged their homes to buy back their church at a court auction…which was being sold to satisfy creditors. The Canfield churches stood as visible daily reminders that God had come with the immigrants on their long journey…They were the stone mortar roots which bound them to the soil of the new world.*

June 20

1921—DYC's Motorboat Racing Champion Gar Wood Wins Harmsworth Trophy on the Detroit River

Many of the trophies at the Detroit Yacht Club on Belle Isle were won by the DYC's most famous member and past commodore Gar Wood. Wood earned worldwide fame and established the DYC as a center for hydroplane boat racing that continues to this day when he won the prestigious Harmsworth Trophy, established in 1903. Wood won the trophy on the Detroit River in front of an estimated 400,000 spectators, driving *Miss America II* an average 59.0 miles per hour. Wood built nine more *Miss America*s and broke the record five times, raising it to 124.9 miles per hour in 1932 on the St. Clair River. He was the first person to surpass the 100 miles per hour mark in a boat. Gar Wood died in Miami at the age of ninety and is buried in Algonac, Michigan.

June 21

1943—Race Riot on Belle Isle Bridge

Confrontation between black and white youths started on June 20, 1943, on a Sunday evening on Belle Isle Bridge. A fistfight broke out when a white sailor's girlfriend was insulted by a black man. The brawl eventually grew into a mob fight between groups of blacks and whites and spread across the city. The riot escalated and went for three days until Federal Troops were called in to stop it. The riot resulted in killing 34, wounding 433 and destroying property valued at $2 million (over $27 million in 2015).

June 22

1898—Michigan Men Invade Cuba in the Spanish-American War

General William Rufus Shafter (hero of the Civil War from Galesburg, Michigan) was given orders to move his army from Tampa to Cuba with a force of seventeen thousand. That army included two divisions from Michigan: the Thirty-third and Thirty-fourth Battalions, including many Detroit soldiers. After conferring with Cuban allies, Shafter selected a beach

and small village called Daiquiri fourteen miles east of Santiago, which was the ultimate prize to capture. On this day, the Americans invaded. Coordination was poor; the transport ships were privately owned but leased by the navy. Owners of the transports refused to endanger their ships by bringing them too close to an iron pier that was at the beach because the surf was too rough, so the army took forty long boats filled with armed soldiers, linked them in long strings and then towed them to the shore by steam-powered motor launches. Boats capsized. Some, overloaded with artillery, sank. As the long boats bounced in the surf, Sampson began the bombardment of the bluffs and blockhouse above the beach. The landing took two days. However, it was considered a success.

June 23

1963—Dr. Martin Luther King in Detroit

"So I go back to the South not in despair. I go back to the South not with a feeling that we are caught in a dark dungeon that will never lead to a way out. I go back believing that the new day is coming. And so, this afternoon I have a dream." It was June 23, 1963, when the Reverend Dr. Martin Luther King Jr. came to Detroit to lead the "Walk to Freedom," a civil rights march of thousands down Woodward Avenue, and he delivered a speech with what would become his most famous words: "I have a dream." The speech came two months before the historic March on Washington. At the time, it was the largest civil rights demonstration in the United States: 125,000 people marched down Woodward Avenue. Along with King were UAW president Walter Reuther, Ralph Abernathy and Andrew Young, as well as other local notables who included Reverend Nicholas

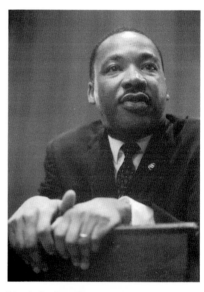

Martin Luther King at a press conference in 1963. *Courtesy of the Library of Congress.*

Hood, Detroit mayor Jerome Cavanaugh and activist Grace Lee Boggs. When King arrived in Detroit, police commissioner George Edwards met him at his plane and said, "You'll see no dogs and fire hoses here."

June 24

1962—Longest Tigers Game in History

The Detroit Tigers and the New York Yankees played the longest baseball game in Tiger history at Tiger Stadium. On Sunday, June 24, 1962, 35,368 fans watched the Detroit Tigers and the New York Yankees play a game that began at 1:31 p.m. and lasted seven hours, going through twenty-two-innings. Finally, a two-run homer in the top of the twenty-second inning allowed the Yankees to beat the Tigers 9 to 7.

June 25

1953—Al Kaline Makes Debut with Detroit Tigers

On June 25, 1953, Albert William "Al" Kaline made his debut appearance in the major leagues as an eighteen-year-old Detroit Tiger in Philadelphia, coming right from high school. Kaline was sent in as a late inning replacement for Jim Desling. He started his career as a Tiger wearing number 25 but asked a teammate for his number 6 after the 1953 season ended. Kaline wore the number for the rest of his major-league playing career. He is known as Mr. Tiger and still works in the Detroit Tigers offices as an advisor. By the age of twenty, Kaline was hitting a .340 batting average. On September 24, 1974, Kaline became the twelfth player in MLB history to make three thousand hits; he hit a double off the Orioles' Dave McNally. He won ten Golden Glove awards for defense play and was selected for the All Star game eighteen times; he was picked every year from 1955 to 1967. His final game was on October 2, 1974. He had played for twenty years in the outfield, mainly right field, although in his later years he played first base and was designated hitter in his final year. Kaline was elected to the Baseball Hall of Fame in 1980, becoming the tenth player in history to be inducted in his first year of eligibility.

June 26

1875—The "Remorseless Monster" of 1875

They were Germans new to Detroit and thought it was a column of "inky black" coal smoke, "rolling over like coal smoke from the smokestack of a tugboat," coming toward them on an August afternoon. But it was coming unusually fast and spinning, and then they noticed flecks of debris spinning in it as well; they'd never heard of a tornado. The greatest destruction was south of Grand River Avenue, basically a German neighborhood, where it touched down with a path that was measured at 150 feet wide. It was reported that rows of houses were taken high up in the air, burst into fragments and scattered across a mile-wide territory. Some house timbers were found two miles away. Everywhere were heard the cries of the wounded. One eleven-year-old boy named Richard Bates was "caught up in the wind" and flung to the top of a 50-foot elm tree. The violent contact with the tree tore the clothing from his body, and he fell the 50 feet to the ground, dead. The difference between a tornado in 2015 and a tornado in 1868 is that there were no warning systems for tornados (called "whirlwinds"); many families were in the middle of dinner when they felt themselves getting sucked out a window. Ten died and fifty people were seriously injured, taken to Harper Hospital. Thirty-three homes were destroyed entirely with nearly fifty damaged.

June 27

2015—Grace Lee Boggs Turns One Hundred

Grace Lee Boggs, Chinese American philosopher, writer and activist, lives in Detroit and on this day turned one hundred years old. For over seventy years, Grace Lee Boggs has been involved with every progressive rights movement in the United States, devoting her life to labor and civil rights, rights of African Americans, feminism, issues of Asian Americans and environmental justice. Her 100th birthday was celebrated at the Detroit Wright Museum of African American History with hundreds of friends and admirers.

June 28

1921—The Detroit River in the 1920s

On this day in 1921, the Polk directory called *Detroit Today* stated, "More tonnage passes through the Detroit River than through Panama, Suez, Long Island Sound, the Seine, the Thames, the Volga, and the Mississippi—combined." On the passenger side, in 1918, Detroit hosted twelve million passengers on steamers, which was more than three times the number from all Great Lakes ports in total.

June 29

1990—Mandela's Eighteen Hours in Detroit

Mandela's visit to the United States was intended to raise funds for the African National Congress, his political party in South Africa. He would visit eight cities on his U.S. tour, but one had to be Detroit. The *Detroit Free Press* quoted the Reverend Jesse Jackson, who explained Mandela's desire to see Detroit: "It's the home of Joe Louis, and Nelson Mandela has always admired Joe Louis…He's also always wanted to see Rosa Parks, and she is here. And the real base of the struggle is the labor unions." On top of that, his then wife, Winnie, wanted to meet Aretha Franklin. Mandela was greeted by Mayor Coleman Young, Governor James Blanchard and his wife, UAW president Owen Bieber and many more; however, Mandela was most exuberant when he saw Rosa Parks, who was seventy-seven years old at the time. On this day, forty-nine thousand filled Tiger Stadium to honor Mandela, and at one point, he told the crowd that he listened to Detroit's Motown music while a prisoner in South Africa. (He called it "Motortown.") He ended by saying, "In the face of your own problems and difficulties, you have not forgotten us." Mandela wiped his face with a white handkerchief. "Thank you," he said, "for being with us when we need you most."

June 30

1953—Chevy Corvette Goes into Production

The first production of a Chevy Corvette was on June 30, 1953. The first-generation Corvette was introduced late in the 1953 model year. The first model was a convertible. Three hundred Corvettes were handmade, available in one color: polo white. It was designed by the head of GM Design Harvey Earl and named by Myron Scott after a small, highly maneuverable battle ship. During the design phase, the car was referred to as "Project Opel." The car has been through seven generations since then.

Louis Chevrolet started out as a Swiss bicycle and then auto racer but later lent his name for General Motors Company to develop an inexpensive car to compete with Ford's Model T. *Courtesy of the Library of Congress.*

JULY

July 1

1976—Tower One of Ren Cen Opens for Business

Ford, Chrysler and General Motors faltered during the oil crisis of the 1970s. The Detroit riots of three years earlier also were not helping the business environment in the city. Ford Motor chairman Henry Ford II believed that the Detroit car manufacturers and other city industrial companies could pool their resources and build Detroit out of its economic spiral. Ford's original design proposed to Detroit City Council called for fifteen towers and nearly one thousand residential units covering roughly thirty-three acres at a cost of more than $500 million. The Renaissance Center is the tallest building in the city and the state (727 feet) since 1977 and the 101st-tallest building in the United States.

Henry Ford II and other business leaders hoped the Renaissance Center would improve Detroit's image for business. The first tower opened in 1976. *Photo by Barney Klein.*

July 2

1833—Captain Chelsea Blake of the Steamer Michigan

The steamer *Michigan* was the largest steamer on the Great Lakes in 1833. The boat held five hundred passengers and their covered wagons and oxen or draft horses. The *Michigan* was captained by Chelsea Blake, who was described as a "giant of a man, a hero in battle (the Battle of Lundy's Lane in the War of 1812) and whose voice was like a trumpet." He was considered the best rough-water steamer captain on the lakes. Blake had worked for Oliver Newberry in Detroit since 1818. In 1849, cholera was prevalent at nearly all the lake ports, and many deaths occurred on ships. Blake was among those who died. He was taken with cholera onboard the steamer *St. Louis*, on its trip up to Chicago while on Lake Michigan.

July 3

1904—First Monkey Driving a Motorcar in Detroit

Charles B. King was the first man to drive a gasoline-powered vehicle in Detroit, but who was the first monkey to do so? It was Monk Parry of the Gentry Brothers animal show, held in 1904 at Brush and Alexandrine Streets. At every show, Monk "looped the loop," which the papers were quick to add was a large loop, not a miniature one. Apparently, Monk had regular accidents with this trick but did not seem to mind, as the *Detroit Free Press* added he seemed "not to be at all afraid and looks forward to the ride and the subsequent applause with apparent pleasure. Other acts included a high-diving dog named Steve Brody.

July 4

1818—Fourth of July on Lewis Cass's Farm

From the very start, the Fourth was honored with parades and bonfires. One city historian, George Caitlin, wrote in his book *The Story of Detroit* that early Fourth of July celebrations in 1818 took place behind Lewis Cass's house on the farm fields. The day included prayers, military marches, a reading of the Declaration of Independence, bonfires, dinners and an

oration; for many years, respected lawyer and mayor of Detroit James Van Dyke gave the oration referred to as the "spread eagle" speech. Launching anvils with gunpowder was always a favorite. Anvils' hollow bases were filled with gunpowder that could shoot an iron anvil one hundred feet or more into the air.

July 5

1865—James Vernor Invents His Famous Soft Drink

The origins of Vernors Ginger Ale are a bit cloudy. James Vernor was a clerk at a pharmacy called Higby and Sterns in Detroit. He experimented with flavors, such as ginger and vanilla, hoping to duplicate a ginger ale imported from Ireland. When Vernor was called to fight in the Civil War, he stored the ingredients in an oak cask. Vernor was discharged on July 1, 1865, and returned to the drugstore a few days later. He opened the cask to find that after four years the oak in the keg had mellowed the ingredients and produced a taste he declared was "deliciously different!" So he now had a soft drink and a drink motto! Vernor opened his own drugstore on Woodward at Clifford Street and sold Vernors Ginger Ale at a soda fountain. Much later, this story of the origins of Vernors Ginger Ale was debunked by James Vernor Jr., who admitted his father developed the formula after the Civil War, making the Vernors registered trademark date 1880 not 1865.

July 6

1881—City Council Approves Funding for Detroit's First Dog Wagon

Two people a day were bitten by dogs, many of them children. On top of this, there was near-panic-level fear of rabies and hydrophobia as people on a regular basis reported "mad dogs." The newspapers even referred to a "mad dog season," which was late summer. In 1881, the city council funded a dog wagon, which was a horse-drawn wagon with a cage for a dog catcher to hold strays and bring them to the dog pound. Dog catchers were generally loathed. At one point, they were paid by the dog, and people claimed the dog catcher would whistle or call for people's pets and then lock them in the dog wagon. People had to pay to get their

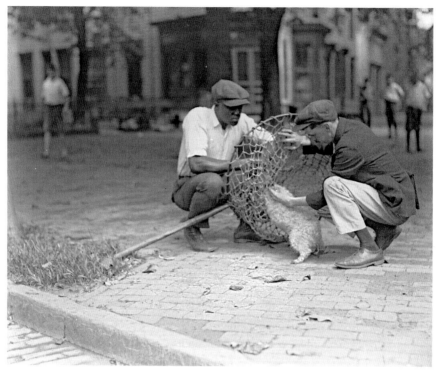

A dog catcher at work in 1924. *Courtesy of the Library of Congress.*

dogs back. Some reported that dog catchers snipped off licenses to take a dog into the pound. Unscrupulous dog catchers would catch popular purebreds, like collies, and sell them on the side. Besides being bitten by dogs, dog catchers were chased by mobs, harassed and stoned by street boys and threatened by women who claimed their pets were stolen.

July 7

1883—Detroit's First City Zoo

The first Detroit Zoo opened its gates on July 7, 1883. It was located at Michigan Avenue and Tenth Street and covered about two acres south of Michigan Avenue to Church Street. Entrance to the zoo was through a brick building on Michigan Avenue that held the offices of the company that owned it (the zoo was a private enterprise) for the superintendent,

managers and keepers. There was an aquarium and aviary, and behind those were sheds and cages for animals. They surrounded a small lake with a pagoda for the band to play music several days a week. Animals included a colony of monkeys, two black bears, a jaguar, a hyena, a "superb silver lioness," a fat-tailed sheep, a lion named Duke (who killed three people and aches to kill more), an elk, two cape buffalo, an Indian deer, a Yak named Mollie, a thirteen-foot-long boa constrictor, a fox, a badger, Muscovy ducks, coons and a pair of camels.

July 8

1915—Detroit Declares War on Rats

As Detroit grew more crowded at the turn of the century, rats went from being a vile nuisance to becoming a real public health threat, an embarrassment for hotels and restaurants and a source of expensive loss of business, as they ate through warehouses and anything stored. In one horse stable, it was reported in the newspapers of 1910, "Recently a hostler [stable worker] was forking hay in one of the barns. There were five tines on his [pitch] fork. In the operation of forking the hostler landed a full grown rat on each tine. That made five rats impaled in one nonchalant sweep." On this day in 1915, Detroit manufacturers invited the "Pied Piper" of rat extermination to plan an attack. He was Professor Louis Hirsch from Heidelberg, Germany. He claimed he could not only exterminate rats but also tame the wildest rat within moments. (It is not explained why he would want to do that.) He failed. The new citywide slogan was "Death on Rats" by the health reformers. Nothing worked until they learned to keep buildings and areas clean.

July 9

1942—Max Stephan of Detroit Is Guilty of Treason

A German prisoner of war, Oberleutnant Hans Peter Krug, escaped from a prison in Bowmanville, Ontario, and came to Detroit in 1942. Through prior contacts, Krug met up with an American Nazi sympathizer named Max Stephan, a restaurant owner and leader in Detroit's German

community. Stephan gave the Nazi POW a several-day tour of Detroit's evening entertainment spots and then sent him by bus to Chicago. Convicted of aiding and abetting the enemy in wartime, Stephan was the first American sentenced to execution since George Washington's administration. On this day, seven hours before Stephan was to hang, President Franklin Roosevelt commuted Stephan's sentence to life in prison, where he remained until he died in 1952. Decades after Krug returned to life in Germany, in an interview, he claimed Max Stephan was a bumbling idiot but Detroit was "exciting."

July 10

2008—Demolition in Full Swing

On this day, a steady flow of onlookers streamed by the corner of Trumbull and Michigan Avenues as huge chunks cement walls of the former Tiger Stadium were destroyed. The stadium had been empty since the Tigers left for Comerica Park after the 1999 season. In the years since, the ballpark sat in limbo as politicians, developers and preservationists struggled to find the right way to deal with the venerable structure. By 1:30 p.m., the demolition was moving along steadily. Many surrounded the stadium, documenting the moment with video cameras and camera phones.

July 11

1805—The Great Fire

On this day, a fire broke out at a careless baker's house. John Harvey, the village baker, harnessed his pony to drive to the mill for the next day's supply of flour. As he mounted the cart, he stopped to knock the ashes from his pipe. The wind caught the ashes and whirled them back through the open door of the shed and into a pile of hay. The fire quickly spread throughout the small village of Detroit, at the time about six hundred souls. Everything burned, including a new school started less than a year before by Father Gabriel Richard of Ste. Anne's Church. Mercifully, no one was killed. Father Richard quickly ordered nearby French farmers to bring canoes of food to prevent starvation. This is also

when Father Richard wrote the city of Detroit's motto: *Speramus meliora; resurget cineribus*—in English, "We hope for better things; it will arise from the ashes."

July 12

1832—Cholera Finds Detroit

"We are obliged to announce to our readers that spasmodic cholera has made its appearance in this city. As might be expected, the prevalence of such a malignant disease among us has produced very general alarm among our citizens." July 12, 1832, saw the first of several cholera epidemics rage across Detroit and the rest of the nation. A second, more virulent outbreak occurred in 1834, and there were additional occurrences in 1849 and 1854. In 1832, 7 percent of Detroit died of cholera. No one had any real idea what caused cholera at the time, but it was believed it was encouraged by intemperate living; any excessive behavior (especially drunkenness) could leave you open to the disease. We now know it is bacteria that invade the digestive tract causing severe diarrhea and vomiting, killing 50 percent of infected people within hours.

July 13

1921—Movie on Citizenship for Women's Vote

On this day, the Women's Citizens League president Mrs. Alexander MacDonald put out an invitation to all Detroit women to meet at the Twentieth Century Club to watch a movie called *Women's Problem* made by the All Star Film Company on the importance of voting responsibly. All U.S. women had won the right to vote a year earlier when the U.S. Senate passed the Nineteenth Amendment to the U.S. Constitution, which prohibited sex-based restrictions on voting and was ratified by sufficient states in 1920.

July 14

1974—"Panic in Detroit" by David Bowie

"Panic in Detroit" was written by David Bowie for the album *Aladdin Sane* in 1973, and on this day in 1974, Bowie released a live version of the song. Bowie based it on friend Iggy Pop's descriptions of revolutionaries he had known as a youth in Michigan. It is also interpreted as being written about the 1967 Detroit riots. Musically, "Panic in Detroit" has been described as a "salsa variation on the Bo Diddley beat."

July 15

1966—Greektown

Greektown began as a German neighborhood and then became home for Greeks, but by the 1920s, the area was becoming primarily a Greek commercial section. Greek residents began moving out while the restaurants, stores and coffeehouses remained. Realizing the culturally significant neighborhood was at risk, Detroit's Greek leaders banded together. With the help of the mayor's office, the streetscape and building exteriors were improved, and additional street lighting was installed. The neighborhood threw a Greek festival in 1966, timed to coincide with Fourth of July celebrations. The festival was a success and was continued for years until turnout grew too large. By that time, Greektown was firmly established in Detroit. The Greektown Historic District was listed on the National Register of Historic Places in 1982.

July 16

1778—Doctor Marries

On this day in 1760, Detroit doctor and part-time farmer George Christian Anthon, originally from England, came to Detroit in his twenties. Much later, at age forty-two, he married his ward Genevieve Jadot, who was fifteen years of age. Family tradition had it that she was still playing with dolls when she was married. He lived to the age of eighty-one. They had nine children; three who survived him became doctors. Anthon Street in Detroit was named after him in 1887.

July 17

1980—Republican National Convention Ends

The 1980 National Convention of the Republican Party of the United States convened at Joe Louis Arena from July 14 to July 17. The Republican National Convention nominated former governor Ronald W. Reagan of California for president and former congressman George H.W. Bush of Texas for vice president. Reagan stayed in the Renaissance Center, at the time the world's tallest hotel, and delivered his acceptance speech at Joe Louis Arena. Other candidates at the time included Jack Kemp, Jesse Helm and Guy Vander Jack from Michigan. During the convention, the possibility of choosing former president Gerald Ford as the vice presidential nominee was given at least some consideration. On ballot as an Independent candidate was John Anderson from Illinois.

July 18

2013—Detroit Files for Bankruptcy

The bankruptcy was filed with the United States Bankruptcy Court, Eastern Michigan District by emergency manager Kevyn Orr and approved by Michigan governor Rick Snyder. Snyder has said that 38 percent of the city's budget is being spent on "legacy costs," such as pensions and debt service. He said police take almost an hour to respond to calls, compared to a national average of eleven minutes, and that 40 percent of streetlights in the city are turned off. "Does anybody think it's OK to have forty-year-old trees growing through the roofs of dilapidated houses?" Orr asked.

July 19

1858—Detroit Wife Ensnared in Free Love Sect

On this day in July 1858, a Detroit man in his twenties reported to a Detroit judge, Justice Purdy, that his wife had been missing for two days. She was young and pretty, and he had no reason to suspect she was unhappy with him. The judge ordered city constables to search for the woman, but they turned up nothing. The judge advised the young man to go home and wait;

something would turn up. It did. In a few days, he returned to Justice Purdy and said one of his wife's relatives told him his wife went with her cousin to a notorious resort called the "Free Love Institution" at Berlin Hill in Erie, Pennsylvania. The young man hurried to Berlin Hill to save his wife and bring her home, prepared to shed blood if he had to. "This place," the husband was told, "is inhabited by a colony of persons who live in the enjoyment of promiscuous intercourse among the sexes giving free license to sensuality and delusions and claiming to cure all bodily and spiritual ills with what they call the 'love cure.'" The young wife found the "love cure" "degrading and loathsome" and renounced her cousin. The husband took her back to his heart and then on to Detroit, "notwithstanding her moral and physical contamination…a shame stricken wiser wife and mother."

July 20

1831—Alexis de Tocqueville Arrives in Detroit

Alexis de Tocqueville, the famous author of the classic work *Democracy in America* traveled to the United States with Gustave de Beaumont in 1831. Their official assigned mission was to study the penitentiary system in the United States, but they traveled and observed much more. De Tocqueville, in going to Michigan, thought he was visiting the "utmost limits of European civilization." De Tocqueville's journal entry as he neared Detroit read, "We arrived at Detroit at 4 o'clock. A fine American village. Many French names on the houses; French bonnets."

July 21

2006—Lindell AC Is Torn Down

The days when athletes used to frequent local sports bars and mingle with the fans stopped some time ago, but it was common at the Lindell AC for fifty-two years. The legend was owned by Johnny Butzicaras, who was eighty-two when he turned out the lights. It opened in 1949 and became a museum of Detroit sports with bronzed jockstraps proudly displayed among walls of photos, mitts, hockey sticks, bats and footballs. It was the place where Detroit Tigers players squeezed behind the bar and gave out free

drinks to customers on the raucous evening the team clinched the 1968 pennant. Montreal Canadian goalie Gump Worsley ("the Gumper") would sit at the bar before games while Lindell AC regulars would buy him drinks hoping to get him cockeyed before going on the ice at Olympia to face the Red Wings. It never worked. It was where former Lion Alex Karras, a one-time part-owner of the bar, was found guilty of taking illegal bets on football games with Green Bay Packer Paul Horning. *USA Today* once awarded it the title of "number one sports bar in America." The "AC" (Athletic Club) got tacked onto the name Lindell thanks to the late *Detroit News* columnist Doc Greene, who was a regular drinking patron; it was a reference to the exclusive and highbrow "Detroit Athletic Club" a few blocks away. The building was torn down on the weekend of July 21, 2006, to make way for the Rosa Parks Transit Center.

July 22

1905—Penobscot Building Annex

The original Penobscot Building opened on July 22, 1905. In the lobby, a portrait of the lumberman and businessman from Maine who financed the original building, Simon J. Murphy, was prominently displayed. Another addition, called the Penobscot Building Annex or "New Penobscot Building," was added in 1916. The final, towering building was designed in the Art Deco style of the Roaring Twenties by Detroit architect Wirt Rowland of Smith, Hinchman and Grylls in 1928. All three buildings together are referred to as the Penobscot Block. The building was named by the Murphy family after the Penobscots, a Native American tribe in Maine where Simon

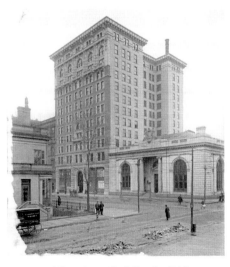

The "new" Penobscot building in 1916, later to be towered over by the well-known Penobscot Tower of 1928. *Courtesy of the Library of Congress.*

J. Murphy made his fortune in lumber. The Penobscot tribe of Native Americans is represented in motifs of the Art Deco–style ornamentation used on the exterior and the interiors.

July 23

1967—'67 Riots

The 1967 Riots, also known as the Twelfth Street Riots, or the "Rebellion," began on a Saturday night in the early morning hours on this day. The triggering event was a police raid of an unlicensed, after-hours bar (a blind pig) on the corner of Twelfth (today Rosa Parks Boulevard) and Clairmount Streets on the city's Near West Side. Those police confrontations with people in the bar and on the street evolved into one of the deadliest and most destructive riots in U.S. history, lasting five days. To help end the disturbance, Governor George Romney ordered the Michigan National Guard into Detroit, and President Lyndon Johnson sent in U.S. Army troops. The result was 43 dead, 1,189 injured, over 7,200 arrests and more than two thousand buildings destroyed; some residents stood on their roofs with garden hoses to prevent fire from spreading to their homes. Destroyed property was fenced off with crude boards painted white, some of which stood as a reminder of the riots for many years.

July 24

1701—Founding of Detroit

Over three hundred years ago, on the evening of July 24, 1701, twenty-five large bark canoes lay along the quiet, wooded shoreline of the Detroit River. The canoes belonged to Antoine de la Mothe de Cadillac, who planned to establish a new post for France in the area. The group numbered one hundred men and, in smaller canoes, a number of Indians who accompanied the French as interpreters and guides. The land from the riverbank to what is now Jefferson Avenue rose sharply up forty feet. It was at the top that the party of French lit campfires. The evening was said to have been very warm. There were fifty soldiers in blue uniforms and fifty voyageurs and settlers. They cleared the area enough to lay blankets and make their beds. All about

was silent wilderness broken by the soughing of trees in the wind, hum of mosquitoes and call of night birds. Sentries, both French and Indian, listened and watched because the English at Albany, New York, might have learned of their plan and, with allied Iroquois, might attack the camp, but things remained quiet as fires burned down in what would be the first night in the city of Detroit.

July 25

2011—Paul McCartney and the Motown Piano

Paul McCartney has always been a huge fan of Motown and even recorded a few Motown classics with the Beatles in the early '60s. So when he was in Detroit on this day for a concert at Comerica Park, he and his fiancée slipped over to the Motown Historical Museum on Grand Boulevard for a private tour of the old recording studios. While going through one of the studios, McCartney was told a piano with a rich history in Detroit music was no longer playable. It was a nine-foot 1877 Steinway grand piano. He decided something had to be done, so he helped fund the restoration of the piano. Steinway & Sons restored the piano in the same New York factory where it was originally built, and Steinway technicians reassembled the piano in the museum in April 2013.

July 26

1770—French Wedding Feast

On this day at Ste. Anne's, a contract of marriage was drawn between Monsieur John Baptist Cicot and Mademoiselle Angelique Poupart La Fleur—solemn business if for no other reason than there was no such thing as divorce. After the ceremony, the wedding feast began at the home of the bride. French Canadian Detroit historian Marie Carrie W. Hamlin described the feast in a presentation in 1878:

> [After dancing] *coup d'appetit was passed around, brandy for the gentlemen, some mild cordial for the ladies; then followed the repast. Soup poissons blanc (whitefish soup); poisson doree (pickerel), pike, roast pig*

with potatoes, blood pudding, partriges, wild turkey, ragouts, venison larded, pate of pomme terre (a potato dish), sagamite (ground corn with maple syrup)…omelet soufflé (floating island dessert), in summer—grapes, pears, and raspberries, and coffee ended the feast.

July 27

1882—Bad Streets

In 1882, four streets were paved with brick and asphalt: Jefferson, Lafayette, Second and Cass. Other streets, like Grand River or Woodward, were made up of cedar block, paving material that first appeared in 1836. This pavement had been a nuisance for at least ten years. The *Detroit Journal* reported on this day that the streets were "150 miles of rotting, rutted, lumpy, dilapidated paving." In summer, sections of streets oozed pitch and resin and occasionally caught fire from discarded cigar butts.

July 28

1833—Oliver Newbury

Travel by steamship on a day such as July 28 on the Great Lakes was flourishing in 1833. During that year, there were ninety steamboat arrivals at Detroit a month, each one jammed with passengers for Michigan and the West; steamboat owners like Oliver Newberry earned from 70 to 80 percent on the cost of their vessels. Newberry financed many of the Great Lakes ships. He was nicknamed the "Commodore." After fighting in the War of 1812, Newberry began business in Detroit as a supplier for U.S. Army forts and Indian trading posts of the Upper Lakes. However, since he was unable to find ships for his goods, he was forced to build his own. This made him a lot of money, so he stayed with ship building. In time, Newberry became owner of the largest fleet on the lakes and the largest warehouse. But he was an eccentric bachelor. He let his hair grow long and kept all of his receipts and important papers in his tall top hat and when required would simply reach in to find what he wanted.

July 29

1909—Cadillac and Henry M. Leland

Henry Martyn Leland began his career as an engineer and precision machinist in the armaments and firearms industry; Leland's apprenticeship during the Civil War imprinted on him the necessity for precision parts. Leland's beliefs became the Cadillac Automobile Company's motto: "Craftsmanship a creed, accuracy a law." Leland's reverence for precision parts was recognized in the summer of 1908 when Cadillac became the first American car company to win the prestigious Dewar Trophy in England. The test was described by the *Detroit Free Press*: "The conditions surrounding this test were not only unusual but most drastic and severe. Three Cadillac cars were then dismantled piece by piece and part by part, then thrown into a heap…With the committee maintaining a watchful scrutiny the work of rebuilding the three cars was begun. Not a file or piece of sandpaper was allowed to be used in assembly." All ran perfectly. The Royal Automotive Club was astounded. Leland retired in 1917 but soon began a new auto company, Lincoln Motors, which Ford purchased in 1922. If that were not enough glory for one man, he went on to invent electric barber clippers.

July 30

1975—Jimmy Hoffa "Disappears" at Machus Red Fox Restaurant

James Riddle "Jimmy" Hoffa was the leader of the International Brotherhood of Teamsters (the Teamsters) who vanished sometime after 2:45 p.m. on July 30, 1975, at age sixty-two. He is widely believed to have been murdered by the Mafia. According to what he had told others, he was to meet there two mob leaders: Tony Giacalone and Tony Provenzano. When Hoffa did not return home that evening, his wife reported him missing. Extensive investigations into the disappearance began immediately and continued over the next several years by several law enforcement groups, including the Federal Bureau of Investigation. The investigations found nothing. For their part, Giacalone and Provenzano were nowhere near the restaurant that afternoon. Hoffa was declared legally dead in 1982. After forty years, nearly two thousand

theories, books, movies, television investigations and more have been put forth on what happened to Jimmy Hoffa. Still, his disappearance remains unsolved.

July 31

1763—The Battle of Bloody Run

The Battle of Bloody Run was an attempt by about 260 British soldiers to surprise attack Pontiac's Indian forces at night and break their siege of Fort Detroit. It was the fiercest battle during Pontiac's war with the British. The British were led by Captain James Dalyell and the famous Royal American frontier fighter Robert Rogers. Either through a traitor or carelessness of the officers, the secret plans became known to the French, who hated the British as much as the famous Indian leader Pontiac. On the moonless night of July 31, the British silently marched out of the fort and down the river road heading east. Their movements were continually followed by Pontiac's hidden scouts. At Parent's Creek, about two miles from the fort along what is today East Jefferson Avenue, the British were crossing a bridge when three hundred of Pontiac's forces, unseen from the dark, attacked. The soldiers were driven into a panic, as men were hemmed in from all sides; twenty died and thirty-four were wounded. The creek ran red with blood, hence the name of the skirmish, Bloody Run. A large Cottonwood tree alongside the creek became famous as Pontiac's Tree, a silent marker of the battle. It is said that through the heroic leadership of Dalyell, who was killed in the attack, the British avoided a complete slaughter by retreating back to the fort.

AUGUST

August 1

1928—Detroit Zoo Opens

Detroit Zoo opened in Royal Oak to the public on August 1. Habitats included bear dens, lion dens, the bird house, an elk yard, raccoon and wolverine habitats, African veldt and completely stocked lakes. The zoo closed on December 3 for the winter, having entertained 1.5 million visitors in its first four months.

August 2

1838—Mrs. Jameson in Detroit

A famous English novelist of the day, Mrs. Anna Brownell Jameson, visited Detroit in 1838 and wrote these observations as she crossed the Detroit River by ferry to Windsor:

> *A pretty little steamer, gaily painted, with streamers flying, and shaded by an awning, is continually passing and re-passing from shore to shore. I have sometimes sat in this ferry-boat for a couple of hours together...amused, meantime, by the variety and conversation of the passengers, English emigrants, and French Canadians; brisk Americans; dark, sad-looking Indians folded in their blankets; farmers, storekeepers, speculators in wheat; artisans; trim girls with black eyes and short petticoats, speaking a Norman* patois, *and bring baskets of fruit to the Detroit market.*

August 3

1906—Gypsy Queen in Detroit

On this day in 1906, out Michigan Avenue a troop of gypsies made their camp, as described by the *Detroit Free Press*: "Way back from the road you catch a glimpse of their white tents among the trees…blue smoke curling lazily from their camp…and the gleam of their red painted wagons." Among them was a real gypsy queen, Queen Stella. Although the reporter was expecting a haughty, scowling woman, he found a kindly lady who held out ring-laden hands in welcome. She was bronzed skin with raven black hair, medium height and had flashing black eyes. She claimed to descend from the Pharaohs of old. She had wandered across every country under the sun and in 1906 held maternal dominion over twenty-four heads of tribes scattered across America and received tribute from them.

August 4

1908—Detroit's Internationally Admired Playwright Dies

Bronson Howard was born in Detroit in 1842. Although mostly forgotten today, Howard was the author of successful comedies and dramas about life in the United States and was the founder-president of the first society for playwrights (the Prismatic Club) in the United States at a time when

Detroit-born Bronson Howard was an internationally famous playwright, critic and social commentator. He lived in London and sent dispatch articles to the *Detroit Free Press* that were very popular. *Image in the public domain.*

plays about Americans were not typically written by Americans. In 1864, he wrote his first play, *Fantine*, in Detroit based on the first chapter of Hugo's *Les Miserables*. It was performed in Detroit at an early small theater, the Anthenaeum at the corner of Russell and Congress. He was also a popular journalist and wrote about his travels. In 1876, he wrote a column for the *Detroit Free Press* on social life in London. Howard frequently came back to Detroit for visits and is buried in Detroit. The obituary from 1908 described him: "He was a man of serene character and silken mind."

August 5

1812—On the War Path

British major Richardson, of the Forty-first Regiment, gave the following description of the Indian warriors on the march one late summer night near Detroit during the War of 1812:

> *No other sound than the measured step of the troops interrupted the solitude of the scene, rendered more imposing by the wild appearance of the warriors, whose bodies, stained and painted in the most frightful manner for the occasion, glided by us with almost noiseless velocity, without order and without a chief; some painted white, some black, others half black and half red, half black and half white; all with their hair plastered in such a way as to resemble the bristling quills of the porcupine, with no other covering than a cloth around their loins, yet armed to the teeth with rifles, tomahawks, war-clubs, spears, bows and arrows, and scalping-knives. Uttering no sound, and intent on reaching the enemy unperceived, they might have passed for the spectres of those wilds—the ruthless demons which war had unchained for the punishment and oppression of men.*

August 6

1851—Land Sharks in Detroit

A good proportion of emigrants came from Europe and spoke no English. They were easy prey for swindlers, as described on August 6, 1851: "Our readers have for several years past noticed the frequent reccurence

of outrageous frauds, perpetuated by land sharks, on the ignorant and inoffensive strangers who have landed on our shores in search of liberty and equality." Despite the land sharks, migrants were eager to reach their new homes. It was not uncommon for the passengers to sing a song about Michigan that was well known at that time in New York and New England:

My eastern friends who wish to find,
A country that will suit your mind,
Where comforts all are near at hand
Had better come to Michigan.

Here is the place to live at ease,
To work or play, just as you please;
With little prudence any man
Can soon get rich in Michigan.

August 7

1866—Death of Elisabeth Denison Forth

Elisabeth (Lisette) Denison Forth was born as a slave in 1786 in Macomb County near Detroit, the second of Peter and Hannah Denison's six children born during the British rule in Detroit. Her family was owned by William Tucker, who was a farmer. When Tucker died in 1805, he specified that Lisette's parents would be freed after his wife's death but willed the children to his brother. Lisette and her brother crossed into Canada shortly afterward to establish residency and gain their freedom. After she returned to Detroit, a free woman, Lisette became a domestic servant in the 1820s. She enjoyed a close relationship with her employers and invested her pay; she became the first black property owner in the city. In 1831, Lisette joined the household of John Biddle, mayor of Detroit. She continued to invest, buying stock in a steamboat and a bank and in 1837 a lot in Detroit. As before, Lisette had good relations with her employers and had become good friends with Eliza Biddle; the two women, both Episcopalians, made a vow to eventually build a chapel. When Lisette Denison Forth died on August 7, 1866, she willed a portion of her estate to her family and the rest, some $3,000, to be used to construct a church, St. James Episcopal located on Grosse Isle. The

church's red doors are dedicated to the memory and benevolence of Lisette Denison Forth, and a State of Michigan historical marker located on the site commemorates both the church and Forth.

August 8

1902—D. Peters Popcorn

On summer nights in 1902 there were no ice cream trucks, but children waited for D. Peters's pony-drawn popcorn wagon. It was described as the world's smallest wagon, barely big enough for D. Peters and his popcorn machine. A tiny bag of popcorn sold for one penny, a large bag for a nickel.

August 9

1909—Ruth Bigelow's Pets

Ruth Bigelow, aged thirteen, on this day in 1909 wrote to describe her dog and cat:

> *I used to live in Detroit with my Grandma, now I live in Yankton, South Dakota. My dog is a thoroughbred English bull terrier, two years old, and his name is "Tiedo." He's very fond of my little Maltese kitten and never hurts her, even if she scratches him when they are playing. She always curls up between his paws to sleep, and in the winter when he comes into the house with snow, she tries to clean it off for him but her little tongue gets pretty tired. He will lie down and put his head on the floor while she washes his face, but when she washes his ears he can't hold still. It seems to tickle too much, I think. It seems strange to see a little kitten and a bulldog such good friends.*

August 10

1950—What's the Magic Word?

In the 1950s and '60s, the magic word was "Twin Pines!" of course. The premier Detroit dairy with "worry free home delivery" was Twin Pines, and their spokesman/mascot/company clown was Milky the Clown. Milky was on Saturday afternoons and became a beloved fixture of local television. Milky was played by Clare Cummings, who was born

in Chicago in 1917 but moved to Birmingham, Michigan, as a child. He started doing magic performance in Detroit, and then after small starts in nascent television, *Milky's Party Time* opened in 1950. It was a two-hour show of cartoons, magic tricks and Milky's gentle voice. Later, it included a live audience of children; attending the show became so popular the wait for tickets was two years. The show ended in 1964, when Cummings had to devote more time to his *paying* job as a paint salesman; however, he made a later appearance to those same baby boomers in 1969 at the Cosmic Circus when he appeared on stage with Joe Cocker, Iggy Pop, Grand Funk Railroad and the MC5. Cummings passed away in 1994.

August 11

1817—President James Monroe Visits Detroit

President James Monroe arrived in Detroit and stayed for five days at the home of Governor Lewis Cass; the first siting U.S. president to do so. Accompanied by Lewis Cass and Alexander Macomb, Monroe was paraded down Jefferson Avenue. Afterward, he inspected the fort and the troops and was presented with an honorary sword. That evening a ball in Monroe's honor was held at the Woodworth Hotel.

August 12

2008—Flight of the Dead

On this day, author and television reporter Charlie LeDuff, writing for the *Detroit News*, told of a stunning aspect of Detroit's white flight. From 2002 through 2007, the remains of about one thousand people had been disinterred and moved out of the city. He based his findings on permits at the city's Department of Health. "Looked at in another way, for about every 30 living human beings who leave Detroit, one dead human being follows," LeDuff wrote, although others believed the figure to be many times as high, reaching the thousands over twenty years. The practice appeared to be most common among families that were former east side Catholic Detroiters who moved to Macomb County years ago, miles away from their dearly departed. The cemetery that appeared to lose

the most is Mount Olivet, located in the heart of the wild east side, with about one hundred disinterments a year.

August 13

2011—Detroit's Really Big Stove Burns Up

Michigan Stove Company was the largest of Detroit's stove manufacturers that dominated the U.S. industry from the 1870s to the turn of the century. Their brand was "Garland" stoves and employed one thousand. For the Chicago Columbian Exhibition of 1893, George H. Barbour, company secretary, ordered the world's largest stove built to tower over their display space during the fair; it weighed fifteen tons and was twenty-five feet tall. After the Chicago exhibition closed, the stove was moved to the front of the Michigan Stove Company factory until 1955, when the company was bought out. The "World's Largest Stove" (it was actually carved out of wood) was moved around Detroit several times; for a long time, it stood near the entrance to Belle Isle. After a restoration, the stove was put on

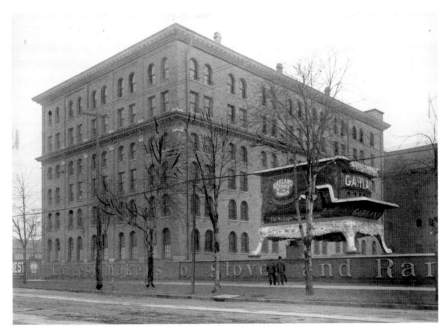

The Garland stove was originally built for the Chicago World's Fair and was displayed in Detroit until 2011 when it was hit by lightning and destroyed. *Courtesy of the Library of Congress.*

permanent display at the Michigan State Fairgrounds. On August 13, 2011, lightning from a severe summer storm hit the stove, completely burning the old wooden structure.

August 14

1898—Detroit Wheelmen Rule the Roads

In 1898, one of Detroit's most popular social clubs was the Detroit Wheelmen's Club, a bicycle club. The newspapers described the popularity of bicycles and racing as a "craze." The Detroit club was originally founded in 1879 by six men, back in the days of the "old ordinary," when stepladders and accident policies were part of bicycling. Club membership ranged between 450 and 500 active members by 1898. Summer and fall bicycle riding ("wheeling") included long trips to Put-In Bay. Also popular on this day and others in August 1898 were lantern runs of 2,000 participants in the evenings, parades on Belle Isle with live music and racing at the Detroit Cycle Track.

August 15

1917—Belgian-Detroit Cycledrome

On this day at Gratiot and Devine Streets were held the Detroit bicycle races at the Belgian-Detroit Cycledrome. The Cycledrome could accommodate three thousand bicycle racing fans. These professional races went for three hours and pitted Detroit's Alfons Verraes, 1916 champion, and Leon Snoeck, both Belgians, against Italian cycling champion Verri and champion Peter Himschoot from Chicago.

August 16

1812—Hull's Surrender of Detroit

William Hull was a hero of the Revolutionary War and was appointed by James Madison to lead state militias to Detroit to prepare for an invasion of British Canada. The British controlled the Great Lakes, so a land route was necessary. After a deadly march across Ohio's Black Swamp, Hull's nearly three thousand soldiers reached Detroit in early July and entered Canada, demanding its surrender. The plan was to attack the British fort

at Malden, but Hull was hesitant and returned across the Detroit River. In the meantime, the British sent the highly experienced General Isaac Brock, who set up a battery of cannons and began the bombardment of the fort at Detroit. Aided by the great warrior Tecumseh, the British crossed the river at daylight the next day. Brock's forces attacked the rear of the fort while Tecumseh's Indian tribes passed through the nearby woods while making loud war cries, giving the impression of a large force. Hull began to despair that they would either be starved out or butchered by merciless Indians; among the women and children were his own daughter and grandchildren. Against the wishes of his subordinates, he surrendered on August 16, 1812, and 582 Americans were taken prisoner to Quebec City. The entire nation was shocked and humiliated, and Hull was sentenced to death for treason, later commuted to life in prison by President James Madison.

August 17

1994—Woodward Dream Cruise

On this third Saturday of August began one of the most popular traditions in Detroit: the Woodward Dream Cruise. It was started by Nelson House, a plumber from Ferndale, who came up with the idea in 1994 to help raise money for a children's soccer field in his community. Organizers initially expected 30,000 or 40,000 people with cars, but nearly 250,000 actually showed up. Today, the Woodward Dream Cruise has become the world's largest one-day automotive event, drawing about 1.5 million people and forty thousand classic cars each year from around the globe. It claims to bring in $56 million every year to the local economy.

August 18

1904—Gem of the Princess River: The Belle Isle Aquarium Opens

It was designed by Albert Kahn and said to be the fourth public aquarium built in the United States. Detroiters loved the aquarium when it formally opened on August 18. The largest attendance in August was 17,071, and by early September of that year, 80,229 people had walked through the doors. There was considerable damage done to the glass-fronted displays by

umbrellas and canes. Park commissioner Bolger made people check them at the entrance. By 1907, the aquarium held two thousand species.

August 19

1966—Summer Trip to Boblo Island Amusement Park

It was founded at the turn of the twentieth century and became Detroit's version of Coney Island. It was originally called Bois Blanc, "island of the white wood," named by the French. The island is eighteen miles downriver from downtown Detroit; it took an hour steamboat ride to get to Boblo—a big part of the day of fun. Along with rides, it once offered the country's biggest dance hall, paid for by Henry Ford and able to house 5,000 dancing couples. During its best days in the late 1960s, about 800,000 Detroiters took the steamer SS *Ste. Claire* for a day at Boblo during the summer season. Boblo closed for good in 1993.

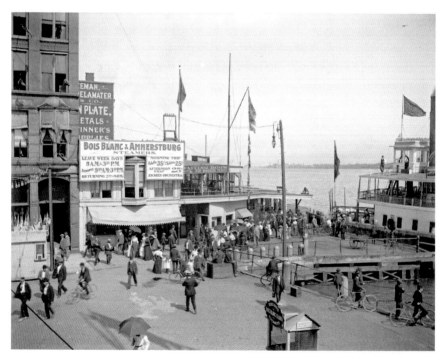

Boblo Island was known as Bois Blanc Island in 1890 at the time of this photograph. This shows the docks for ferries coming from Detroit. The ferry ride was a big part of the fun. *Courtesy of the Library of Congress.*

August 20

1794—Mad Anthony Wayne and the Battle of Fallen Timbers

Although the Americans had defeated the British in the Revolutionary War, the British clung on to western regions of the United States. The Battle of Fallen Timbers was the final battle of the struggle for American control of the Northwest Territory. George Washington ordered Revolutionary War hero General "Mad" Anthony Wayne to build and lead a new army to crush resistance to American settlement. (He was called "mad" due to his terrible temper.) Wayne's new army, the Legion of the United States, made up of 2,000 Kentucky soldiers and cavalry, would fight 1,500 native tribes with British reinforcements. The head of the Indian alliance, a leader named Mississacoh, an Ottawa chief the Americans called "Turkey Foot," took a defensive position along the Maumee River near Toledo, Ohio, where a stand of trees had been blown down by a recent storm (hence—"fallen timbers"). Wayne's force won a decisive victory. In 1796, General Wayne entered Detroit at the head of his army and formally took control of the city from the British. On the same day, Wayne County was created and named in his honor.

August 21

1908—Carrie Nation, "Saloon Smasher," Visits Detroit

The most famous anti-saloon and liquor reformer in the United States at the turn of the twentieth century was Carrie Nation, who wielded her characteristic "saloon smashing" hatchet. Nation was the daughter of a fundamentalist Kentucky planter father and a psychotic

Carrie Nation, the famous saloon-smashing temperance leader, visited Detroit and, with a mob, chased down the governor of Michigan. *Courtesy of the Library of Congress.*

mother. Some historians believe Carrie Nation herself was also psychotic. She was nearly six feet tall and 175 pounds. She wore only a gray raglan dress and a black straw bonnet. She toured the United States and at many train stops was greeted by thousands of supporters. In 1908, she reached Detroit, entering Considine's Saloon on Monroe Street on this busy night in August, made busier with rumor of her arrival. She walked through the saloon to the backroom, where the boys "ate beefsteaks and drank beer at small tables." She scrutinized the art on the wall that the paper described as "pictures of feminine beauty that are undeniably artistic but not because of their superfluous drapery." "A gilded Hell!" she screamed and stormed over to lecture the bartenders and then moved on to other saloons and finally a twenty-minute harangue at Michigan Central Station to a large crowd.

August 22

1922—Detroit's First Traffic Signal

Detroit was not only a leader in automobile manufacturing in the early decades of the twentieth century, but due to the sheer number of vehicles on Detroit streets, the city also was forced to become a leader in traffic control. In 1917, Detroit installed a new approach to policing traffic by erecting a tower "crow's nest" at Woodward Avenue and Grand Boulevard. The tower was placed in the middle of the intersection and was manned by a police officer. He would manually turn the signal atop the crow's nest

An early Detroit innovation: the "crow's nest" located on Grand Boulevard. *Image in the public domain.*

that said "stop" and "go." Instead of a yellow caution signal he would ring a large bell to warn drivers the signal was about to switch. On August 22, 1922, the policeman in the crow's nest was replaced by a mechanical "traffic semiphore" device. It cost one-tenth the price to install as a "crow's nest" without the expense of a traffic cop standing in it all day. The signals were invented by Detroit police superintendent William L. Potts and Harry Jackson, head of the traffic division.

August 23

1873—Detroit News *First Edition*

On this day, the *Detroit News* published its first newspaper, then called the *Evening News*. It sold for two cents an edition. The *News* was founded by James E. Scripps, who wanted the reporters to write their copy as people talked, targeting working-class men and women. The *Evening News* was a success and made Scripps a fortune. Scripps was an early and significant donor of European paintings to the Detroit Institute of Arts. The paper's eventual growth, however, is largely credited to Scripps's son-in-law, George Gough Booth, who came aboard at the request of his wife's father. Booth went on to construct Michigan's largest newspaper empire, founding the independent Booth Newspapers chain.

August 24

1893—Hurlbut Memorial Arch

Detroit had no shortage of wealthy, self-made men in the nineteenth century who donated money for memorials to themselves. Chauncey Hurlbut is a good example. He came to Detroit in 1825, made a fortune in the grocery business and then moved into public

Hurlbut Memorial Gate is a monumental structure, 132 feet long, 50 feet high and 40 feet in depth, at the entryway to Water Works Park located at East Jefferson Avenue. *Photo by Barney Klein.*

service. Hurlbut joined the water works and was key to establishing the water works as one of the best in the country for its time. Common for the late nineteenth century was an over-the-top entrance way. Hurlburt donated his fortune of $60,000 for development of the entrance gate, formally called the "Hurlbut Memorial Arch." And it's a beauty at 132 feet long, 50 feet high and 40 feet deep. The project was made public on August 24, 1893.

August 25

1783—Treating Smallpox

Dr. William Barr, a British Surgeon, was assigned to Detroit and Mackinaw during the Revolutionary War at various times. At one point, smallpox had broken out among a group of British Loyalists. Five had died and sixteen were still suffering, and Dr. Barr was sent to treat them. Barr reported on August 25: "Bedding and wearing apparel, especially anything woolen, has been purified by fire and smoke, things known from experience to be the most effectual in purifying all Tainted Places and Materials. Tents were also pitched in the fields for receipt of cool, fresh air…Cold weather will probably prevent spreading of the disease."

August 26

1817—University of Michigan Founded in Detroit

With Reverend John Montieth and Father Gabriel Richard, Chief Justice Augustus B. Woodward drafted a charter for an institution he called the Catholepistemiad of Michigania or the University of Michigania. On August 26, 1817, the governor and judges of the Michigan Territory signed the university act into law. This institution became the University of Michigan. Woodward drafted a territorial act establishing a "Catholepistemiad, or University, of Michigania," organized into thirteen different professorships, or didaxiim, following the classification system he had published the year before in his book *A System of Universal Science*. U of M moved from Detroit in 1837 to land offered by the City of Ann Arbor. It became a model for other public universities in the United States.

August 27

1894—Interview With a Dentist

"That tickles a little," said the dentist, interviewed in the *Detroit Free Press* on this day in 1894. He was turning his dental drill and quietly laughed. "I had the same kind of tooth," he continued. "And when my uncle, who is also a dentist, operated on it I said I would rather die than go through the experience again. Recently an Irish girl came to my office and I advised her to take gas. When the tooth had been pulled and she returned to consciousness, she said: 'I had a dream. I dreamed I was dead and I went to the gates of Hell and they let me in. Now, I don't know whether I am there or not.'"

August 28

1886—Anarchist Meeting at Germania Hall

Eight hundred men watched by two dozen police dressed in civilian clothes gathered at Germania Hall on this evening to protest the conviction of eight Communists in Chicago during the famous McCormack reaper factory protests. One newspaper said that the speeches were "red hot and show that Anarchy and Socialism have advocates in Detroit." The main speaker of the evening was local Socialist Samuel Goldwater, described by a reporter as "a tall, handsome man with a dark strong face, black hair and a mustache of the same color." "I have taken part in this great movement both as a Socialist and an Anarchist. I have never yet possessed so much as a revolver, but I say that if these men be hung, 100,000 will arise to take their place!" The meeting was described as generally orderly and dispersed at 10:00 p.m.

August 29

1835—A Tourist in Detroit

On this day, a tourist from New England named Cyrus P. Bradley was sixteen when he wrote this journal of his time in Detroit:

We arrived at Detroit about half past two and I spent the afternoon in walking around the city…On the little narrow street, near the river, or

rather of which the river formed one side, is settled by the French, the descendants of the original proprietors. They are a singular people—hate the Yankees—will not mix with them, will not suffer their children to learn the language or have any intercourse with them…Their farm…lots, in running back, cross the main street, and make four or five building spots, but their jealous owners will not sell these spots though they do not improve them themselves, except in cultivation, and though many of them would command almost any price that could be named.

August 30

1905—Ty Cobb's First MLB at Bat with Detroit Tigers

Tyrus Raymond Cobb, "the Georgia Peach," played twenty-two seasons with Detroit. He was credited with establishing ninety Major League Baseball records, two of which still stand today, including career batting average (.366) and most career batting titles (eleven). His first game as a Detroit Tiger was

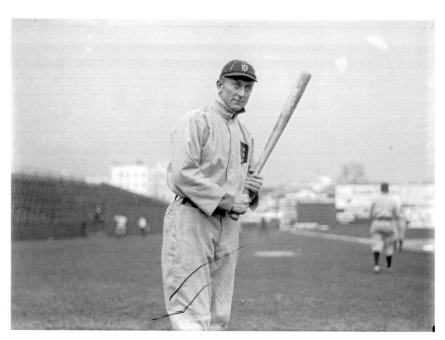

Tyrus Cobb, "the Georgia Peach" played twenty-two seasons with Detroit. He was credited with establishing ninety Major League Baseball records. His first game with Detroit was on August 30, 1905. *Image in the public domain.*

on August 30, 1905, only three weeks after his mother killed his father. Cobb started in center field, and in his first at bat, he doubled off Jack Chesbro of the New York Highlanders, one of the league's leading pitchers. Cobb was eighteen years old at the time, the youngest player in the league by almost a year. While an undeniably great player, his career was overshadowed by a vicious temper, aggressive playing style and savage racism.

August 31

1913—Marrying Age

Today, in a feature column called "Women of Today," Detroit women were asked about the appropriate age for marrying in 1913. The responses in the newspaper ran from don't ever marry, marry an older man because they are more patient, marry when you can and don't marry too late. Women from "the old days" preferred to marry early when they were young and strong. This response was from one unhappy woman:

> *I was married at seventeen so do not approve of early marriages. Before I was 36 I was so tired of married life and the monotony of cooking and cleaning that I was irritable, disagreeable, and grew old before my time. My husband, in the prime of life, grew tired of my nagging, became estranged and was soon going out with other women. My life has been a failure and I attribute it to too youthful marriage. Today at 40 I am a lonely woman and my divorced husband goes his way and I go mine.*

SEPTEMBER

September 1

1818—Steamship Walk in the Water's Summer Voyages

Soon after the first steamboat *Walk in the Water* docked at the pier in Detroit in the summer of 1818, it began the new age of the steamships on the Great Lakes. The ship made seven trips to Detroit in its first season; each trip took about nine or ten days chugging along at eight miles per hour. *Walk in the Water* accommodated one hundred passengers. In these days, when it rounded the bend from Lake Erie to the Detroit River, it was common for a cannon shot to be fired to announce the ship's arrival. When it docked, nearly the entire town came out to meet it with stagecoach rides to hotels, food or other items to sell to travelers. *Walk in the Water* was named after a Wyandotte chief. *Walk in the Water* ran for three seasons but in November 1821 ran into a gale that drove it ashore in Buffalo. Passengers and crew escaped, but the boat was lost.

September 2

1902—First Person Killed in Detroit by an Automobile

George Bissell, an eighty-one-year-old successful Detroit businessman, is recorded as the first person killed by an automobile in the city. Bissell was riding in his horse-drawn carriage at Brooklyn and Lysander Streets when the auto struck the carriage and threw him against a post and to the street. His skull was fractured, and he died sometime later at Harper Hospital. The driver of the automobile was not named.

September 3

1971—Pewabic Pottery Listed on National Register of Historic Places
On this day in 1971, the Pewabic Pottery studio was listed as a National Historic Place. The pottery was developed in 1903 by the artist and teacher Mary Chase Perry Stratton and her partner Horace James Caulkins. Through Mary Stratton's artistic leadership, the studio on East Jefferson Avenue produced lamps, vessels and its famous tiles. The Pewabic iridescent glaze is what people recognize. Pewabic pottery has been treasured by Detroiters since its inception. It can be found in homes, churches, libraries and commercial buildings throughout the city—even on People Mover stations and Comerica Park. The name *Pewabic* comes from a Chippewa Indian term that means "clay with a copper color" found in the Upper Peninsula's Copper Country, where Perry was born.

Pewabic Pottery on East Jefferson Avenue was founded in 1903 and has beautified Detroit homes, churches, buildings and more ever since. *Photo by Barney Klein.*

September 4

1913—A Touch Off!

Hotel fires were not uncommon in big and small hotels, and in 1913, it is estimated that about one-quarter were set intentionally; the number was suspected to be higher, but the sources of many fires were undetermined. At the time, it was called "Incendiarism." It began in the 1880s and continued through the early twentieth century. People set fires using alcohol, which was said to produce a clear white flame that roared out of windows and that fire departments soon came to recognize. On this day, the newspapers reported a fireman who yelled, "A touch off!" recognizing a fire set intentionally at a hotel. Some of the incendiaries were hotel guests. They might use something as simple as a cigar dropped in a waste basket or something more elaborate, such as that described by a New York fire chief at a conference to deal with the crime: "I have entered a building to see many bladders filled with oils hanging around ready for a flame to scatter their streaming contents." One of the most important, albeit played-down, duties of bellhops at the turn of the century was to be discreetly on the lookout for firebugs.

September 5

1899—Best Labor Day Ever

The tall chimneys along the river front were smokeless, the cigar makers left their tables, the iron molders dropped their ladles, the painters let their brushes hang in the paint pails, the printers left their cases and machines and the tired clerks put on their hats and went out into the street. Even the elevator boys closed up the iron gratings in front of their lifts and as a result business people who had no time to celebrate the labor holiday had to climb the stairs.

So wrote the newspaper on this Labor Day, since every laborer was in a union and every union was on parade this day. Each union wore matching outfits and marched in order starting at Grand Circus Park. The Pingree and Smith band swung from Park onto Woodward playing stirring marches. Crowds thronged the sidewalks and every window was jammed with viewers

Labor Day parade in Detroit, 1946. *Courtesy of the Library of Congress.*

from above. Boys climbed streetcar poles to get a better view. The union winner of the day was the Detroit River Lodge of the Amalgamated Association of Iron and Steel Workers for having the best-drilled team. Their prize was a "fancy clock."

September 6

1964—Beatles! At Olympia!

The Beatles performed two sellout concerts at Olympia on this day. The other acts on the bill were the Bill Black Combo, the Exciters, Clarence "Frogman" Henry and Jackie DeShannon. The Beatles played for about twenty minutes. The shows were complete mayhem as preteen and teenage

girls screamed through them. Many claimed to have passed out. On the main floor, fans threw at the stage jelly beans that the Beatles had to dodge and then threw back at the fans. One former attendee remembered, "Afterwards, on the way out, people were breathing so hard from twenty minutes of screaming, that the walls of the exit corridors were literally dripping with exhaled moisture!" After the show, the Fab Four stayed at the Whittier Hotel. Following their departure, the sheets they slept on were purchased by a radio station and cut into small squares, which were then sold to fans. Much later, Paul McCartney played in the summer of 2011 at Comerica Park. Two tickets for the 1964 Beatles: $8. Two tickets for 2011 Sir Paul: $570.

September 7

1903—Lucius

At the Hotel Cadillac in 1903, the concierge was Mr. Lucius Purtscher, a resplendent man with an even more resplendent mustache. As he manned the counter or sauntered about the lobby, he was described as a "millionaire in disguise." He could size up a patron the moment he stepped through the door. He remained unflappable, assigning rooms, directing bellhops and answering a thousand questions a day. On this day, he told guests which churches had the best choirs, where to rent bicycles, which steamship was the nicest and endless answers about the train schedules.

September 8

1925—Dr. Ossian Sweet Moves into the East Side of Detroit

Dr. Ossian Sweet, an African American physician, bought a home in an all-white, middle-class neighborhood on Detroit's east side. Ossian Sweet and his wife, Gladys, moved into the house on September 8, 1925. That night, a crowd of neighbors gathered outside the house, determined to keep the neighborhood white, but other than a short barrage of rocks, nothing happened. On the following night, Sweet told his brother that he was "prepared to die like a man" and arranged for some friends and relatives to stay with him for a few days. He also brought along guns and ammunition.

A Detroit Street for blacks only in the 1940s.
Courtesy of the Library of Congress.

As expected, another crowd, now estimated at four to five hundred people, formed and began throwing rocks and bottles at the house. At close to 10:00 p.m., shots rang out from Sweet's house: one man was killed and a second wounded. Six police officers arrived and arrested all eleven occupants of the house. The NAACP stepped in after hearing about the arrests and asked Arthur Garfield Hays and Clarence Darrow to take the case. Hays and Darrow agreed, and they arrived in Detroit to piece together the events of September 8 from the defendants. After forty-six hours of deliberation, the all-white jury was unable to come to a decision. A mistrial was declared, and Ossian Sweet was free to go.

September 9

1972—Dinner at the Pontchartrain Wine Cellars

The Pontchartrain Wine Cellars was one of the few French restaurants in Detroit despite Detroit's French origins. You went to the Pontchartrain Wine Cellars to get French onion soup, frog legs Provençal and delicious Pommes Delphine (garlic and cheese potato balls). Intimate and understated, it was narrow with two stories of wooden tables and brick walls. It was founded by Harold Borgman and later owned by Joe Beyer in 1971. It had no hard liquor but featured a respectable wine list that included its own original "Cold Duck," a sparkling red wine of German origins developed by Borgman in 1937. The recipe was based on German frugality, combining the leftover wine of unfinished bottles and mixing them with champagne.

September 10

1813—The Battle of Lake Erie

The Battle of Lake Erie was in two parts. Part One was a race. U.S. master commandant Oliver Hazard Perry had to build a battle-ready fleet of sailing ships and train a fighting crew in the middle of what was then wilderness. The British controlled Detroit and had ships poised for fighting. Perry had no ships but brought with him Dutch shipbuilders, cannons, sail makers, sailors and supplies to a small protected bay at Erie, Pennsylvania. Part One took eight months. Part Two was the battle itself, and it took about three hours on September 10, 1813. The gruesome, close-range battle, one of the last using wooden tall sailing ships, marked the first time in history an entire British squadron had surrendered to a foreign power. It saved Detroit, gave control of the Great Lakes to the United States and made instant superstar heroes of Oliver Perry and his men, who for a year were paraded through town after town where proud Americans relived the battle and cheered the American victors.

September 11

1903—Bowling Takes Over Detroit

By 1903, Bowling had become the most popular indoor winter sport with over one hundred places to go bowling across the city. Detroit was declared a bowling center for the country. On this day, league bowling season was opened. Teams included Drug Wholesale, Pneumatic Tool, the Amaranths, KOTM, the Wheelmen, Rough Riders and more. A sportswriter said, "Bowling is truly a democratic, cosmopolitan, and sociable sport…the heads of big corporations are not ashamed to be seen going through the streets carrying a bowling ball when they have some engagement in one of the numerous tournaments."

September 12

1761—Party Detroit British Style

Despite the threat of Indian ambush, the howl of the wolves and the military drumbeat of the fort, young men and ladies still found time for gatherings, especially dancing. Sir William Johnson came to Detroit, then under British

flag, and was introduced to the ladies of the town. He wrote in his diary, "At 10 o'clock Captain Campbell came to introduce some of the town ladies to me at my quarters whom I received and treated with cakes, wine and cordial. (Tuesday, 12th) In the evening the ladies and gentlemen assembled at my quarters, danced the whole night until 7 o'clock in the morning when all parted very much pleased and happy…There never was so brilliant an assembly here before."

September 13

1939—"Jaws" Born in Detroit

Richard Kiel was born in Detroit on this day. He was a character actor best known as the gruesome giant assassin "Jaws" in two James Bond movies: *The Spy Who Loved Me* and *Moonraker*. Kiel was seven feet and one and a half inches tall. He was blind in one eye and also had the hormonal condition acromegaly, which causes excess growth hormones to be produced. Among his early jobs were cemetery plot salesman and nightclub bouncer. Once he moved to California and began taking acting roles, he supplemented his erratic income by working as a night-school math teacher. He cornered the market on playing giants, freaks, henchman and Big Foot. He complained that fans confused him with Fred Gwynne (*The Munsters*), Ted Cassidy (*The Addams Family*) and wrestler-actor Andre the Giant. Kiel died in 2014.

September 14

1930—Hank Greenberg Starts with the Tigers

On this day, Henry Benjamin "Hank" Greenberg, born in New York City, nicknamed "Hammerin' Hank," "Hankus Pankus" or "the Hebrew Hammer," started his American Major League Baseball career as a first baseman for the Tigers. He became a major player in the 1930s and 1940s. A member of the Baseball Hall of Fame, he was one of the best hitters of his generation and is widely considered one of the greatest in baseball history. He was an All-Star for four seasons and an American League Most Valuable Player for two seasons. In 1938, Greenberg hit fifty-eight home runs for the Tigers. Greenberg was the first Jewish superstar in American

team sports. He attracted national attention in 1934 when he refused to play on Yom Kippur, the holiest holiday in Judaism, even though the Tigers were in the middle of a pennant race. In the year 2000, the Detroit Film Theatre at the Detroit Institute of Arts ran a tribute film: *The Life and Times of Hank Greenberg*. The *Detroit News* called it "a purposeful, rangy, beautifully researched documentary by Aviva Kempner, it's a film that gracefully weaves the story of Hammerin' Hank's fabled career as a Tiger of the '30s and '40s with social history that correctly establishes Greenberg, a Jew, as the Jackie Robinson of his own time and people."

September 15

1916—Billy Sunday in Detroit

"Now you bull neck degenerates," he declared. "I defy you in the name of Jesus Christ." On this day, Billy Sunday came to Detroit to preach at his tabernacle at Woodward and Forest Avenues. His Sunday church services were a major event in Detroit, as it was in other cities big and small across the country. He arrived a day early and was the toast of the wealthy elite in Grosse Point, but on Sunday, Detroiters came by the thousands to see Billy Sunday preach; his "men only" service drew twenty-nine thousand men while the crowds open to everyone were enormous. In his book *Preacher*, Roger Bruns describes a Sunday in Detroit with Billy Sunday on stage:

> *Billy opened the revival in top form. He made them laugh, quiver, cry, shout, and sing...the body gyrations, the platitudes, the hysteria..."Help old Detroit," he implored the Almighty. "Throw your arms around her. Go into the barbershops, Lord, into the hotels, factories, saloons. Help the man on the street—the floater and the drunkard. The devil has him almost out, Lord, help him. He's on the ropes and groggy, Lord. Help him, Lord. Square his shoulders. Help him raise his dukes and cry, 'Yes, Lord, I'll come when Bill gives the call!'" A huge choir then filled the tabernacle with song:*

> *"Where is my wandering boy tonight?*
> *Ruined and wrecked by the drink appetite,*
> *Down in the licensed saloon"*

Billy Sunday's tabernacle at Woodward and Forest Avenues brought in tens of thousands to hear his frenetic preaching. *Courtesy of the Library of Congress.*

September 16

Billy Durant, the founder of General Motors. *Courtesy of the Library of Congress.*

1908—General Motors Founded

On September 16, 1908, one of America's best-known companies was born. That was the day that Billy Durant founded General Motors Corporation. Durant started out as a cigar salesman in Flint and eventually moved to selling carriages, transforming $2,000 in start-up capital into the Durant-Dort Carriage Company, which became the largest horse-drawn vehicle in the world. With those amazing skills he started Buick Motors in Flint. He formed General Motors in 1908 by consolidating thirteen car companies and ten parts-and-accessories manufacturers. He built the massive Beaux Arts General Motors Headquarters on Grand Boulevard in 1924 as its first home. But when the Great Depression hit in 1930, Durant's buying and selling of companies ended, and he declared bankruptcy in 1936. He died in obscurity.

September 17

1862—Detroit's Twenty-Fourth Michigan Infantry at the Battle of Antietam

A distinguished Civil War regiment was the Twenty-Fourth Michigan infantry, made up of volunteers from Detroit and Wayne County. It trained at the fairgrounds and later on Woodward and Canfield Avenues. On this day, the new recruits arrived to fight in the Battle of Antietam, which was the bloodiest single-day battle in American history with a combined tally of dead, wounded and missing at 22,717. After their outstanding courage, they were incorporated into the Union's famous "Iron Brigade." They opened the Battle of Gettysburg. The men from Detroit were almost completely destroyed, holding back the Confederate

advance until the entire mass of the Union army could get into position. The Twenty-fourth's casualty rate was the highest of any Union regiment in the battle.

September 18

1987—Visit of Pope John Paul II

One of the biggest events in the life of the Catholic Church in southeast Michigan took place on this day, when Polish-born Pope John Paul II made a pastoral visit to Detroit, held Mass for 100,000 at the Pontiac Silverdome and then came to Hamtramck for a visit. As reported by the *Chicago Tribune*:

> [Hamtramck:] *In the early morning darkness and drizzle, Renata Wyszynswki was awash in a sea of Polish songs, and a surge of memories suddenly touched her. As she waited patiently on a crowded sidewalk for the Pope's arrival Saturday, memories of long-ago Easters and Christmases, and life on a farm in Poland—the life she had left only three years before—flashed through her mind. And as more and more people crowded onto the busy street, she felt proud that they were coming to see the Pope, not because he is the leader of the world's Catholics, but because, she said, he is Polish. "This the first time in this country I feel proud that I'm Polish."*

September 19

1922—Masonic Temple Founded

Grand Lodges of Freemasons began in 1717, in London, and Masons were founded in Detroit in 1764 when the British controlled the city. Detroit was a major city for the Masons, and on this day, the nineteenth of September, the cornerstone of their magnificent temple was placed using the same trowel that George Washington (a Grand Mason of Virginia) used to set the cornerstone of the United States Capitol in 1793.

September 20

1879— Advice from President Rutherford B. Hayes

On this day, U.S. president Rutherford B. Hayes paid a call at Detroit and stayed overnight. With Hayes was the famous Union general William Tecumseh Sherman who drew the big crowds at Whitney's Opera House. At an evening reception in which Hayes shook hands with over one hundred people, he was asked if he ever tired of receiving lines. "Oh, no," answered President Hayes. "It is with this as in every battle in life. The attacking party always has the advantage. You must never allow a person to grasp your hand; always take his hand, then you are safe. But if you extend your hand as a bait, the fish will swallow it and you will be squeezed and hurt."

September 21

1945—"Hank the Deuce" Becomes President of Ford Motor Company

On this day in 1945, Henry Ford II became president of Ford Motor Company at age twenty-eight. He was Henry Ford's grandson and the son of Edsel Ford. Since it had been assumed that Edsel Ford would continue in his capacity as president of the company for much longer (Edsel died suddenly of stomach cancer), Henry Ford II had received little grooming for the position. He served as president from 1945 to 1960 and as chairman and CEO from 1960 to 1979. He continued to have a strong presence at the company until his death in 1987. He was said to have an aggressive management style. Henry Ford II allowed the offering of public stock in 1956, which raised $650 million for the company, but his radical new car, the Edsel, lost the company tremendous amounts of money and prestige. He hired the brilliant Lee Iacocca, who developed the Ford Mustang, in 1964 but soon after fired Iacocca due to personal disputes. Henry Ford II was famously quoted as saying, "Sometimes you just don't like somebody."

September 22

1981—Edgewater Park Closes Its Gates

Edgewater Park was a quaint, twenty-acre amusement park at Grand River and Seven Mile Road on Detroit's west side. It opened in 1927. It quickly became one of Detroit's most popular recreation spots, particularly during the Depression and World War II. The park featured popular attractions such as the wooden roller coaster Wild Beast, a gigantic 110-foot Ferris wheel and the Hall of Mirrors. The park maintained its popularity all throughout the 1950s and 1960s, earning a reputation as one of Detroit's greatest teenage hangouts. In September 1981, after years of declining revenues and the growth in popularity of rival theme parks, Edgewater Park welcomed the last visitor through its turnstiles.

September 23

1958—The Spirit of Detroit *Dedicated*

On this day, the sculpture *The Spirit of Detroit*, which some nickname the "Jolly Green Giant," was dedicated to the city. The bronze statue was commissioned for $58,000 in 1955 and sculpted by Marshall Fredricks. It is located at the Coleman A. Young Center. The twenty-six-foot sculpture was the largest cast-bronze statue since the Renaissance at the time it was built. In the statue's left hand, it holds a gilt bronze sphere, emanating rays to symbolize God, and in its right, it holds a family group symbolizing all human relationships. Depending on the sports team, *The Spirit of Detroit* is frequently garbed in Red Wings, Detroit Lions or Detroit Tigers jerseys.

It is called *The Spirit of Detroit*, commissioned in 1955 and sculpted by Marshall Fredricks. The twenty-six-foot sculpture was the largest cast-bronze statue since the Renaissance at the time it was built. *Photo by Barney Klein.*

September 24

1830—The Last Execution in Michigan

Stephen Gifford Simmons was an enormous, "Herculean" man who owned a tavern in Wayne County and was described as handsome and even kind when sober but a "dangerous ruffian" when drunk. While on a drinking "spree," he insisted that his wife should drink with him, and after she did to gratify him, she refused to drink more. Thereupon, he struck her a "terrible blow" in the abdomen that killed her in moments. If this were not horrible enough, his two daughters were the principal witnesses to the crime. He was brought to the Wayne County Jail in Detroit. September 24, 1830, was set for his execution. On that day, a huge crowd composed of the entire town and farmers, trappers, Indians and more from the surrounding areas came to see the hanging. Simmons stepped from the jail wearing his "grave clothes" and walked to the scaffold past a line of pioneer scouts wearing blue shirts and stove-pipe hats. A "band" made of up three drums and a flute played a funeral dirge as Simmons mounted the steps. The noose was slipped onto his neck, and a priest placed a hood over his head. The band played with "renewed enthusiasm" as the crowd pressed in closer to the gallows. The cord was jerked, and Simmons shot through the trap door, which snapped his neck. That would be Michigan's last hanging. Michigan's was the first English-speaking government in the world to abolish totally the death penalty for ordinary crimes.

September 25

1905—J.F. Kohl Eats Frog Legs

On this day, J.F. Kohl, director of the Detroit Opera House, went froggin' in Northville with friends. They "netted" 480 frogs in one day, as he related. "Not the little green fellows that subsist on grasshoppers and flies, but the mamoth [sic] sort with record hops of several yards. They were whoppers," said J.F. dreamily. Out of the nearly fifty dozen caught that day, J.F. took ten dozen home, and that night, he and his wife ate all ten dozen frog legs. "Yes, we ate one meal, but we ate nothing else," J.F. defended himself weakly.

September 26

1679—La Salle and Le Griffon Disappear

Le Griffon was a seventeenth-century sailing ship built by René Robert Cavelier, Sieur de La Salle, in his quest to find the Northwest Passage to the Far East. It was constructed and launched at or near the Niagara River. La Salle and Father Louis Hennepin set out on *Le Griffon* in early August 1679 with a crew of thirty-four men, sailing across Lake Erie, Lake Huron and Lake Michigan. These waters were generally unknown, having been explored only by canoe. The Frenchmen stayed near the shore, sounding the depth as they went through fog and moonless nights, with the sound of breaking waves as a guide. They disembarked and, in September 1679 during its return trip from Green Bay, Wisconsin, the ship vanished with all six crew members and a load of furs. Father Hennepin later wrote that *Le Griffon* was lost in a violent thunderstorm. Others have claimed competitive fur traders and even Jesuits caused its destruction. Some said that the Ottawas or Pottawatomies boarded it, murdered its crew and then burned the ship. La Salle himself believed the pilot and crew treacherously sank the ship and made off with the goods. The loss and location of the sunken ship remain a mystery to this day.

September 27

2009—Faygo Root Beer Named Best in United States by Bon Appétit

Bon Appétit's September issue ranked Detroit's own Faygo Root Beer No. 1 in a tasting of other brands across the United States. The magazine said root beer was the newest restaurant drink trend. The magazine described it as "dry and crisp, with a frothy head, a good bite and a long finish." Faygo Beverages was started in Detroit in 1907, as the Feigenson Brothers Bottling Works. The Feigenson brothers were bakers from Russia who immigrated to Detroit and used their icing recipes for their first three Faygo flavors: grape, strawberry and fruit punch.

September 28

1813—British Major General Henry Proctor Abandons Detroit

When the American general and governor of Michigan Territory William Hull surrendered Detroit to the British in the War of 1812, Hull was taken away as a British prisoner of war, and Major General Henry Patrick Proctor became the commander of Detroit, which was now in British hands. He asked American chief justice Woodward, the highest remaining official, for the boundaries of the Michigan Territory and proclaimed himself civil governor. He was considered severe and at times cruel, allowing Indians to torture and commit atrocities to prisoners. On September 13, 1813, the Americans defeated the British fleet in the Battle of Lake Erie. With control of the waterways, Proctor knew he had no chance, so he began the evacuation of Detroit and Fort Malden on the Canadian side of the river on September 28. Within days, Proctor and his ally Tecumseh were defeated at the Battle of the River Thames in October 1813. American leader William Henry Harrison had himself appointed civil governor for Michigan and Detroit until a new governor was appointed by the U.S. government.

September 29

1797—Detroit's Need for Heat

Then as now, Detroit winters were cold. The earliest record of heating stoves in Detroit came in 1797. (This was the original purpose of stoves; cooking "ranges" would come later.) A September 29, 1797 letter from Quartermaster General John Wilkens Jr. in Pittsburgh to Matthew Ernest in Detroit read: "By boat which went a few days ago, I sent twenty stoves for the use of the garrison in Detroit. These will aid in making the soldiers more comfortable and save firewood." Most stoves during this period came from Montreal and were rented during the winter season. They came into more general use in 1830.

September 30

1899—Shopping at Eastern Market

At this time, immigrants were coming to Detroit by the thousands, and each nationality shopped on a separate day at the Eastern Market. Eastside Jews came on one day, and Polish ladies brought their husbands on another. German house fraus were considered very independent, and Belgians were described as "close buyers but good customers." Hungarians took trains from Milwaukee Junction. Italians and Syrians came another day from "streets by the river." All to save a penny or two as the market had the cheapest prices in town, and the stall owners knew what each nationality wanted and, therefore, what to put on sale.

OCTOBER

October 1

The University of Detroit School of Commerce and Finance season of 1920–21 classes began on the first Monday of October and ran through the end of May. They were held at the University Building at 350 East Jefferson Avenue. Tuition costs were $100 for a full course of classes or $50 for a single course. Courses were held in the evening. The freshman schedule of classes was as follows:

Monday: 7:30 p.m. Economics; 8:15 p.m. Accounting; 9:00 p.m. Accounting
Wednesday: 7:30 Economics; 8:15 p.m. Law; 9:00 p.m. Real-estate or elective
Friday: 7:30 p.m. Corporate Finance; 8:15 p.m. Accounting; 9:00 p.m. Accounting

Women were encouraged to enroll. As stated in the bulletin, "Opportunities for women which seemed temporary during war conditions [World War I] have developed a permanent character under peace regulations, without effecting a displacement of male executives and assistants."

October 2

1941—John Sinclair Born

On this day, author, poet, agitator, leader and activist John Sinclair was born in Flint but will always be synonymous with the tumultuous late 1960s and 1970s in Detroit. In 1966–67, Sinclair founded the Detroit Artists Workshop and joined Detroit's working-class version of the Cultural Revolution. He is most famous for managing the MC5 with regular performances at the Grande Ballroom and free concerts given all over. While not the most musical band to hit the scene, the MC5 are now referred to as "proto punk," and their first album in 1968 had that manic energy. Sinclair also founded the White Panther Party. That along with marijuana and other activism brought the attention of the FBI and several stints in jail.

October 3

1776—The Revolutionary War in Detroit

On this day, the British controlled Detroit at the start of the American Revolutionary War. The British leader in Detroit, Lieutenant Governor Hamilton, was fearful of attacks from American settlers in Ohio and Kentucky, and he hoped to induce the Indian warriors into attacking Americans. In a letter to General Haldimand dated 11:00 a.m., October 3, 1776, Hamilton wrote, "Last night the savages were assembled, when I sang the war song, and was followed by Captain Lernoult and several officers." The British killed an ox for an ox roast. Its head was cut off, and several of the Indian chiefs stuck a large tomahawk into the head and presented it to Hamilton. They told him the head represented the head of an American.

October 4

1880—What the Hotel Bellboys Say

The Detroit hotel bellboys had some guarded yet commonly shared secrets of their profession that were published on this day in 1880:

That cheap boarders give the most trouble,

That bachelors give much more trouble than married men in hotels,

That the average hotel detective is not worth his salt let alone his wages,

That the best clerks are those who have the least to say about themselves,

That Boston people always want a room where the carpets harmonize with the furniture,

That female boarders who laugh and chat are the kind who purloin soap and towels,

That country people's joy is ringing the electric bell and asking a variety of ridiculous questions,

That running up and down stairs materially shortens their lives.

October 5

1988—Anita Baker's Hit Album Sells Five Million Copies Worldwide

Anita Baker's album *Giving You the Best That I Got* was released in October 1988. It was an immediate success, topping the Billboard 200 and selling five million copies worldwide, three million of which sold in the States. Anita Baker was born in 1958 in Toledo, Ohio. Her childhood was not easy. She was the youngest of four girls, and when she was two, her mother abandoned them. Baker was raised by a foster family in Detroit. Her foster mother ran a beauty shop and instilled a strong work ethic in Baker and her sisters. When Baker was twelve, her foster parents died, and her foster sister raised her afterward; however, already Baker wanted to be a singer. In 1982, "Angel" became Baker's first top-ten single. In 1986, Baker released her second album, *Rapture*. She received two Grammys. Over her career, she has received eight Grammy Awards and been nominated seventeen times.

October 6

1862—A Letter from Julia Loomis, Age Twenty-two Years, to Her Brother, Leonard, Age Twenty-one

In 1862, as an inducement to get young men to enlist, local officials decided to offer a bounty of $50 for each single man and $100 for married men who volunteered for military service.

To Leonard
From Julia

October 6th 1862

Dear Brother:

Leonard Loomis, former Civil War veteran from Detroit, in the 1920s. *Author's collection.*

I have not heard any thing from you in a long time. Mother spoke of your enlisting. Oh! Leonard!...If my brothers are compelled to go and fight for the flag, the constitution and their country then I say go, but do not condescend to go for the "almighty dollar" our country cannot prosper it appears to me as long as this is the uppermost thought in the people's minds.

No Sir. Every heart must be inspired with patriotic love for and devotion to our country ere the Lord of Hosts will not send upon the efforts needs to save the Union. Are the people very much interested in behalf of our bleeding nation there or how are the minds tending? I wish you would answer all the questions I ask for I do not ask any only what I earnestly desire to know.

Write soon and tell all you can the more the better. Remember and do not enlist unless you are obliged to for just think of the anxiety that we must have about you. You know ma has not any husband and we have not any father.

Your sister, Julia

October 7

1986—Steve Yzerman Named Youngest Captain of the Red Wings
Following the departure of the previous captain, Danny Gare, after the 1985–86 season, Coach Jacques Demers named Steve Yzerman captain of the team on October 7, 1986, making him the youngest captain in the

team's history. The next season, Yzerman led the Wings to their first division title in twenty-three years. Ultimately, Yzerman led the Wings to five first-place regular season finishes and three Stanley Cup championships (1997, 1998 and 2002). Mike and Marian Illitich had purchased the Red Wings in the summer of 1982 and wanted to draft Pat LaFontaine, who was from the area. LaFontaine was instead drafted by the New York Islanders in 1983. The Illitiches, with help of general manager Jimmy Devellano, turned to their second choice, Steve Yzerman. It worked out.

October 8

1973—The Arab Oil Embargo

On October 8, OPEC (Organization of the Petroleum Exporting Countries) negotiations with major oil companies to revise the 1971 Tehran Price Agreement failed, and in response to American aid to Israel in the Yom Kippur War, OPEC raised the posted price of oil by 70 percent, to $5.11 a barrel. The following day, oil ministers agreed to the embargo: a cut in production by 5 percent and continued cuts of 5 percent increments until their economic and political demands were met. Prices on a barrel of oil rose until the 1980s, but for Detroit, it was the end of the gas-guzzling car era. Detroit automakers lost their mojo and their market dominance. They had ignored warnings of this vulnerability. A Ford Galaxie 500 in 1965 weighed 3,542 pounds with a small engine. By 1973, the same car clocked in at 4,300 pounds: a weight gain of 757 pounds. Its fuel efficiency was at 11.8 miles per gallon.

October 9

1940—From Cars to Tanks

On this day in 1940, Washington passed the Assignment of Claims Act to allow banks to loan funds for war production. To coordinate the effort, the National Defense Council was formed with GM president William S. Knudsen as chairman. Armored plating for tanks, engines for planes and forgings for artillery were a lot different than parts for Fords, Chevys and Dodges, even if the manufacturing was similar. The problem was how to quickly find companies to make products they were unfamiliar with.

Knudsen and a famous pilot of the day, James Doolittle, were in charge of aircraft production. Working with a team of others, they gathered together every nut, bolt, bushing, weldment, casting, forging and more for several aircraft and laid out the parts, with signs on the floor of an old plant on West Warren and Wyoming. They then invited toolmakers, manufacturers and more to walk through the aisles of displayed parts. Representatives of more than 1,500 companies walked up and down aisles inspecting samples. If somebody found something his plant could make, he was given a contract or subcontract to get at it.

October 10

2012—Detroit Lion Alex Karras

Alex Karras was born in Gary, Indiana. He was drafted in the first round of the NFL by the Lions in 1958. He quickly became a Detroit favorite and one of the most feared defensive tackles in pro football, playing for twelve seasons (1958–62 and 1964–70), all with the Lions, missing the 1963 season for gambling activities. But he was much more. After the gambling conviction that occurred at the Detroit bar Lindell AC and a stint in pro wrestling that would be the end of most careers, he managed to keep going. Early fans realized the fierce defensive lineman was also funny, intelligent and very human. His post-football career was perhaps more successful; Alex Karras could act. He did comedies and serious roles: he was the enormous, shirtless "Mongo" who famously punched out a horse in *Blazing Saddles* with his line, "Mongo only a pawn in life." His biggest hit was a 1980s television sitcom called *Webster*. He played the lovable, adoptive father, George Papadapolis. Karras even wrote two books. In his later years, Karras suffered several serious health problems, including dementia, heart disease and cancer. Alex Karras died on October 10, 2012, at age seventy-seven.

October 11

1836—The Hard Road of the Pioneer on Michigan Avenue

Pioneering families heading west with wagons loaded down left Detroit and traveled about nine miles the first day. While nine miles doesn't seem very

far, at that time it took an entire day. Some wagons reportedly sank to the hubs in sticky mud for mile after mile. One experience is related by the Mills family in 1836:

> *It was a beautiful day in mid-October that our party left Detroit...We advanced with our slow paced oxen team, we began to feel that we were going away from home, not to one...Our experience with the roads during the day—if the land was timbered, the road was proverbial bad...We found scattered along the road here and there polls and rails, used as levers, broken tongues* [part of the wagon used to hook up horses or oxen], *pieces of felloes* [the outer circle of a wheel to which the spokes are fitted], *an old wagon wheel, or an entire wagon, or sometimes an old abandoned stage coach laid careened and moldering by the roadside: each fragment or hulk telling a tale of adventure or mishap—mute reminders of the trials of those emigrants who had gone before.*

October 12

2012—Caucus Club Closes

As the iconic restaurant was celebrating its sixtieth anniversary, the storied Caucus Club suddenly announced it was closing. A fixture for decades in the Penobscot Building, the dark and clubby spot is where the legendary Barbra Streisand launched her career in 1961. It's long been a place for Detroit movers and shakers to meet for business lunches and dinners. The final owner, Mary Belloni, who began as a waitress at the Caucus Club, could no longer afford rising building rent prices. Belloni bought the restaurant out of bankruptcy in 1993. The Caucus Club served standards including oysters, escargot, London broil, veal piccata, fettuccini primavera and numerous traditional fish dishes. Its outstanding fried perch was once featured on the Food Network when Bobby Flay cooked it up. The Club was also famous for its "Zip" sauce served with steaks and hamburgers. The Caucus Club was started by Les Gruber as a lighter, more casual venue than the formal London Chop House.

October 13

1909—Fumbles Almost Kill DUS Against Oberlin

On this day, Detroit University School (DUS) nearly lost a grueling football game to Oberlin of Ohio. The field was described as "vile." The *Free Press* described it:

> *Lake Erie itself couldn't have been any wetter than the gridiron. The high spots were a bog, and the low places were pools of water several inches deep. Fumbling naturally was to be expected, and in this respect D.U.S. was woefully weak. The home boys managed to make a mess of nearly all their attempts to catch punts and their inability to squeeze the slimy pigskin kept them in constant trouble…But the bulldog tenacity of the Detroiters defense completed the obstacle.*

DUS beat Oberlin 6–2.

October 14

1813—A Soldier of the War of 1812 in Detroit

Samuel R. Brown was an American volunteer soldier in the War of 1812. Brown fought under then general William Henry Harrison on the Canadian side of the Detroit River and chased down the retreating British troops. The Americans caught up to them at the River Thames for the final battle, which the Americans won. After the battle, Brown and the American soldiers were stationed in Detroit. In October, Samuel Brown wrote to describe Detroit and surrounding areas:

> *The town of Detroit is situated on the western bank of the strait, nine miles below Lake St. Clair, and eighteen above Brownstown. The town contains about two hundred houses, which are inhabited by more than one thousand two hundred souls; under one roof, are often crowded several families. The principal streets run parallel with the river, and intersected by cross streets at right angles. They are wide, but not being paved, are extremely muddy in wet weather; but for the accommodation of passengers, there are foot ways in most of them, formed of square logs. Every house*

has a garden attached to it; the buildings are mostly framed, though there are several elegant stone and brick buildings…The country round Detroit is very much cleared.

October 15

1900—Detroit's First Chinese Restaurant

The earliest mention of Chinese restaurants in Detroit newspapers was in the 1870s, and these restaurants were in Asia or San Francisco. One of the first to open in Detroit was the Oriental Café in 1900. In a few years, Detroit boasted having twelve Chinese restaurants—a strange escape from mundane life with all the clichés firmly exploited. The décor was exotic, as described in a restaurant review of the day: "The ceilings are painted to represent the blue sky…Looking up one sees the blue sky and the clouds. In the night the light is furnished from above, but to carry out the illusion the moon and stars shine out in splendor and some of the electric lights are held in place by birds." One restaurant on Larned was busted in 1906 for housing an opium den in the basement where white women "hit the pipe" in "dark, smutty rooms."

October 16

1946—Gordie Howe Debuts in Detroit

Gordie Howe, aka "Mr. Hockey" (the name is trademarked), was born in 1928 in the tiny town of Floral, Saskatchewan, Canada. He played twenty-six seasons in the National Hockey League from 1946 to 1980. Twenty-three of his seasons were with the Detroit Red Wings. Howe tried out for the New York Rangers at age fifteen but did not make the team. Later, he was recruited by the Red Wings and made his NHL debut on October 16, 1946, playing right wing. He scored his first goal at age eighteen. He led the league in scoring each year from 1950 to 1954 and then again in 1957 and 1963. He ranked among the top ten in league scoring for twenty-one consecutive years and set a league record for points in a season (ninety-five) in 1953. Howe won the Stanley Cup with the Red Wings four times, six Hart Trophies for most valuable player

and six Art Ross Trophies as the league's leading scorer. Howe retired in 1971 and was inducted into the Hockey Hall of Fame the next year.

October 17

1839—MCRR Connects Detroit to Ann Arbor

In October 1839, the Michigan Central held a huge celebration to honor completing the railroad from Detroit to Ann Arbor. Eight hundred people rode in four long trains. At nine o'clock, they left Detroit. A reporter for the *Detroit Advertiser* described the scene: "The progress of the train was rapid. We flew as if 'we were on the wings of the wind.' Woods, fields, and cottages appeared and receded with lightening rapidity...On we flew through the beautiful valley of the Huron. Upon arrival of the cars in Ann Arbor they were met by a vast concourse of citizens...who met them with loud and enthusiastic cheers." Then, following speeches, several hundred people were escorted to a common square for an open-air dinner with plenty of drink, resulting in no fewer than thirteen toasts, including toasts to "this day—long delayed, long to be remembered!" "the State of Michigan," "the Central Railroad," "the University of Michigan—genius aided by science, the true source of all practical good" and, lastly, "to Women! Cupid's Locomotive!"

October 18

1808—Detroit's First Proposal for a Public Library

According to city historian Clarence Burton, the earliest suggestion to begin a public library is found in a petition addressed to the territorial governor and judges by Father Gabriel Richard, the priest at Ste. Anne's Church, on October 18, 1808. In 1817, the City Library Society was formed. It issued and sold stock at $5 each and generated $450 of working capital that it used to buy books. The library opened in a room at a building on Bates Street near Congress.

October 19

1834—Sports at the Michigan Garden

The first showman of Detroit was Major D.C. McKinstry. In 1834, when Detroit's population was about five thousand, he maintained a theater, a circus, a museum and a public garden at the same time. The Michigan Garden at Brush and Lafayette Streets was described as "at the northern extremity of the town." It advertised a restaurant, bathrooms and many kinds of trees and plants. On this day, the Michigan Garden advertised in the papers the following entertainment: "To Sportsmen!!! Rare sport at the Michigan Garden! Two Bears and one Wild Goose will be setup to be shot at, or chased by dogs on Tuesday, 20th October, at two o-clock p.m. N.B.—Safe and pleasant seats will be in readiness for Ladies."

October 20

2001—Gateway to Freedom International Memorial to the Underground Railroad

Located on the riverfront at Hart Plaza, the Gateway to Freedom International Memorial to the Underground Railroad commemorates Detroit's role in the Underground Railroad. It was sculpted by Edward Dwight, who won a competition to design the memorial, and dedicated on October 20, 2001. The project was a collaboration between Detroit 300 and the International Underground Railroad Monument Collaborative.

The Gateway to Freedom International Memorial to the Underground Railroad commemorates Detroit's role in the Underground Railroad. It was sculpted by Edward Dwight in 2001. *Image in the public domain.*

October 21

1867—"How to Remove Corpulency" or Dieting in Detroit in 1867

People have always wanted to feel healthy and look good, and this day in 1867 was no different. Some of the recommended food and exercise in 1867 is not too different than today, nearly 150 year later. First, the author claims to have surveyed 3,019 "perfectly healthy males" to determine the ideal weight for men in 1867:

Height	**Weight (in pounds)**
5'2"	120
5'5"	136
5'7"	145
5'10"	169
6'0"	175

(He goes no higher than six feet.) The dietician recommends eliminating anything that creates fat in the diet: "milk, beer, potatoes, fresh bread, butter, sugar, and any kind of vegetables except tomatoes." For breakfast, six ounces of sliced beef or mutton. For dinner (lunch), the largest meal of the day, "slices of beef, mutton or chicken, venison, partridge, or quail, cooked plainly with no vegetables except a good mealy potato and quantities of tomatoes. No spiritus [*sic*] liquors; wine is okay."

October 22

2009—Soupy Sales

Soupy Sales was born Milton Supman, in Franklinton, North Carolina. His father, a dry goods merchant, had immigrated to America from Hungary in 1894. His was the only Jewish family in the town. Sales joked that local Ku Klux Klan members bought the sheets used for their robes from his father's store. Soupy's nickname came from his family. His older brothers were nicknamed "Hambone" and "Chicken Bone." Milton was dubbed "Soup Bone," which was later shortened to "Soupy." He began his television career on WKRC-TV in Cincinnati. He moved to Detroit in 1953 and worked for WXYZ-TV (Channel 7). He was best known for his daily children's

television show, *Lunch with Soupy*. He claimed that he and his visitors had been hit by more than twenty thousand pies during his career. Soupy passed away on October 22, 2009, at age eighty-three.

October 23

1988—Michael Jackson Donates to the Motown Museum

Michael Jackson donated a personal signature black Fedora hat and white rhinestone studded right-hand glove, along with $125,000, to the Motown Museum. The money was the net proceeds of his "Bad World Tour" performed at the Palace of Auburn Hills.

October 24

1998—Hudson's Demolished

By 1961, the downtown J.L Hudson's department store had become the tallest department store in the world and was second only to Macy's in New York for square footage. The downtown store accounted for half of Hudson's revenue until people moved to the suburbs. It was demolished on October 24, 1998—Joseph L. Hudson's 152nd birthday. "Mr. Hudson's career has been a remarkable one, but pluck, perseverance, and true worth are at the bottom of it," the *Detroit Free Press* wrote in 1893.

October 25

1999—Detroit Public Schools Stop Using Coal for Heat

In 1986, a federal judge told Detroit Public Schools to stop using coal to heat twenty-one of its buildings. On this day thirteen years later, the school district was taking steps to comply. Fourteen elementary buildings and three other schools still relied on coal, which had been long abandoned as a heating fuel because of environmental and health concerns. "I'm thrilled to death we don't have coal," said Diane Fleming, principal of Schulze Elementary since 1989 in an interview with the *Detroit News*. Two new gas furnaces would warm her west side building on Santa Maria by the next

month. "Coal burns dirty, and it's hard for our children with asthma." In 1999, the district still owned a huge pile of coal on Zug Island in southwest Detroit. "Coal is high-maintenance," Schulze's principal said. "On a Monday morning after the weekend, the gas heat comes like this," she said, snapping her fingers. "Coal takes too long. Coal is too hard. Try shoveling 17 wheelbarrows full of coal to get the heat started."

October 26

1825—The Erie Canal Is Completed

Nothing may have had a more profound effect on Detroit than the completion of the Erie Canal. The Erie Canal was 363 miles long from Albany, New York, on the Hudson River to Buffalo, with thirty-six locks to accommodate an elevation change of 555 feet. It was about 4 feet deep on average and cost an unheard of price of $20,000 per mile to create. It opened on October 26, 1825, providing for the first time a navigable water route from the Atlantic Ocean to the Great Lakes and to Detroit. Boats called "packets" were towed by teams of horses that walked along the side of the canal. The packets were towed all day and all night. It was faster than wagons and cut freight transportation costs by 95 percent. The trip from beginning to end took about one week. Between 1830 and 1840, the population of Detroit rose 302 percent from 2,222 to 9,102 due in large part to the Erie Canal.

October 27

1811—Birth of Young Hotspur the Stripling

Born on this date was Michigan's boy governor, Stevens T. Mason, also known as "Young Hotspur and the Stripling." He was elected governor of the state of Michigan at age twenty-three in 1835 and served until 1840. Mason is the youngest state governor in American history. Cyrus P. Bradley was a visitor to Detroit at the time it was the state capital. He described the young governor in 1835:

After tea, I called on Gov. Mason and at length found him at home. I was prepared to see a young man, but not such a boy in appearance. He was,

however, a perfect gentleman in manners. He is short and thick-set, of dark complexion, handsome square features, high forehead and large head. He has black hair and black eyes, dresses in showy style, wore a broadcloth surtout and is much of an exquisite.

October 28

1846—Elmwood Cemetery

In the spring of 1846, a group of gentlemen decided the city needed a suitable place for a significant city cemetery away from the noise and bustle of the city. They selected a portion (forty-two acres) of what was then the George Hunt farm in Hamtramck, about a mile from then downtown Detroit. They paid $1,858 for the land, and it opened in October 1846. Burial lots were sold at prices of $15 to $100. The cemetery was described in a promotional directory from 1851: "[The burial lots] are beautifully placed on the highest land of this vicinity, and command fine and extensive views of the City and River of Detroit, and the surrounding country."

October 29

1813—Lewis Cass Appointed Governor of Michigan Territory

"At Detroit my situation is at all times very unpleasant and sometimes very unsafe."
–Lewis Cass, Detroit, 1814

As a reward for Lewis Cass's battlefield performance during the War of 1812 (he actually saw very little real action), on October 29, 1813, James Madison appointed Cass as governor of the Michigan Territory. When he arrived in 1814, life in Detroit was in shambles. Fences and barns were torn down, livestock stolen. War had prevented farmers from planting crops, so starvation had taken over. Some inhabitants were subsisting on boiled hay. Cass wrote to the U.S. secretary of war for help, noting that unless people "are assisted from the public stores they must literally perish...Hunger stalks the land." One visitor described

Detroit as "misery and ruin and famine and desolation." Indian bands, no longer supported by the British, raided Detroiters and at times pillaged and murdered farm families within sight of the fort; alarms sounded constantly. But Cass was relentless in pursuit of renegade bands of Indians and in placating those Indians friendly to Detroiters. He was persistent in writing to Washington for assistance. In May 1815, President Madison convinced Congress to approve $1,500 for food supplies, which Cass used to feed the starving.

During his long political career, Lewis Cass served as a governor of the Michigan Territory, an American ambassador, a U.S. senator and secretary of state. He was the losing nominee of the Democratic Party for president in 1848. *Courtesy of the Library of Congress.*

October 30

1914—The Horse Barn

On this day, a man in Detroit explained to the newspaper why a garage can never share the magic of horse barns:

> *The barn holds a hallowed place in our memories. The* [boyhood] *recollections of rainy afternoons in the hay mow…the barn was our haven and our refuge. Here if the mood seized up we found solitude…what was better than the companionship of old Dobbin* [farm horse] *or the sympathy of the spotted dog? The barn fitted our moods…on more gala occasions, assembled the boys of the neighborhood. It was the meeting house, the social center of boydom. It was boydom's castle…The garage is a poor substitute. It lacks sentiment…the garage will rise in trim, mowless, inhospitality.*

October 31

1860—Halloween in Old Detroit

The first mention of Halloween in the Detroit newspapers was in 1860; the autumnal holiday drew attention in Detroit and elsewhere in the United States when Irish and Scottish immigrants, who celebrated All Hallows' Eve overseas, began to settle. In the mid-nineteenth century, Halloween was made popular by the Scottish poet Robert Burns, whose long poem "Halloween," published in 1786, became a popular verse in nineteenth-century Detroit. It was based on the farmer and peasant celebrations in Scotland that Burns recorded. The *Detroit Free Press* described the old but unusual holiday in 1866: "It is still believed that on 'Halloween' the evening of the 31st of October the living have power not only over the spirits of the dead but over their fellow mortals, that by the practice of certain prescribed rites, they can summon, at will, the spirits of the departed, and that they can then obtain insight into their own future."

NOVEMBER

November 1

1930—Detroit–Windsor Tunnel Is Opened

On this day in 1930, President Herbert Hoover turned a "golden key" via telegraph in the White House to mark the opening of the 5,160-foot-long Detroit–Windsor Tunnel. The first passenger car it carried was a 1929 Studebaker. The construction method used is called "immersed tube." First, barges dredged a 2,454-foot-long trench across the river; next, workers sank nine eight-thousand-ton steel-and-concrete tubes into the trench and welded them together. Today, about thirteen thousand vehicles go through the tunnel every day. There was a recognized problem of how to tow out disabled vehicles without the ability to turn a tow truck around or back out. Tunnel management developed a unique method: the vehicle had two drivers, one facing in the opposite direction of the other. The tow truck drove in, the disabled vehicle was hooked up, and then the driver facing the other way drove it out.

November 2

1871—Ebenezer African Church Founded

Ebenezer African Church was founded on this day on Calhoun Street between Beaubien and St. Antoine Streets. It originated with 13 members led by Reverend G.C. Booth and was a Methodist Episcopalian church. Sunday school began the next Sunday with now 23 students. By 1880, the

church had grown and had on average 125 people attending on Sundays. The pastor's salary was $400, and the annual expenses were $800. To this day, the church is still providing Sunday services.

November 3

2014—Rising Up, Back on the Street

It is six thousand square feet, an enormous mural on Russell Street near Milwaukee Junction and not too far from Henry Ford's original car factory, the Piquette Plant. It was painted by street artist David Hooke, who goes by "Meggs." Meggs is from Australia and now lives in Los Angeles. As Meggs said about the mural, "The tiger, namesake of the Detroit Tigers baseball team for over a century, is a symbol that Detroiters relate to and feel proud ownership of. It was born from the city's past glory and survived through its unfortunate losses. The power of a tiger and its relationship with Detroit now represents a continuing symbol of tenacity & hope for a new era of positive change and re-growth."

Rise Up is a six-thousand-square-foot mural on Russell Street by Australian artist David Hooke, who is known as Meggs. *Photo by Barney Klein.*

November 4

1974—Coleman Young Elected Mayor of Detroit

Coleman Young was born in Tuscaloosa, Alabama. In 1923, his family moved to Detroit, where he graduated from Eastern High School in 1935. He worked for Ford Motor Company and was blacklisted for involvement in union and civil rights activism. He later worked for the U.S. Post Office. While there, he started the Postal Workers Union. During World War II, Young served in the 477th Medium Bomber Group (the famous Tuskegee Airmen) of the U.S. Air Force. In his early career, Young represented far left wing politics (some historians say that he was a member of the U.S. Communist Party), but when elected mayor of Detroit in 1974, Young moved toward a more left-center position, working well with Detroit businesses. His personality was blunt, crude and at times antagonistic toward white suburbia and state politicians. While he failed to control crime in the city and could not stop the flow of middle-class people fleeing the city during his tenure, in general he kept the city in good financial condition despite the economic uncertainty of the times. Young served five terms as mayor.

November 5

1851—News from the Underground Railroad

A newspaper was published in Sandwich (now Windsor, Ontario) by Henry Bibb called the *Voice of the Fugitive*. It reported news on the Underground Railroad. This day's issue reported, "This road is doing better business this fall than usual. The Fugitive Slave Law has given it more vitality, more activity and more passengers, and more opposition, which invariably accelerates more business…We can run a lot of slaves through from almost any of the bordering Slave States to Canada, within forty-eight hours, and we defy the slaveholders and their abettors to beat that if they can."

November 6

1857—The Panic of 1857

The Panic of 1857 was a typical financial bust following a financial boom due to speculation gone crazy in railroad construction, manufacturing growth, overexpansion of wheat farming and unregulated state banking. Michigan was hit hardest among the states due to a poor wheat crop and depressed lumber business. Between 1857 and 1858, hundreds of businesses went bankrupt. In Detroit, workingmen and women were released from their jobs, and breadlines were common. In Corktown, Irish children turned out to go begging for food and clothing to support families.

November 7

1957—Lodge Freeway Dedicated

On this day, the John C. Lodge Freeway (M10) was dedicated. It started as a small segment downtown but later connected other roadways, such as James Couzens Highway and Northwestern Highway, to reach all the way to Southfield in 1964. John C. Lodge began in Detroit as a reporter. He was a member of the constitutional convention that drafted the Michigan Constitution of 1908, a former member of the Michigan legislature and Detroit alderman and councilman. He later served as mayor of Detroit in 1918–19 before returning to the City Common Council from 1932 to 1947. He died in 1950, and the Lodge Freeway was named in his honor.

November 8

1870—Black Detroiters Vote for the First Time

For the first time, black people voted in an election. Seventy-five U.S. deputy marshalls were sent to Detroit on this day to control the polls, much to the resentment of Detroit newspapers. They alleged that political operatives were going to Windsor to recruit over one hundred black voters living in Canada to come to Detroit and illegally register to vote. Other accusers wrote that black voters were brought to Detroit from Buffalo and Chicago. It was never proven.

November 9

1973—Donald Byrd Plays with the Blackbyrds

On this night, you might have seen Detroiter Donald Byrd play trumpet with his band the Blackbyrds. Donaldson Toussaint L'Ouverture Byrd II was a jazz and rhythm and blues trumpeter born in Detroit in 1932. A sideman for many other jazz musicians, Byrd was among a great generation of bebop jazz artists who came out of Detroit in the 1950s; by high school, Byrd was considered a brilliant trumpeter. He began his career in the 1950s playing for Art Blakey's legendary Jazz Messengers. In the early 1970s, he formed the Blackbyrds, a fusion band; Byrd was best known for bebop jazz, but he also pioneered the funk, soul and fusion genres. As a bandleader, Byrd was also notable for his influential role in the early career of renowned keyboard player and composer Herbie Hancock. He died in 2013 at age eighty.

November 10

1997—Little Gem Theatre Moved

On this day in 1997, facing certain destruction to make room for the new Comerica Park, the restored historic Gem Theatre was moved by its owner, developer Charles Forbes. It was trucked five blocks to Madison and Brush Streets, breaking the 1986 Guinness Book of Records for heaviest building moved on wheels. It began as a clubhouse for socially prominent women in Detroit known as the Twentieth Century Club. A theater (the Gem) was added in 1928. The club disbanded and went through many changes, eventually becoming an adult movie house in 1967 until it closed in 1978. Developer Charles Forbes purchased the combined Gem/Century building and began a complete restoration of the Gem Theatre in 1990. The refurbished Gem opened in 1991.

November 11

1923—World's Biggest Flag

On this day (Armistice Day—celebrating the end of World War I, later changed to Veterans Day), Hudson's department store in downtown Detroit

draped across the Woodward side of its building an enormous American flag that covered seven stories of the building façade. The flag was 90 feet high by 230 feet long. Nearly a mile of rope was needed to hang it. It was also hung on Flag Day and the Fourth of July. The flag was replaced after twenty-six years with a new, even larger flag in 1950. It was seventeen stories high and was last displayed in 1976 for the U.S. bicentennial, afterward donated to the Smithsonian Institute in Washington, D.C. The gigantic flags were made by the George P. Johnson Company, a flag maker and sail repair company in Detroit.

November 12

1943—Detroit's Gotham Hotel

In Detroit's black community, the place to be was the nationally famous twin-towered Gotham Hotel at 111 Orchestra Place on the northern edge of downtown where Ford Field now stands. It was an Albert Kahn architectural design, built in 1925 as a lavish private residence for a medical supply magnate, Albert Hartz. In 1943, Hartz sold the mansion to John J. White and Irving Roane, two black Detroit businessmen, for $250,000. They turned it into a social center for Detroit's black community. It had nine stories with three hundred rooms. At its peak of fame, it hosted one thousand guests a week. Some of the regulars who lodged and dined at the Gotham over the years included Ella Fitzgerald, Benny Goodman, B.B. King, Jesse Owens, the Harlem Globetrotters, Langston Hughes, Louie Armstrong, Thurgood Marshall, Duke Ellington, Sammy Davis Jr., Dr. Martin Luther King Jr., Sarah Vaughn, Joe Louis and Adam Clayton Powell. The Gotham closed as a hotel in 1962 after falling on hard times. The building on Orchestra Place was razed in 1963.

November 13

1920—Losing Control of Motor Traffic in the Motor City

Motorcars were overwhelming cities in the first decades of the twentieth century. In Detroit, things happened about three years earlier than in the rest of the United States due to the auto industry's being concentrated in the city. From 1916 to 1917, Detroit police reported an increase in accidents from 3,987 to 4,554. Stolen cars rose from 1,097 in 1915 to 4,405 two years later. Traffic

A traffic jam in the 1910s. Detroit led the United States in innovative traffic control. *Courtesy of the Library of Congress.*

complaints to the police skyrocketed from 5,952 in 1916 to 30,036 in 1917. Fatalities from automobiles and trucks rose from 34 in 1915 to 108 in 1917; many if not most of these were young children ages five to nine years who played in the streets. To combat this, James Couzens, then head of the police department, used a device borrowed from a tennis club to mark lines in the street that were deemed "Safety Zones." They were located near stops for streetcars in which people would exit a street car and not look for oncoming traffic. They worked and became known in the United States as the Detroit System.

November 14

2007—Quicken Loans Moves to Downtown Detroit

The November 14, 2007 *Detroit News* reported:

> *There's good news in Detroit today with the announcement that Quicken Loans will move its headquarters into the city. The mortgage company's*

move from Livonia bolsters Detroit's revival and further legitimizes the city as a place for companies to locate. Quicken owner Dan Gilbert says the move to Detroit is about more than just moving the headquarters from Livonia. He's interested in helping revive the urban core and will join the likes of Compuware's Peter Karmanos, the Ilitch family, Roger Penske and Dave Bing, to name a few, in helping do just that.

November 15

1929—Ambassador Bridge Opens for Business

The Ambassador Bridge opened on November 15, 1929, its total cost $23.5 million. It took two years to complete. When completed, the bridge had the longest suspended central span in the world—1,850 feet, which was surpassed in 1931 by the George Washington Bridge in New York City. The bridge's total length is 7,500 feet. The bridge is made up of nineteen thousand tons of steel, and the roadway rises as high as 152 feet above the Detroit River. Only the main span over the river is supported by suspension cables. Originally, the Ambassador Bridge was painted glossy black, but during a five-year refurbishment, from 1995 to 2000, it was repainted teal.

November 16

1914—Those Rock 'Em, Sock 'Em Brothers Dodge

The Dodge brand was the work of two brothers, Horace and John Dodge. Horace was the gifted mechanic while John handled sales and managerial duties. They were born in Niles, Michigan, in the 1860s and were virtually inseparable for their entire lives. The *Detroit News* reported that Horace and John Dodge were to build a new plant on twenty-four acres in Hamtramck, and on November 16, 1914, the first Dodge car rolled off the line, priced far higher than Ford's Model T but offering more. Despite their immense wealth, enormous Grosse Pointe homes and growing influence in the business community, the Dodge brothers' personal conduct made them socially at odds with most of Detroit's wealthy elite. John had a violent temper and when drinking in Detroit saloons got into brawls and threatened people with

guns. The *Detroit Free Press* reported one brawl in 1911 at Schneider's Saloon in which John Dodge and a friend severely beat a lawyer. The lawyer was quoted: "He choked me and knocked me toward Dodge who struck me several times. I went to the floor and felt someone kicking me." He was hospitalized, which was bad enough, but later it was reported the victim had two wooden legs.

November 17

1807—Treaty of Detroit

The Treaty of Detroit was between the United States and the Ottawa, Chippewa, Wyandotte and Potawatomi Native American nations. The treaty was signed at Detroit, Michigan, on November 17, 1807, with William Hull, governor of the Michigan Territory and superintendent of Indian affairs the sole representative of the United States. With this treaty, the First Nations ceded claim to a large portion of land in what is now southeast Michigan and northwest Ohio.

November 18

1883—Legends of Le Detroit *Published*

On this day, Marie W.C. Hamlin's classic collection of French Detroit mythical legends and French family history called *Legends of Le Detroit* was released by Detroit publisher Thornkdike, Nourse and Company. It was delightfully illustrated by Detroiter Isabelle Stewart. The legends were first published in the *Detroit Free Press*. A review on this day of the classic Detroit history came out at the time: "In this new volume… Mrs. Hamlin gives a history of the Golden Age before civilization had banished romance, and the early French Habitant brought his quaint customs, his chivalric presence, his love and his loyalty to Detroit… There is much valuable historic lore embroided [*sic*] with threads of romance." Hamlin was an expert in genealogy, herself a descendant of the celebrated Godfroy family of Normandy and Brittany.

November 19

1988—Fox Theatre Reopens

The Detroit Fox Theatre is one of five Fox Theatres built in the late 1920s by film pioneer William Fox. The others were the Fox Theatres in Brooklyn, Atlanta, St. Louis and San Francisco. Walking into the Fox Theatre takes your breath away with the over-the-top décor and immensity of the space. Architect C. Howard Crane designed the Fox with a lavish interior featuring a wild blend of Asian motifs from Persia to India. The exterior of the attached ten-story office building features a façade with Asian motifs that, when illuminated at night, can be seen for several blocks. The Fox opened in 1928 and remained Detroit's premier movie destination for decades. It was the first movie theater in the world to be constructed with built-in equipment for sound films. Unlike many neighboring theaters, it operated continually until it was closed in the 1980s for restoration. In 1988, the theater was acquired by new owners, Mike and Marion Ilitch, who fully restored the Fox at a cost of $12 million.

November 20

1859—City Mortality

During November 1859, the city of Detroit reported the number of people who died and what killed them:

Scarlet fever—14 (deaths), inflammation of the brain—1, congestion of the brain—1, fits—1, stillborn—1, teething—2, consumption—12, cramps—1, liver complaint—3, accident—4, apoplexy—1, diarrhea—2, croup—6, childbed—1, dyspepsia—1, old age—2, dropsy—1, delirium tremens—1 and unknown—8.

November 21

1899—Theodore Finney's Orchestra

In 1857, Theodore Finney, a black musician, came to Detroit from Columbus, Ohio, at a time when Detroit's black population was around 1,200 people.

His band would be one of Detroit's first to feature "syncopated music," a style that would lead to the popular jazz brass bands of the 1900s. The Finney orchestra was a regular on the steamers, especially the *Frank Kirby* that ran between Detroit and Sandusky, Ohio. His orchestra played for all occasions, including dances, parades, political rallies, weddings and formal concerts. Theodore Finney was riding a bicycle in Detroit carrying a violin and music when he collapsed with heart failure on this day.

November 22

1981—Corrado Parducci

On this day, Corrado Giuseppe Parducci passed away. Parducci (he went by "Joe") was an Italian American architectural sculptor and celebrated artist for his numerous early twentieth-century works in New York but especially in Detroit and surrounding areas. He came to Detroit at age twenty-four to work with architect Albert Kahn, and his decorative design work can be found on many buildings in downtown Detroit and southeast Michigan. Parducci was born in Buti, Italy, a small village near Pisa, and immigrated to New York City in 1904. He attended the Beaux-Arts Institute of Design and Art Students League. With the automotive industry booming in the 1920s, Parducci moved his family to Michigan and ended up spending the rest of his career working from Detroit. One of Parducci's known Detroit studios was located at Cass Avenue and Sibley Street, but it has been demolished. The Parducci Society, founded in 2012, is producing a film on his life and work entitled *Parducci: The Man Who Made Detroit Beautiful*.

November 23

1909—Boys at the "Burlies"

A survey entitled "Survey of the Boyhood of Detroit, 1909" was conducted by the YMCA in Detroit of boys on the city streets in 1909. It reported the following: "There were six large theatres in Detroit: 2 burlesque, 2 vaudeville, 1 melodrama and 1 first class opera house. Of the two burlesque houses one attracted more boys than the other. It was suggestive

in the extreme. The melodrama was largely attended by boys and girls, the majority being boys. The performances were suggestive of immorality in the lives that the actors impersonated."

November 24

1943—Dave Bing

Dave Bing was born on this day in Washington, D.C., in 1943. On the basketball court as a child, he could beat out older and bigger children, such as future Motown superstar Marvin Gaye. (Bing and Gaye forged a friendship that continued later in life.) Bing's basketball star rose at the University of Syracuse, and later, he became a high-scoring guard for twelve seasons in the NBA, nine of which were with the Detroit Pistons. A very effective player but modest man, Dave Bing was never a well-known celebrity but excelled in an NBA era of backcourt legends that included Jerry West, Oscar Robertson and Walt Frazier. He made the transition to the business world. In 1980, Bing opened Bing Steel with four employees in a rented warehouse from $250,000 in loans and $80,000 of his own money. By 1985, Bing Steel had expanded to two plants with sixty-three employees and was posting revenues of $40 million. In 2008, Bing announced that he would be a candidate for the mayor of Detroit and was elected to complete former mayor Kwame Kilpatrick's term, which ended on December 31, 2009. Bing was reelected to a full term in 2009.

November 25

1868—Dr. Eleanor M. Howe

The resident doctor at the Woman's Hospital and Foundling's Home that opened in November 1868 was a female physician, Dr. Eleanor M. Howe, the first of a series of female doctors who served as resident physician and matron without remuneration; male physicians refused take such a post for it required nursing, prescribing medicine, arranging meals, providing clean linens, managing household finances and conducting daily worship. Other subsequent physicians at the hospital were Dr. Mary Forsyth, Dr. Sara Craig, Dr. Mary Smith and Dr. Elizabeth Farrand.

November 26

1872—Woman Sees the Nain Rouge

If anyone doubts the existence of the Detroit's infamous hobgoblin, the Nain Rouge, the menace was confirmed by a woman who lived on Elizabeth Street East in 1872. The Nain Rouge (in English, "Red Dwarf") was a hideous creature that appeared on the road before Detroit's founder Le Mothe Cadillac. Cadillac, out of his infamous arrogance, made the mistake of swinging his walking stick at the beast, which has brought bad luck to the city ever since. In 1872, Jane Dacy was preparing for a night errand when in the dark backroom of her house she saw a ghost with "blood red eyes, long teeth and rattling hoofs." This description fits the Nain Rouge like a haunted glove! Naturally, Ms. Dacy "saw the fearful spectre and fell down in a lump, fainting so far away that camphor had no effect." The newspaper went on to say it took her several days in bed to recover her senses.

November 27

1834—Detroit's First Thanksgiving

Before the 1830s, Detroiters, who were mostly French Canadian Catholics, did not recognize "Thanksgiving." But with the huge influx of New Englanders and New Yorkers arriving in Detroit, it was time to bring the Thanksgiving holiday to the city. In 1834, the declaration was made by Michigan's "boy governor," Stevens T. Mason, who at that time was secretary of the territory (Michigan achieved statehood in 1837):

> *I do hereby appoint Thursday, the Twenty-seventh of November next as a day of thanksgiving and prayer; that contemplating with reverence and resignation the dispensations of the Supreme Ruler of the Universe in the destructive pestilence that has visited our territory* [in 1834, Detroit suffered from a cholera epidemic that killed 7 percent of the population], *we may present our prayers of gratitude for being permitted still to enjoy a participation in the blessings of his providence.*

November 28

1999—Rosa Parks Tribute at Orchestra Hall

Vice President Al Gore presented civil rights hero Rosa Parks with the Congressional Gold Medal at a sold-out tribute at Detroit's Orchestra Hall as well-wishers cheered, clapped and shed tears. "I thank God she was not afraid," Gore said. "I thank God love, not fear, guided her that day." Parks defied Jim Crow laws in the South in 1955, when she refused to give her seat to a white man on a city bus in Montgomery, Alabama. Due to threats on her life, she moved to Detroit in 1957. On this night, Rosa Parks was a frail, eighty-six-year-old. She was escorted into the hall in a wheelchair as more than two thousand politicians, celebrities, community leaders and admirers gave her a standing ovation. Parks smiled, thanked the crowd and in a very soft voice said that she was very happy. "I hope and pray that it continues," Parks said, referring to the civil rights movement. The star-studded event, which was hosted by actors Ossie Davis and his wife, Ruby Dee, featured a long list of politicians and celebrities, including Detroit mayor Dennis Archer and Aretha Franklin, who serenaded Parks. Rosa Parks passed away in 2005.

Each person must live their life as a model for others.
—Rosa Parks

November 29

1760—British Take Possession of Detroit from French

On the twenty-ninth of November, 1760, French colonel Bellestre officially surrendered French Detroit and the fort to the British. In September, French Canadian governor Vaudreuil had written a letter for Belleste stating the conditions of surrender. Major Robert Rogers was sent to Detroit with two hundred of his famous rangers in fifteen canoes to take control of the fort. Despite horrific weather, they arrived at the head of Lake Erie and were told four hundred Indians were waiting to attack if they continued to Detroit. Despite this, Roger's party moved on unmolested. When Rogers was within half a mile of the fort, Bellestre requested the official letter from Vaudreuil and then surrendered the fort to Rogers. The French garrison consisted of

three officers, thirty-five regular army and seventeen English prisoners of war. The French soldiers were sent to Philadelphia, and from there, many returned to France.

November 30

1816—A Hack Job on Michigan from Edward Tiffin

In 1815, Ohio native Edward Tiffin, the U.S. surveyor general, visited Michigan and reported on November 30, 1816, to the U.S. secretary of war. They were looking for land to give to veterans of the War of 1812 as reward for service. Tiffin gave a notoriously inaccurate accounting of Michigan: "There would not be more than one acre out of a hundred if there would be one out of a thousand would…admit of cultivation…It was unsafe for men or pack mules, the ground sinking at every step and shaking for several feet around, having indications of being over a vast underground lake covered by a thin crust though which a man or mule might easily break and be lost." It is likely that Tiffin and his team of surveyors saw very little of Michigan. As a result of the Tiffin report, President Madison recommended to Congress that, since the lands in Michigan were covered with swamps and unfit for farming, only a small proportion could be applied to the intended grants, and that other lands should be designated to take the place of Michigan's portion. It has been said that the Tiffin report delayed statehood for Michigan by ten years.

DECEMBER

December 1

1953—Cinerama Music Hall

Before there was IMAX, there was Cinerama. Cinerama with its wraparound screen became that bigger-than-life movie theater experience in 1953. In the United States, only three cities could boast of having theaters with Cinerama: New York, Los Angeles and Detroit's Music Hall. Music Hall boasted the best attendance and premieres of the era. It was set up by William McLaughlin. The Music Hall and Cinerama had been closed since the 1967 riots. In 1971, David DiChiera, founder of the Michigan Opera Theatre, began by taking over the abandoned Detroit Music Hall as a startup opera house. With a group of volunteers, DiChiera took down the old Cinerama screen. He explained to the *Detroit News* in 2013, "We thought the balcony had a dirty carpet, but when we started cleaning, it wasn't a carpet. It was dirt."

December 2

1861—John B. Gough

Temperance groups used every tool they could find to get people to give up drinking. One method was through emotion, especially melodrama, and they found John Bartholomew Gough, the reformed drunk. He was born in 1817 in Upstate New York, moved from farm to the city and after a bookbindery job became an actor. He drank heavily as he acted in theater

and sang in squalid dives. Usually drunk, he lost his wife and child, was arrested countless times for being drunk and disorderly, was on the streets penniless and suffered from delirium tremens. A man from Massachusetts saved him and made him sign a pledge to stop drinking. In addition, he was to confess his tragic story to a small gathering of "drys." For Gough, it became an awakening. His hold on that audience as he told them his heart-rending story was absolute. He came to Detroit several times over twenty years to give lectures to temperance audiences. December 2, 1861, was one: "He is unsurpassed by any living orator. At will he moves an audience from convulsions of laughter to floods of tears…His lectures are entrancing as plays, his acting equal to that of the finest 'star,' while he inspires his hearers with healthful sentiments and noble thoughts."

December 3

1883—Volunteers Stay at House of Corrections

On this day and through the winter months, unemployed men and transients down on their luck voluntarily applied to stay in jail at the Detroit House of Corrections as a "good place to winter." As Judge John Miner described the situation at the time: "The numbers vary in different years greatly, and from observation should say that such applications bear a pretty close relation to the state of demand for Labor in the Country." Most were native Detroiters, but many came from Ireland, Germany, England and Canada. Most were described as "laborers," but many were also seamen and farmhands. Their ages ranged from sixteen to mid-thirties. As one man said, "I had to come here or starve or commit crime; could not get work for my board."

December 4

1999—Kennedy Center Honors for Stevie Wonder

On this day, Stevie Wonder was recognized for his lifelong contribution to the arts and culture of the nation by the Kennedy Center for Performing Arts in Washington, D.C. Other honorees in 1999 included Sean Connery, Jason Robards, Judith Jamison and Victor Borge. Introduced by the event's

host, Walter Cronkite, Wonder was described as "a child of Michigan and Motown who in the wonder of music looked up from his blindness and saw the world lifted up."

December 5

1915—Henry Ford on Oscar II

Henry Ford was against U.S. involvement in the European war—World War I. In November 1915, he announced to a New York City press conference that he had chartered the ocean liner *Oscar II* for a diplomatic mission to Europe and invited the most prominent pacifists of the age to join him. This included Hungarian American Rosika Schwimmer, Jane Addams, William Jennings Bryan, Thomas Edison and John Wanamaker. The criticism was severe; many called Ford crazy.

Henry Ford Sr. *Courtesy of the Library of Congress.*

The *Oscar II* was labeled the "peace Ship by some but by others the 'Ship of Fools.'" The *Oscar II* set sail from Hoboken, New Jersey, on December 5, 1915, as fifteen thousand people watched in what the press called a "circus-like" atmosphere. When the *Oscar II* docked at Norway, Ford shocked the delegation and walked away on December 23, saying he had had enough. A peace conference was arranged, but continued German submarine warfare ended any chance for success. The United States was drawn into the war a little more than a year later.

December 6

1901—Milkman's Lament: The Milk Bottle

Milk bottles were introduced to Detroit in the 1880s, but some milk peddlers, who, prior to bottles, ladled milk out of cans for housewives, didn't like the bottles. Bottles had to be cleaned, and there was the expense; bottles disappeared. Milk men claimed housewives stole them. As one milkman complained to the newspaper on this day, "What do they do with the bottles? Why they use them to put up catsup and fruit. I got after one woman who had been working me for bottles for some time and a search warrant showed thirty-five of my bottles on her preserve shelves!"

December 7

1824—Fish in the River

On this day, the newspaper the *Commercial Advertiser* reported:

> *White-fish, as we have been told by an old inhabitant, were first taken with nets in the Detroit River about fifty years ago. It is said that a British lieutenant, who was stationed at that time at this post, first discovered the movements of the white-fish, and suggested the idea of taking them with nets…he had heard at times a rushing noise in the water. The lieutenant waited a few minutes, and had the pleasure of hearing the rushing, which, as he was somewhat acquainted with fishing, he knew to be caused by an immense number of fish rising to the surface of the water. A small net was immediately got in readiness, and such was the number caught, that, from four dollars, the price soon fell to four shillings a hundred.*

December 8

1941—Detroiters Tighten Up for World War II

As soon as Pearl Harbor and World War II were made official, price controls and rationing were announced. Detroiters were locked into their jobs: no one was permitted to quit or transfer without the consent of the War Labor Board. Wages were frozen but to soften it, rent rates and prices

for food, clothing and other essentials were also locked. To make sure the U.S. military had enough resources, gasoline and tires were rationed. With limited car travel, major highways were deserted except for trucks and buses. People were encouraged to carpool, and many Detroiters hoarded gasoline coupons for special trips. By 1942, shortages made rationing necessary for numerous commodities, including meat, canned goods, fuel oil, sugar, shoes, clothing, liquor and cigarettes.

December 9

1935—Lions' First Championship

The Detroit Lions won their first NFL championship by beating the New York Giants 26–7. It was the third-annual title game for the nearly new NFL. The champion of the Western Division was the Detroit Lions, and the champion of the Eastern Division was the New York Giants. The Giants were attempting to win two consecutive championships while the Lions were attempting to win their first. The weather in Detroit for the NFL championship game was gray, wet and windy. The field at the University of Detroit's Titan Stadium, where the Lions played, was sloppy. When asked about the game over seventy years later, Glenn Presnell (who was also the last surviving member of the Detroit Lions inaugural 1934 team) said this about the game: "I remember that it was a snowy day, very cold, and there were far less fans there than the '34 Thanksgiving Day game. In those days, people didn't go very often when it wasn't nice weather." The Lions also won championships in 1952, 1953 and 1957.

December 10

1887—Ashes to Ashes: Detroit's First Crematorium

The state's first crematorium was opened in Detroit on Fort Street at Springwells. The papers described it as a "red brick building with a low roof—a queer looking building." It included a columbarium: a hall with windows, benches and niches that held funeral cinerary urns. The crematorium was started through the efforts of Dr. Hugo Erichsen, a German immigrant to Detroit. Dr. Erichsen had to go to Lancaster, Pennsylvania, in

1885 to have his wife cremated. With other medical and health officials, he founded the Michigan Cremation Association in 1886 and, through petitions, got approval for the crematorium in Detroit. The first person to be incinerated in the state was Mrs. Barbara Schorr of Millersburg, Ohio. She was cremated on December 10, 1887, and her ashes were presented to her son, Dr. Ernst Schorr, of Detroit. The newspaper described the ashes as "white and slightly splintery." Her painted portrait was presented in 1914 by her son and hung at subsequent Detroit crematoria.

December 11

1898—Edgar Guest, Detroit's People's Poet

Edgar Albert Guest was born in 1881 in Birmingham, England, and came, with his family, to the United States in 1891. He began as a copyboy at the *Detroit Free Press*. On this day, his first poem appeared in print. What Edgar Guest did at the turn of the twentieth century was pen very homey poems that critics loathed but regular folks read and loved. His poems were the type to appear in *Reader's Digest*, sentimental verse your grandmother memorized and taped to the wall; however, sentimental or optimistic poems regularly ran in U.S. newspapers throughout the nineteenth century. Guest's work was really of that era. He became a naturalized citizen in 1902 and wrote his poetry for forty years, syndicated in three hundred newspapers. Judith Guest, author of the novel *Ordinary People*, is the great-niece of Edgar Guest. On the television show *All in the Family*, Edgar Guest was Edith Bunker's favorite poet.

When you're up against a trouble,
Meet it squarely, face to face,
Lift your chin, and set your shoulders,
Plant your feet and take a brace,
When it's vain to try to dodge it,
Do the best that you can do.
You may fail, but you may conquer—
See it through!
—Excerpt from "See It Through"

December 12

2013—Packard Plant Purchased

The 3.5 million-square-foot Packard Motors plant opened in 1903 and was considered state of the art for manufacturing. It is located on forty acres of land off East Grand Boulevard on the city's east side. It has been closed since 1958. After decades of neglect, vandalism and scrapping, it became the world's biggest, scariest and most dangerous ruin. However, in 2013, a Spanish investor, Fernando Palazuelo, expressed interest in owning the Packard Plant. It was purchased for $405,000 on December 12, 2013. While many people were skeptical about why anyone would buy such a colossal wreck, Palazuelo showed that he is sincere and has a vision for the facility. He moved into the plant on April 9, his fifty-ninth birthday.

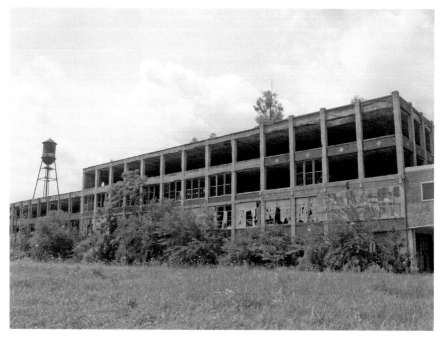

The Packard Plant on Detroit's east side was designed by Albert Kahn and was considered state of the art in manufacturing when built. *Photo by Barney Klein.*

December 13

1979—"The Joe" Opens

The Joe Louis Arena was opened for the first time in Detroit on this day. Named for boxer Joe Louis, who had grown up in Detroit and defended his heavyweight championship title a record twenty-five times, the arena has been a symbol of Detroit since it was completed in 1979. The $57 million cost of the building's construction was publicly funded by the city. "The Joe" is capable of holding roughly twenty thousand spectators and has been the home of the Detroit Red Wings since 1982. More than a dozen college hockey events are held annually at the Joe. The Joe's sold-out concert events have included Janet Jackson, Frank Sinatra and Luciano Pavarotti.

December 14

1840—Dinner at the Steamboat Inn

At this time, American hotels offered the "American plan": a room and meals combined. This included Detroit's Steamboat Inn. The alternative was called the "European plan," which did not include meals. The American plan was popular in America because there were no restaurants, only small taverns. However, a lot of travelers disliked the American plan. One traveler, Amos Andrew Parker, was from New Hampshire. He described the free-for-all at the Steamboat Hotel:

> *When the bell rang for dinner, I hardly knew what it meant. All in and about the house jumped and run as if the house had been on fire; and I thought that to have been the case. I followed the multitude, and found they were only going into the hall to dinner. It was a rough and tumble game at knife and fork—and whoever got seated first, and obtained the best portion of dinner, was the best fellow. Those who came after must take care of themselves the best way they could; and were not always able to obtain a very abundant supply.*

Parker was also not pleased with his accommodations: "At night, I was obliged to sleep in a small room having three beds in it, take a companion, and a dirty bed."

December 15

1893—Traveling "Drummer" Stops in Detroit

On this day, a guest of a Detroit hotel, such as a traveling salesman, a "drummer," on Sunday would take the day at a more leisurely pace. He typically climbed out of bed late, bathed and visited the hotel barber. As described in the Detroit newspaper:

A shave with a few hot towels adroitly applied will make him look like an Adonis. His clothes are neatly brushed and he buys a flower. His necktie is of the latest style with a small bow, flowing at the ends; he wears an elaborate scarf pin and his shoes are bright and shining, his trousers have no wrinkles and he carries a stick that is not too loud, just loud enough. After a heavy breakfast he strolls to the counter and purchases a paper…then placing his feet on the windowsill so he can command a good view of passersby, he lights a mild smoke and puffs at it leisurely and with great appreciation…As he sits there he has no thought and no care, and there is not a wrinkle on his face, and his mustache has a perfectly free-and-easy curl to it that bespeaks an easy going temperament.

December 16

1854—Shopping

Shopping on this day in 1854 in Detroit was described by city historian Silas Farmer:

The store has a free stone front and is four stories high…Comprising ten rooms, each with twenty-five feet in width and one hundred feet deep, filled to their utmost capacity with carpets, cloths, millinery, and clothing. The retail rooms are four in number, finished in the most gorgeous style. About three hundred gas lights are required to light the several apartments. From sixty to seventy-five sales men and from one hundred to one hundred and fifty person altogether are employed in the several departments. With outside seamsters and seamstresses, the firm gives employment to about six hundred persons.

December 17

1916—Skating with Four Thousand Others

The Arena Palace, at Woodward and Hendrie, opened for ice skating in 1916, and no fewer than four thousand people lined up for tickets to skate, blocking sidewalk and even the streets as they mobbed the entrance. Once inside, it was a winter frolic as the band played Hawaiian music and tangos while masses of people, mostly teenagers, all skated in unison to the rhythm of the music.

Ice skaters at Belle Isle. *Courtesy of the Library of Congress.*

December 18

1913—Detroit Seven Destroy Toronto Club in Hockey

Led by star Gordon Meeking and Captain Heffernan, Toronto Rowing, an amateur club, was formidable as it came to Detroit for a game of hockey. A sportswriter described the star: "Meeking is very fast on his skates, a beautiful stick handler, and a man who is constantly in on the net when attacking his apponent's [*sic*] goal. He scores time and time again on the rebound." Nevertheless, the Detroit Seven won 7 to 5. (Seven men played on the ice at that time; however, for this game, Detroit's "rover" was ill so both teams played with six men per side, a change advocated by eastern teams at that time.)

December 19

1887—Detroit Symphony Orchestra's First Performance

The Detroit Symphony Orchestra (DSO) performed the first concert of its first season at 8:00 p.m. on Monday, December 19, 1887, at the Detroit Opera House. The conductor was Rudolph Speil. For this initial evening concert, the DSO performed Beethoven's Symphony No. 2, an Overture by Lindpainter, two movements of Berlioz's "Damnation of Faust," Gottschalk's "Last Hope" and a Hungarian Rhapsody by Liszt. A soprano named Miss Dora Henninges was guest soloist for arias in Verdi's Sicilian Vespers. The critic wrote, "The audience was extremely flattering in numbers as well as manifestly critical in taste," but he ripped up Miss Henninges: "She fell far short of general expectations."

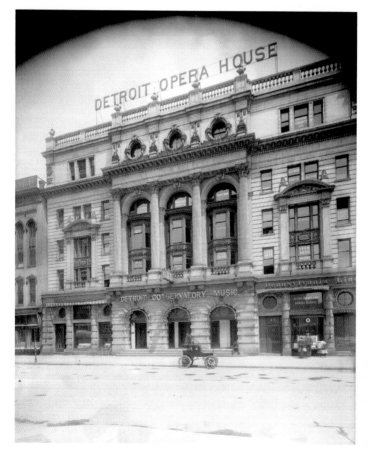

The Detroit Opera House, the first home of the Detroit Symphony Orchestra. *Courtesy of the Library of Congress.*

December 20

1919—Christmas Safety Warning

It had grown so dangerous that it became an annual Christmas tradition for the Detroit fire marshal to issue his fire warnings. Here is one from fire marshal Gabe Coldwater in 1919:

> *The use of celluloid ornaments and cotton to represent snow on trees is a great menace.*
>
> *Lighted candles and children in highly flammable dresses effect a combination that is very likely to prove disastrous.*
>
> *Open lights on trees should be watched the entire time they are burning. Handling or touching the tree may cause the decorations to fall on a lighted candle.*
>
> *When Christmas greens are dry they are extremely dangerous. They should not be left in the house more than one week after Christmas.*
>
> *The use of greens, harvest specimens, leaves, etc. either natural or artificial, and other materials such as scenery, cheesecloth, draperies, tissue paper, and cotton bunting are decidedly objectionable from a fire hazard point of view.*
>
> *In crowded stores and places of assemblage the danger of panic and loss of life in the event of fire cannot be exaggerated.*

In 1909, Detroit's fire chief Broderick summed up his views succinctly: "Don't have a Christmas tree at all!...The worst of it is they go up like tinder once they get a good start."

December 21

1880—Boy's Letter to Santa

A boy from the sixth ward of Detroit wrote a letter to Santa published on this day in 1880:

> *Dear Santa,*
>
> *I want a Bob sled, a pair of Ice King skates, a velocipede [bicycle], a banjo, a flute, an unabridged dictionary; I want to go to the German school, a whole lot of candy, a Demas scroll saw, a printing press, a bowl to eat*

my bread and milk in, a new house with a playroom and a stove in it, lots of wood for the scroll saw, a ticket for Beller's, a knife—four bladed with a corkscrew and a pair of scissors in it, a book slate, and a set of clappers.

December 22

1882—First Electric Christmas Tree Lights

The first known electrically illuminated Christmas tree was the creation of Edward H. Johnson, an associate inventor of Thomas Edison. While a vice-president of Edison Electric Light Company, he had workers hand make small, colored electric light bulbs for him. He proudly displayed eighty red, white and blue incandescent walnut-sized bulbs on a tree in the window of his New York City apartment on December 22, 1882. Newspapers considered it a publicity stunt, but a Detroit reporter covered the event and made it a national sensation. Johnson became the father of the electric Christmas lights, but electric lights on trees did not become widespread until the 1930s.

December 23

1903—Christmas Shopping

Last-minute Christmas shoppers crowded downtown streets in the thousands, as described in 1903:

Woodward Avenue, especially north of Michigan Avenue in the down-town section was the busiest thoroughfare in Detroit…The large department stores were crowded to their utmost capacity. Weary clerks leaned on their elbows whenever opportunity offered…worked their hardest to satisfy the demands of Christmas shoppers…Floorwalkers found it impossible to handle the crowds satisfactorily…At one of the downtown stores it was a problem to get inside the door. In order to make the entry it was necessary to get in line with other shoppers.

December 24

1830—Midnight Mass and a French Detroit Reveillon Dinner

It was Christmas Eve 1830, when Detroit had a population of less than 1,500 people, still mostly French Canadian. For French Detroiters, this night was more important than Christmas Day. This special night was called "the Night of Miracles." The evening began at Ste. Anne's Church for *Messe de Minuit*, or midnight Mass. Each family brought a lantern that they left outside the church with a poor person to guard it. When Mass concluded, they would pick up the lantern and pay the guardian with a coin as a Christmas gift. Once home, the enormous yule log was started; Christmas trees were not seen in Detroit for another twenty years. The family and friends sat down for a nightlong dinner called the *Reveillon* (pronounced "rev-eh-yon," meaning to revive). The meal included a wild game pie seasoned with clove, mace and cinnamon called a *tourtiere*; *creton* (a pork pâté); pea soup; small meatballs; fricassee (a quick-cooking stew); and, for dessert, a maple sugar tart. The children put their shoes by the hearth with small carrots for Pere Noel's donkey. If the donkey took the carrots, the children found gifts, such as sugar roosters, gingerbread Indians or horses and other small toys, in their shoes. (Bigger gifts were given on New Year's Day.)

December 25

1888—A Victorian Christmas Dinner

For many years, Christmas dinner remained unchanged. During Detroit's Gilded Age, those families of means always had turkey, goose, plum pudding and the candies called sugar plums. According to the columnist Mrs. Rores in the *Detroit Free Press*, puddings had to be made two weeks before serving "to ripen and grow rich," candies made two days before and stored in a tin box and the turkey and goose had to be "carefully wiped and hung in a cool, dark place five days ahead." Here is Mrs. Rores's glorious Victorian Christmas dinner menu for twelve guests, complete with ginger sherbet served between each course to keep the palate clean.

Menu
Oysters on the half shell
Soup Crecy [a French carrot soup]

Fried Smelts, Sauce Tartar, Parisienne [sic] *Potatoes*

Roast Turkey, Oyster Stuffing, Cranberry Sauce
Boiled Rice, Scallop of Okra and Tomatoes, Cauliflower

Roast Goose, Applesauce, Sweet Potato Croquettes
French Artichokes with Lettuce and Mayonnaise Dressing

Water Biscuits, American Brie
Plum pudding, hard sauce
Fruit, Nuts, Raisins

Coffee

December 26

1945—Quiet In Detroit

The *Wall Street Journal* reported on this day that since August 1, 1945, the UAW CIO union and others had been wrangling with automotive companies nonstop in "bitter cross table confrontations." Picketers were on strike in 1945 at nearly one hundred General Motors plants across the nation, but at this time of year, they were taking a "pickets holiday" to be with their families; they had been on strike since November 21 with a demand for a 30 percent wage increase. Ford Motor Company and the union called a truce until January 8. The union denounced Ford's offering of a fifteen-cents-an-hour wage increase. Chrysler labor continued to operate without a contract until after the holidays.

December 27

1950—Detroit at Its Largest

As the final days of 1950 ended, Detroit was the fifth-largest city in the United States. It was the year Detroit's population peaked at 1,849,568. As of 2013, Detroit became the only city in the United States to have a population that grew beyond one million and then fell below that figure. The first time Detroit appeared in the top-ten largest U.S. cities was in the 1910 census. From the 1920 to 1940 censuses, Detroit was the nation's fourth-largest city; it followed New York, Chicago and Philadelphia. In 2015, the largest U.S. cities are New York, Los Angeles, Chicago and Houston, while Detroit is eighteenth largest with an estimated population of 680,250 people.

December 28

1921—Fruit Cake

On this day, Joseph Mills of Detroit made a Christmas fruit cake in the shape of a Great Lakes freighter. The cake was twenty-six inches long and weighed in at twenty-five pounds. Mills sailed the Great Lakes as a steward on a freighter and made his fruit cake a perfect replica, accurate in every detail, including chocolate-formed stairs and tiny fruit buoys. On this year, he made the cake in his home kitchen. When on the ship during Christmas, the ship ovens allowed him to make much larger cakes.

December 29

1782—Gifts for Indian Friendship

The following list includes merchandise ordered by British in Detroit for one full year:

30 pieces of embossed serge, 500 felt hats, 100 castor hats, 50 beaver hats, 500 pieces white melton, 500 pieces blue melton, 100 common saddles, 400 bridles, 500 powder horns, 20 doz tobacco boxes, 30 dox snuff boxes, 80 gross pipes, 300 large feathers red, blue, green, 300 ostrich feathers, 200 pairs shoes, 250 pairs buckles, 100 pieces Hambro lines, 10

doz mackerel lines, 10 doz spurs, 50 gross Morris belts, 50 gross brass thimbles, 6 pieces red serge, 10 gross Jews harps, 500 Fusils, 200 rifles guns small bore, 50 pair pistols, 5 doz Couteau de Chasse, 50,000 gun flints, 60 gross scalping knives, 10 gross clasp knives, 20 gross scissors, 20 gross looking glasses, 20 gross razors, 300 pnds thread assorted, 20 pieces spotted swan skin, 12000 pnds gunpowder, 36000 pnds ball and shot, 1 gross gun locks, 500 tomahawks, 500 half axes, 300 hoes, 30 gross fire steel, 10000 needles, 400 pieces calico, 15000 lbs tobacco, 600 lbs beads assorted, 40 gross awl blades, 40 gross gun works, 30 gross box combs, 30 gross ivory combs, 20 nest brass kettles, 20 nest copper kettles, 200 gross gartering, 200 gross bed lace, 250 pieces ribbon assorted, 30 doz cotton handkerchiefs, 100 dox silk handkerchief, 20 pieces Russia sheeting, 50 pieces coarse muslin, 2000 pnds vermillion in 1 pnd bags.

December 30

1922—Flappers

Where ever you are, no matter how far
From the gay clatter on Main Street
You'll see her flap with sparkle and snap
From her head to her dainty feet
In all her whirl with skirts aswirl
In any old burg you visit

A flapper cartoon from the 1920s by Russell Patterson. *Courtesy of the Library of Congress.*

The cake-eaters all can't help but fall
And holler in glee—"This is it!"
–Detroit Free Press

December 31

2000—Memorial Century Box

The Memorial Century Box was a time capsule created in Detroit on December 31, 1900—in the final seconds of the end of the nineteenth century. Mayor William C. Maybury organized the capsule, which consisted of a copper box filled with photos and letters containing the then current state of affairs in Detroit along with predictions for the future. The box was stored in a vault. One hundred years later, Mayor Dennis Archer presided over the opening of the capsule at Orchestra Hall on December 31, 2000. Among the fifty-six people asked to contribute letters was Augustus D. Straker, who was a well-respected African American lawyer and judge.

ABOUT THE AUTHOR

Bill Loomis is the author of *Detroit's Delectable Past* (2012), *Detroit Food* (2014) and numerous articles on culinary and social history. His writing has been published in the *Detroit News*, *Michigan History Magazine*, *New York Times*, *Hour Detroit* and more. Mr. Loomis was born in Detroit and grew up for a number of years in the North Rosedale Park neighborhood in the city. Mr. Loomis lives in Ann Arbor with his wife and children.

About the Photographer

I am a part-time photographer living in Ann Arbor with my wife and two teenage sons. As a history buff and a lover of photography, this was a most enjoyable project to work on. Thank you to Bill Loomis for showing me things in Detroit I did not know were there. Detroit has many, many gems. Thank you to my family. Time after time, they wait patiently as I stop once again for yet another shot that I just have to have.

–Barney Klein